The Darker Passions
Frankenstein

The Darker Passions Series:
Dracula
Frankenstein

Coming Soon:
Dr. Jekyll and Mr. Hyde
Carmilla
The Fall of the House of Usher
The Pit and the Pendulum
The Picture of Dorian Gray

The Darker Passions
Frankenstein

Nancy Kilpatrick

writing as

Amarantha Knight

Circlet Press, Inc.
Cambridge, MA

The Darker Passions: Frankenstein
by Nancy Kilpatrick, writing as Amarantha Knight

Originally published by Masquerade Books
Circlet Edition Copyright © 2003 Nancy Kilpatrick

Cover Illustration Copyright © 2003 Adrian Welch, Darkroom
Designs (www.darkroomdesigns.com)
Series cover design by Hugues Leblanc

Printed In Canada

First Printing, August 2003

ISBN 1-885865-35-X

Circlet Press, Inc.
www.circlet.com

Acknowledgements

Sephera Giron, Eric Kauppinen, Hugues Leblanc, Caro Soles, Mari Anne Werier, MK with the golden hands, and Cecilia Tan, for her incredible vision. And of course, Mary Wollstonecraft Shelley, a woman who dared to dream big, and who wasn't afraid to hang out with the poets.

"In just seven days, oh baby!
I can make you a ma-an-an-an-an!"
—Frank 'N Furter
The Rocky Horror Picture Show

Chapter One

Ice. Nothing but cold, inhuman ice. Where was the warm, hot flesh, burning with desire, moist with longing, eager to melt before a passionate will?

Robert Walton wondered what had possessed him to captain this desperate ship lurching along on its ill-conceived voyage through the land of mist and snow. He gazed off into the distance of the frozen wasteland before him. Far out on the white north Atlantic—on the western horizon—Robert imagined the speck he saw moving across the floes to be a human being. A person like himself—desperate for companionship. Eager for solace against the chilly winds that were a day-to-day reality. Eager for the fires of passion to ignite and envelop the body and transcend the soul.

But, of course, that speck was no homo sapien. Impossible. An hallucination. Likely an animal, a seal perhaps, or some sturdy bird suited to this unfortunate climate was what he had seen.

Damn! he thought. What had brought him here? Some pathetic sense of adventure? An urge to display his mettle, to prove himself a man in charge? A man who could seek out the perfect being to be the Psyche to his Eros, the nail to his driving hammer.

He glanced around his ship, staring at the various low-life crew members sullenly performing their tasks. His money had paid for this vessel, and their wages, and yet only yesterday they had threatened mutiny. He had taken the cat to a dozen backs, flailing flesh hardened by wind and salt water until his fury was spent and the decks were paint-

ed red. And yet in his heart, he suspected his crew of more sanity than he himself possessed. For what was the point of sailing these inhospitable seas, questing for friendship and love? For months his only contact had been Billie, the cabin "boy," a wiry, humorless eighteen year old who barely warmed his bed at night. Billie, a female disguised as a male, performed well enough yet lacked a certain *élan*, as the French would say.

"Dogsled approaching from the East, Sir," the crewman at the crow's-nest called.

Robert hurried starboard. "Good God!" he shouted. Then, "You men, hurry! Over the side and halt that sled. The driver has collapsed."

Indeed, the bundled figure strapped to the rear of the sled appeared to have fainted. Either that, or he was dead.

Half a dozen sailors leaped over the side of The Virgin to block the path of the run-away dogs. Five white, grey and black huskies with haunting pale eyes dragged the dead body of a sixth dog along, as well as the packed sled complete with a driver incapable of control. Within ten minutes the strong crewmen had the wild dogs subdued. The driver was unstrapped and hauled onboard The Virgin and brought immediately to the captain's quarters below deck.

"Heat the stones," Robert ordered Billie, "and wrap him in furs. This man needs attention. His limbs are blue and I don't doubt he'll lose a few digits."

Billie did as instructed, covering the comatose man with lambs wool blankets and slipping the sizzling stones into wool cases which she positioned against the stranger's flesh. Robert directed the lass to mix a hot toddy. The captain tilted the mug of warm rum against the frozen man's icy lips. Some of the sweet drink made it down his throat. Within moments his lids parted and glacial blue eyes stared into Robert's brown ones.

"We must find them!" the stranger whispered. "Before it is too late." With that his eyelids dropped and he slept for the next two days.

"I'm fine. Fit as a fiddle," Victor Frankenstein declared, struggling to get to his feet.

"If you were a fiddle, your casing would have cracked long ago from the severity of the temperatures," Robert said. "I suggest you lie back

and gather strength."

The suggestion was unnecessary, however, since the weakened Herr Frankenstein did not have the ability to sit much less stand on his own. When his legs gave in, he did indeed fall back onto the bed.

"Billie!" Robert called.

The slim young woman who imitated a slim young man ducked her head through the door at the top of the steps. "Captain?" The voice was high, but most of the crew thought Billie simply a late developer; none suspected a female aboard ship. Had they, chaos would have reigned. Billie would have no doubt enjoyed the plowings, since the girl was insatiable, if rather coarse. Robert had seen her eagerly getting her rear hole plugged in a darkened galley by more than one sailor, who suspected nothing and believed that the behind in question belonged to a lad and not a lass.

"My guest has need of your services."

A grin spread across Billie's ruddy-cheeked face. A toothless grin, for she had often scrapped with the heftier port barmaids long before Robert's ship left Glasgow two months ago. Every tooth in her head had been knocked out. Rather than this being a tragedy, Billie declared the incident a blessing in the long run. And, in fact, that hollow cavity of pleasure did not make her ugly, but oddly increased her beauty. That mouth consisting of only pink flesh, worked wonders over a swollen cock. It had convinced Robert to take her aboard and those same eager gums were the remedy he had in mind now for the ailing Dr. Frankenstein.

Billie was already undressed, facing the bed, her slim back to her master, who sat on the three foot long bench used for various purposes. In the dim light of the gas lamp, Billie's slim but full-cheeked behind glowed only a faint pink. Robert had been so preoccupied with his visitor of late that he had neglected his duties.

"Billie!" he called sharply. The girl turned. Yes, the proof of it was on her insolent face. Not only had she the expression of one simply performing a task, like scrubbing the deck, but her nipples betrayed her. They were neither hard nor pointed. The entire impression was lackluster. Robert had no intention of looking bad before his guest by sending an inferior lifeboat to the rescue.

He pointed to his lap. "Over the knee. Now!" A glint of excitement

flashed in the girl's dark eyes, followed by a look of longing. She hurried across the small room. But when she reached him, she stopped and looked confused.

"Captain, sir..."

"What is it?"

"You've no implement. Shall I fetch your razor strop?"

"I've two good natural implements, hardened enough, as you will soon recall. For your insolence, you will taste each of them. Now, must I tell you again? Over the knee!"

Billie bent forward and then fell across his lap in an awkward manner. Her toes and fingertips touched the floor, allowing her lush behind to curve over the side of his right leg.

The flesh quivered in anticipation. He felt her body hot through his pants. His cock stiffened immediately and strained against the fabric. He ran a hand over first one cheek and then the other. Billie trembled in anticipation. In the bed against the wall, Victor Frankenstein managed to prop himself up, watching eagerly.

The ship's captain slid a finger down the crack in Billie's welcoming ass. The bottom hole seemed to open like a little mouth when he passed over it. He traveled further, cutting between her moist hot nether lips. His hand felt the heat rise from her like heat emanating from the round-bellied coal stove in the corner of the room. He intended to stoke that fire, though, so that she would provide a sufficient level of combustion to warm his chilled guest properly.

Billie required little preparation, and he gave her none. His palm smacked her cheeks, one after the other, in quick succession. "There's nothing like the sound of flesh on flesh," he said warming to the delightful task. His visitor nodded.

Smack! Smack! Each in turn. As the moments passed, the cheeks reddened. Billie moaned, at first softly, soon louder. Little cries joined the cracks and seeped through the portholes, a fine musical blend of pleasure and pain. Soon those fleshy cheeks were dancing and Billie was singing in harmony. A quick glance at Frankenstein assured Robert he had his guest's full attention.

One of Robert's strengths was his hands. The flesh was hard but not calloused. He had yet to find the bottom that would not tire before he did. As he spanked the jiggling cheeks, Billie's legs flew out. She now

held on only by her hands propping her up against the floorboards. She kicked wildly as he whaled the daylights out of her disobedient little ass. Now the cheeks resembled a brilliant Atlantic sunset. No doubt her cries could be heard throughout the ship. He expected every member of the crew had one hand inside his pants.

Across the room, Frankenstein's mouth lay open and his eyes bulged. He was warm, no doubt, having tossed off the covers. Sweat covered his naked body and his cock stood thick and hard and throbbing in his hand. Robert noticed the gold nipple ring affixed to his left tit and, in passing, wondered about it.

The glow on Billie's bottom turned the color of blood, although no skin had been broken. Her sobs filled the room, bathing the walls in the moisture of desire. He felt the insides of her thighs and discovered them slick.

"Up!" he commanded.

Billie stood on shaky legs. The nipples of her pert breasts had hardened to fleshy pebbles. Obviously his efforts had proven effective. But she could do far better than that for his guest.

"Over the other knee!"

Her face—wet with tears—looked shocked, but also delighted. "Captain, sir, I beg you—"

"Silence!" It was a game between them. She would beg him to cease, all the time wanting more. And he would satisfy her wants and needs because in the end she would satisfy him with that mouth that was like no other.

He pointed severely and she moved around him. From this side Victor Frankenstein had a far healthier view of her flaming derriere.

"Fortunately I am ambidextrous," Robert enlightened him, and at once set to on Miss Billie's fanny from this new perspective.

Her flesh was cosy and hot to the touch. This spanking would last her a day or two, that was certain.

His left hand was perhaps a bit more powerful, which is why he'd saved it. Each smack resounded around a room otherwise silent save for Billie's wails. Robert felt the pressure at his crotch becoming unbearable and regretted this tanning would not benefit him.

He smacked and smacked the trembling cheeks, spanking with a full swing, enjoying the feel of her bottom moulding to the shape of his

hand at the moment of connection. Again, Billie let her legs fly up into the air while she balanced against the floor boards. Her hips bucked and her mound knocked against his leg in time to the punishment, adding to her excitement. No doubt Frankenstein had a good gander at her wet cunny.

Finally, regretfully, Robert finished. He could have continued, but his guest was about to be overcome with enthusiasm.

"Attend to Herr Frankenstein," he instructed Billie, who got quickly to her feet and hurried across the room. She bent at the waist and placed her hands on the bed on each side of Frankenstein's body. Then she lowered her toothless mouth over that swollen hot rod and began to lap and suck the juices out of him.

Robert's intention had been to be the gracious host, simply allowing his guest to enjoy his hospitality. But the sight of Billie's fiery ass poised in the air one moment, then bobbing with her movements the next, her legs spread so that the red cunny lips, saturated with moisture, twinkled in the lamp glow as if inviting visitors, well, all of it proved too much for him.

He unbuttoned his trousers as he stood and had his own rod deep in that cunt fast. She closed on him immediately. The heat inside matched the heat of her ass cheeks. He banged against that sore bottom, his cock sliding in and out of her tight, rippling flesh. The room filled with the sounds of Victor's moans as Billie's talented mouth slurped and coaxed out his creamy seed.

The three came together in a sound that resembled waves breaking over the shore. Victor cried out. Billie, her cunt-like mouth full of pulsing penis, moaned loudly as her vagina contracted sharply. Robert let his head fall back and a roar escape his lips as he rammed deep into her tight inferno one final time.

Billie cleaned the men with her ever-hungry mouth and, once she'd resumed her masculine disguise, departed, climbing the steps, her no-doubt burning bottom swaying in complete and joyful liberation.

Robert poured two glasses of Jamaican rum and handed one over to Frankenstein.

"A rare wild flower," Victor said, downing his liquor in one gulp. "A definite asset to a ship's captain."

"If you mean she has the rough beauty of a weed garden that

requires wildflower reseeding on a regular basis, yes, that is true. I find her willing enough. That is not the issue with Billie. More, it is that she is too pedestrian in her tastes, lacking finesse, as you Swiss would say." He refilled Frankenstein's glass and they drank in silence for several moments.

"Now that you've regained your voice, Doctor Frankenstein, for I learned of your profession from your papers which I took the liberty of examining when we thought you near death, perhaps you'll enlighten me. What is a man of obvious breeding doing this far north? On the frozen ocean? And alone?mons veneris"

Frankenstein eyed him, an appraising look, one that showed curiosity and questioned the fabric of which the speaker was made. "I might ask you the same thing. You are obviously not a career sailor, but of the aristocratic class, like myself, and yet you captain a vessel." Frankenstein's voice was firmer than the situation called for, perhaps made so by recent exertions. Still, an obvious battle of wills could ensue, should Robert allow that to happen. As it was, he felt in control of the situation, and of his position here on his boat, his territory. This man, despite the hint of power in his eyes, was no threat. At least not for the moment.

"If you must know, my plan had been to travel the North Atlantic and cross east to the North Pacific. True, this is a long way around, and a difficult passage, but I am searching the world for a partner, one who will join me in my unusual passions and engage with me in any manner I choose. Before you inquire, someone of a finer disposition and temperament than our Billie. I am not concerned with gender—male or female will do equally. What I seek has more to do with constitution on the outside and subtlety on the inside."

A spark of recognition glinted in Frankenstein's eyes, followed by a hollow laugh. All this was accompanied by a nod of understanding. "The moment I awoke and laid eyes on you, Captain Walton, I saw as if in a mirror. You and I are alike, which is a pity, since I am here as a living example of such passionate goals gone awry."

"And how is that?"

"If you will permit me, I shall tell you a story, a long tale that will take time to repeat. But once you have heard my experiences, I think they will alter your own goals somewhat, if not completely."

"Well, now that we are caught in the ice floes, waiting for enough of a thaw to sail either ahead or back, other than struggling to subdue the mutinous blackguards who call themselves my crew, and struggling equally to keep under control the melancholy fueled by a wild nature such as my own barely fed in this environment of scarcity, I have little else to do. I expect a good tale will entertain me, if nothing more, and might even be a distraction from the longing which possesses me night and day. Go ahead. Tell your story. What have I to lose?"

"What, indeed? A question I once recall asking myself when I was perhaps more naive."

Suddenly his face became excited, his tone equally so.

"You know, we are all unfashioned creatures, half made up. I once had a friend, no, a lover, the most noble and intense of beings. Now I have lost everything. But, if you will indulge me, I shall begin my tale of woe."

Chapter Two

I can only tell you, Robert, that I am the product of an honorable family of scientists, and therefore have no excuse for my actions. I was born in Geneva, the eldest of two sons, to parents who adored and indulged me. I cannot fault them for my dark nature.

Our family has a long and illustrious history, for is not the name Frankenstein itself indicative of the rocks which make up the landscape and of which our ancestral home had been built?

I was destined to carry on the tradition and study the physical sciences at university and at eighteen attended Oxford.

As a child I'd been attracted to the theories of Cornelius Agrippa and Paracelsus, and, of course, Albertus Mangus. Simple ideas by today's standards, and yet they had absorbed my young mind and fired my creative spirit.

When I entered university, though, these ancient scholars were complimented by the latest scientific theories and I began to see the universe in a fuller perspective and to sense the possibilities. If you had been able then to unearth secrets I kept even from myself, what would have been revealed was that I searched for the Philosopher's Stone, an Elixir of Life no less.

Of course, to utter this would have been heresy in an institute of higher learning. For all intents and purposes, though, I was a model student, and quite brilliant, as my professors were inclined to inform me.

The summer before my second year at Oxford, during the school holidays, I went vacationing at Lake Como with my parents. My kind-

hearted mother discovered a girl in the market place, so thin from mal-nourishment she could apparently not feed herself. The girl was, though, of good breeding. Her father, recently deceased, had been a Milanese nobleman; her mother, who had died just after the girl's birth, had also been of the upper class. An unfortunate set of circumstances had deprived this orphan of her rightful fortune, and mother took pity on her.

This girl was twelve months older than my own nineteen years, and as lovely and fair a thing as I'd ever seen. Hair the brightest living gold, and enormous eyes like a cloudless blue sky contributed to her waif-like quality. Her full lips were sensual and, I suspected, sweet, and right from the start I longed to taste them.

On hearing her story, my mother virtually adopted Elizabeth, and she returned with us to Geneva. The arrangement worked well on all counts, since my mother had always wanted another female in a house-hold congested with males.

Elizabeth proved to be intelligent as well as beautiful.

Her curiosity knew no bounds. She was adventurous and liked to investigate where others feared to tread. This appealed to my scientific thrust, as I was an investigative type myself, although not nearly as daring as she. I was soon to discover that she also possessed an appetite for sensory stimulation, and experimented constantly with ways to heighten experience.

I do not believe she had been in our home two weeks when we were alone together breakfasting in the gazebo one sunny morning. My father and brother were away, and mother was down with a cold.

I picked up the sterling tea pot of just-boiled water a servant had brought us and, distracted by Elizabeth's airy chatter, burned my knuckle against the blazing metal. A small cry escaped me. Elizabeth fell silent and watched me avidly. Embarrassed by my outburst, I ignored the pain and continued pouring my tea. I was just sipping the warmth and comfort from my gold-rimmed china cup when she said in her sweetly seductive voice, "Victor, show me your manliness."

Hot tea sputtered from between my lips. I stared at her, aghast. Those taunting but lovely eyes of blue sparkled daringly in the sunlight.

"Unless, of course, you're embarrassed," she added.

"I am not embarrassed," I declared, although in truth I was. It had

occurred to me already that Elizabeth was far more experienced than me. Still, this I would not admit. "I shall show you my family jewels if I can see your *mons veneris*."

She laughed, a light, sparkling sound that caused her body to quiver and her golden curls to jiggle. In truth, she looked fetching and I longed to kiss her. "I'll show you these mountains first," she said, slowly unbuttoning her dress from the high neck down.

I cannot adequately express the tension within me as her flesh came into view. I had not seen a woman's breasts before, at least none I remembered, and as each tiny pearl button slid through the hole and exposed more fair skin, then the shadowy valley between the two mountains swelling above them, my heart beat faster. I could not breathe. My palms grew sweaty. I felt a pressure at my groin. Each mountain became more and more bathed in the sunlight. And then those gorgeous circles of strawberry fields emerged, with the reddest, ripest fruit of all at the delicious peaks.

"Would you like to touch them?" she asked.

My mouth was dry but I managed to nod.

"Then give me your hand."

Without being aware of it, I reached out my hand and touched one of those warm mountain ranges. Her hand led my fingers from the firm flesh of the hillside, here hot, here cooler, the undersides hotter still, and moist, then to the soft areola to the sassy hard red nub at the tip. The moment I touched it, her lips parted and a moan filled the screened-in enclosure. It seemed to me the fleshy nub became even firmer as I rubbed my fingertip across it.

And rub it I did. I used all my fingertips, then my palm. I fondled and toyed with this magnificent region for what seemed an eternity. All the while Elizabeth squirmed in her seat as though my every movement sent a spasm through her. Then instinctively I took the nipple between my thumb and first finger and pinched hard. Elizabeth's back arched as she thrust her eager little tittie towards me for more.

"Oh Victor!" she cried. "If only your lips and teeth would speak to me as strongly!"

At first I thought she wanted words from me, but my aching member sent me a message that this was a silent language she wished to hear. My head moved forward.

"Lick my tittie," she whispered.

I did.

The taste of it was like fleshy honey, sweet, so sweet I wanted more. Within my trousers, my cock longed to be free of his restraints and find a liquid of his own to taste. I was about to use my entire mouth to devour that delight when suddenly a hand blocked my lips. I looked up into her blue eyes fringed in pale, wispy lashes.

"First, Victor, you will show me what you have to offer."

I knew what she meant. She wanted to see my cock, now swollen to capacity with excitement. I was terrified to reveal him, afraid that one glance from her would unlock the floodgates.

I reached out for her nipple again, thinking that the pleasure I would bestow would make her forget the request. A hand slapped my face soundly.

The slap stung me more emotionally than physically, although she was surprisingly strong.

"You will unlock that mystery now, sir, or you will not savor my delicacies!"

Oddly, that slap combined with her demanding words did not dampen my ardor, but inflamed it beyond my ability to control myself. My body betrayed me. I spewed all that was in me into my pants.

Elizabeth, of course, knew well enough what was going on.

I expected the worse, that she would laugh at me. She did not disappoint. Both of my cheeks reddened in shame. I'd lost all honor before her. I wanted nothing more than to slink away. In fact, I began to stand, to retreat to the house, to my room, if only to clean myself up.

"Stop right there, sir," she said in a cold voice. "You have not been dismissed." Whatever possessed me, I cannot say, but I did obey her. "You have shown yourself worse than an animal, incapable of control. How will you ever satisfy a woman if you cannot maintain yourself at the crucial moment."

I know my face flared again from the neck up, and yet I could do nothing but accept this tongue lashing, feeling myself inadequate on all counts.

Suddenly her features shifted. She looked playful again. "There is a way you may redeem yourself and your pride, if you are man enough."

"How is that?" I asked in a trembling voice.

"Unbutton your trousers and drop them to the floor."

"But if mother should look out the window—"

"You're of age, you know. But if you are still a momma's boy, then I'm wasting my time with you."

I felt dumb before her. Of course I was no longer a child, but a man. And the gazebo was fairly well hidden. Besides, my mother's eyesight was not good at a distance.

All of these rationalizations confirmed to me that I wanted to obey Elizabeth, more than anything. I found myself undoing and dropping my trousers. Now my full but spent manhood stood half-heartedly before her, sticky with my recent emission.

Tenderly, Elizabeth leaned forward and licked at the liquid. Then she leaned back. "Salty," she decided. "Yet a bit sweet as well." She licked again, which no doubt confirmed her first opinion. Soon she had me licked clean.

I must admit that the actions of her tongue revived my fellow considerably. When he had risen to the occasion, she lapped at his head and licked up and down the shaft in a different manner entirely. Her tongue even found my testicles and worked at them, licking and sucking, she took them one at a time into her mouth, sucking and rolling them until they were high and firm.

I stood with eyes closed, fists on my hips, struggling to keep the sounds from being released into the air, feeling for all the world like a king, no, a demi-god, being attended to by the fairest nymph in all of heaven. The pleasure her full lips and warm tongue gave me was exquisite. I felt a delicious pressure in my groin that increased moment by moment. And when her mouth covered my cock like a warm duvet, I believed I had died and entered a state of eternal bliss.

My bliss was just about to abandon itself to ecstasy when a searing pain blazed across my right ass cheek. Instantly I gasped and jerked forward, thrusting my cock deeper into her mouth. The pain stayed with me, increasing because of its continuous presence. One of her arms locked around me, holding me in place.

I glanced behind to see the belly of the hot sterling silver teapot she held pressed against my bottom cheek. The muscles beneath the singed flesh hopped around, trying to avoid what they could not avoid.

In truth, I suppose I could have simply shoved her hand away. But

again, as before, the pain only added to my pleasure in a diabolical manner. It was as though I were caught in a chasm where two sensations rippled through me with equal intensity, so equal that to lose one would mean to lose the other. I could not decide which I preferred and because of that and the fear that both would end, I struggled to hold on to each.

The tension in me had to break. I came in a full blast into Elizabeth's mouth, shooting round after round of my seed down her receptive throat.

When it was over and the hot pot had been removed from my steaming ass cheek, Elizabeth demurely rebuttoned her dress, stood and headed towards the house as though this had been an ordinary breakfast. Part way up the rose path, she turned. I stood dumbly, my trousers still around my ankles, the fire in my behind and the wondrous feeling of satisfaction consuming me. I had never seen such angelic beauty as what stood before me. She smiled at me up through those pale lashes, her eyes traveling up and down my bare parts, lingering in the area of my groin. I could not move. I was in a kind of after-shock of ecstasy.

"The moon will be full tomorrow evening, Victor, and you will meet me at midnight here. Between now and then you must not relieve yourself, else I shall know it and punish you exceedingly." She smiled a little, as though she did not believe me capable of restraint; at that moment I vowed to prove myself. She turned, her delicate figure moving briskly up the path. I could only imagine the delights which lay beneath the layers of the fabric of her skirts.

Now, alone in the gazebo, naked from the waist down, I felt the after effects. My ass cheek throbbed in pain. A quick glance showed a round burn mark made by the blazing metal, already blistering. I knew that would be uncomfortable for days to come, especially when I was forced to sit at meals and in the evening, during the long and boring family recitals. Still, that pain reminded me of Elizabeth and the joy I had encountered at her hands and would no doubt experience again. Even the thought of our tryst the following evening brought my fellow to his feet again. His longing, the ache in my balls, and the burning ass flesh carried me through the day and a half of torment until I should be subject to Elizabeth's will once more.

Chapter Three

Time crawled by until finally a day and a night and another day had elapsed. At midnight, with the full moon high in the sky, I slipped out of the house and down the rose path to the gazebo. It was just midnight, but after what felt to be thirty minutes wait and no sign of Elizabeth, I began to worry that I had gotten the time wrong. Or worse, that she was not coming.

I was about to return to my bed and my moist dreams when I saw her form moving through the darkness like an alien being. As she approached, I saw she carried something in her hand, but did not know what. Even with the moonlight, it was too dim because of the trees.

The moment she stepped into the gazebo, I reached out my arms to embrace her, but she pulled away. "In due time," she said, her voice sending a thrill through me. "Undress."

"Completely?" I asked.

"Of course."

Another feeling of excitement raced through my loins as I removed my clothing. I'd been so occupied by my task that I had not noticed until I finished that Elizabeth had removed her own clothes. Through the trees, bits of moon shown white and brilliant. It illuminated our forms as it penetrated the screened-in sides of the gazebo, creating slivers of shadow and light. Elizabeth handed me something and I took it.

"A branch?" My hand ran the length of a good thick tree branch, flexible, that narrowed. Now I was confused.

"A birch from the garden," she said. "For teaching control in life,

and bringing life to the dead."

"Well, what...?" I was really thoroughly confused now.

"We shall take turns. You may start. Pick a number from one to ten and use the switch that many times on me. Then it's my turn to whip you."

Well, this game had possibilities. "Alright," I said enthusiastically. "I choose the number three. Where shall I lay this."

"Anywhere you like," she said seductively.

A peculiar feeling I had not experience before seemed to be born in me that instant. The notion of being able to take the birch to her, to control her, filled me with a fantasy that was fresh. As a lad, I had escaped all forms of corporal punishment. Recently, though, I had accidently seen the bottom of my best friend, Henry Cherval, a fellow my own age, on the receiving end of a riding crop held by his family's stable master. Despite my inner protestations, my excitement had inflated me wildly. And here I was being offered the delicious fair skin of Elizabeth, in just such an arrangement. Still, I did not lose all my wits.

"Have you been birched before?"

"Never," she said.

I did not know if I believed her professed virginity in this area, yet it did not really matter. She had never felt my hand swinging a birch, which was the point.

"Alright. Lie over the table, then."

"Did you want my bottom up or my front exposed?"

The idea had not occurred to me that there were other places to switch. Still, I had not yet gathered all the courage I would need and opted for a conservative approach. "Face down," I ordered her, as though I did this every day.

She did as I requested. The moon illuminated two smooth round cheeks awaiting my attention. I longed to touch them, to run my hands over their soft warmth and to discover the treasures between them, yet I did not know if this was part of the game we were playing. Until I learned the rules, I did not want to break them and frighten my opponent away.

I took a position to her left. Without further ado, I raised the branch about chest high and brought it down smoothly onto her behind. The birch swayed and whistled as it cut the air, then snapped soundly against the waiting flesh.

I was astonished. Elizabeth did not even flinch. The moon showed me a streak across the middle of her bottom, though, which I found both encouraging and invigorating. I raised the switch again, this time shoulder high, and brought it down. Still no reaction on her part. Now there were two streaks, doubling my pleasure.

Suddenly I began to worry that she was in severe pain. Perhaps she had even fainted. After all, she was the fairer sex, gentler, less able to cope with pain. As a man, I was expected to endure. She might be enduring but I may have pushed her beyond her capacity.

"Elizabeth," I stumbled, "are you alright? Have I wounded you too greatly?"

A silence ensued that unnerved me to the point where my erection began to dim. In the moonlight I noticed her body trembling as if she were sobbing silently. I was beside myself. I did not know what to do. Guilt plagued me. I felt on the verge of falling onto my knees and begging her forgiveness.

"Continue," she said in a scathing tone. That's when I realized that not only had I yet to near her capacity, I had failed to make a dent. Rather than crying, she was laughing at me.

In fury I raised the switch high above my head and brought it down hard across her ass. This time I got a reaction. Her bottom hopped into the air and a gasp escaped her lips. Then, "Much better."

Even in the moonlight, it was clear my third stripe was more prominent than the first two by far. Once I had finished, Elizabeth was on her feet. The moon showed me an expression on her face far different than any I'd seen there before. I did not understand its meaning, but I knew I wanted to see more of it.

"My turn," she said, holding out her hand for the switch.

I handed it over.

"I believe we need a further incentive," she said coyly. "How about this? Whomever cries 'uncle' first is the loser of the game. Then the winner gets to have his or her way completely with the other."

"Sounds fair enough," I said, thinking that it was ideal. One could only win in such a competition, no matter the outcome. "But what if the birch breaks?"

"Then the game is over. That will be a challenge, won't it? If the whipping is too severe, the birch will shatter. If, however, it can be done

in a skilled manner, the tool will last long enough to properly mark the flesh and incite the passions."

"Alright," I said, eager for this turn-about. "And where do you want me?"

"Oh, on your tummy for the first five."

"First five?"

"Yes. I've picked ten. I'll give you five on each side. Now quick. Onto the table. At the edge, please, so that my target is well positioned."

I lay with my swollen cock pressing into the cool birch table top. I was tense with anticipation. Within seconds I heard the birch whistling through the air, and instantly felt it whip against my ass in five hard strokes. This happened so fast I had no time to catch my breath. My ass stung as if dozens of bees had found it and taken their revenge. The spot marked the day before by the burning teapot suffered the worst.

Tears filled my eyes. Even the cool night air caressing the stripes only added to their bite. My bottom throbbed against the night. My cock throbbed under me against the table.

"Onto your back!" Elizabeth demanded.

"You are a harsh mistress."

"No speaking. For that I am entitled to double my number."

"What? You can't make up rules as you go?"

"And why not?"

Of course I had no answer. For how could rules of fair play intrude on this game where pain equaled pleasure and pleasure was exquisitely painful? And besides, I was beginning to get the drift of this erotic entertainment. "Alright," I acquiesced, and was rewarded by seeing a smile spread across those luscious lips.

"Spread your legs," she said. "Wider!"

Once they were spread wide enough for her, she gave me four quick hard ones on the inside of each thigh. If the stinging on my ass had been shocking, this was nearly unbearable.

My legs quivered with tension. Again, tears filled my eyes and I struggled to keep them in check and to stifle the sounds threatening to erupt from between my lips.

Still, despite all the agony, my cock had never felt so hard and full. I wondered how I could contain him tonight; he threatened to burst at any moment.

Elizabeth must have realized the fullness of my situation.

The tail end of the switch whacked me smartly across the shaft of my cock. A howl burst from me. But the scalding heat from the pain only added to my excitement. When the birch struck my cock again, all hell broke loose. I cried out as sperm shot into the air. My pelvis thrust forward hard, tightening my sore ass cheeks against the raw wood. Never had I felt such wonder, such release.

But when I sat up, Elizabeth stood with her arms folded under her bare breasts, the switch dangling from her fingers. She looked angry.

Suddenly my elation turned to ashes. I had let Elizabeth down, fulfilling myself while leaving her high and dry. "Here. Give me the switch. Lie across the table and I shall bring you to completion," I offered. Now she looked disgusted with me.

"Well, sir, I can see that restraint is the order of the day. Use that scientific brain of yours to good advantage, if you know what's good for you. You will design an apparatus to inhibit ejaculating. Then and only then will we play the game again, is that clear? And by the way, I still owe you five."

She threw the switch at me, grabbed her night dress and stormed down the path, leaving me with burning body parts and a desire that bordered on compulsion to play this game again with Elizabeth, and this time to play it right.

Chapter Four

The time between that second encounter and our third was excruciatingly long. Weeks went by. Being in the same room with Elizabeth, knowing the possibilities but not being able to indulge in them was pure torture.

All the while my feverish brain struggled to come up with an invention that would do the impossible—forestall male ejaculation. In desperation, I confided my difficulty in my friend Henry.

We sat on bales of hay in his family's stables discussing the conundrum.

"In truth, Henry, I suspect you've had more experience than me."

"At Gilles' hands, yes, but never with a woman."

"Does the fairer sex not interest you?"

"Like any sane man, all genders interest me. Why limit one's opportunities?"

We were youths then and, like youths, spoke as though we were world weary. In fact, I knew that Henry had not had an opportunity with the female half of the population any more than I'd found myself in circumstances with those of my own gender. All that, though, was about to change.

"Tell me, Henry. How long has Gilles been cropping you?"

"Cropping, birching, strapping, paddling. Why, he's adept with anything he can get his hands on. I've enjoyed his instruction for close to six months now. Ever since he came to work for us."

"And before?"

I knew Henry wanted to list his credits, yet we were too close for

lies. He confessed he'd had only his own company before the stable master took charge of his passions.

"Well, do you have trouble? You know, with finishing too soon after you've started?"

Again, Henry wanted to fabricate. In fact, he may have been about to begin a boast of his prowess, when a deep voice behind boomed, "A man, he learns to discipline himself through being disciplined. Training is the solution to your problem, *mes amies.*"

Gilles stepped from behind a horse stall. Apparently he had overheard our conversation from the beginning.

He was short, as Frenchmen often are, his muscles firm and bulging against the thin cotton shirt he wore. I found his trousers excessively tight at the crotch for jodhpurs, and what bulged there boggled the mind with wonder—how large could this man be?

His face was stern, the lines etched there over more than three decades. His dark features looked sinister to me at that moment, but I found such danger thrilling.

In his hand he held a long-handled crop, with a four inch tongue. This he swung against the side of his leg as he spoke. The sound both excited and startled me and I imagined an arm that strong laying a crop that long on my bare flesh. An involuntary shudder ran through me and my cock leaped up.

"Monsieur Cherval, he has come very far in a short time, is this not so?"

"Ye...yes, Master," Henry said.

I stared at my friend. Obviously he had undergone enough training that he understood how he would address the stable master, and the proper tone to take.

"When I first come here, Monsieur Cherval, his fountain would shoot forth like a geyser. This is the difficulty with youth, is it not? And now, my young friend, he has learned some restraint. It has been a painful experience, no? Show Monsieur Frankenstein your badges of honor."

Henry looked embarrassed at the idea of stripping off his clothing before me, although, of course, we had swum nude together as boys throughout the summers. And yet he also appeared thrilled by the notion of exposing himself. His trousers went down, revealing a well-marked bottom.

The short red criss-crosses, obviously produced by the stable master's crop, were spread evenly over that derriere and the backs of his thighs. Some marks looked fresh, while others could have been made over the last weeks. "I should think it takes much skill to not overlap," I said, examining Cherval's bottom in my scientific manner.

"Skill is gleaned from seasons of repetition," the stable master said. "But your difficulty, it is not with my abilities, but with your own, am I correct?"

Involuntarily I sucked in my lips and nodded. My face, ever the betrayer, flushed in embarrassment at my weakness. "Yes," I whispered.

"Lower your trousers!"

The command sent a chill through me. I glanced at the barn door and noticed the beam was across it—no intrusion, no escape. The nasty-looking crop slapped against his thigh again, as if it were calling my name. The stable master's face was stern, foreboding and it brooked no discussion, only obedience. I found my hands unbuttoning my pants and they fell to my knees.

"Onto the saddles. Both of you!"

I looked around in confusion. Surely he did not mean for us to mount horses bare assed! I was clever enough to follow Henry's lead.

A row of riding saddles had been positioned for waxing over a stall, about chest high. I noticed they had been tied tightly to the beam as if to a horse. Both Henry and I, trousers about our ankles, shuffled over to the saddles. Henry gripped the beam and hoisted himself up, then bent over the saddle sideways. He squiggled about until his ass was high and prominent. I selected the saddle next to him and followed his lead.

The cool leather creaked as I lowered my stomach over it.

The sweet, serious scent of the tanned cowhide filled my nostrils. That and hay and horse dung. The scents were like a perfume to me, intoxicating, promising what was wild and unrestrained. I had lifted my shirt, exposing my ass to the air and the stable master's view, imitating Henry.

Why did I feel so under his power? Certainly Henry and I were the masters here. Our families were wealthy and paid the wages of brawny men such as this. And yet it was as if our roles had been reversed. Henry and I submitted as though we had been born enslaved to this powerful man and his will.

"In turn, I shall whip you, each for several minutes. You will not make a sound. You will release no fluids. The least sound, a mere drop on the fine leather saddle, and the chop will speak louder. Do you understand me?"

"Yes, Master!" Henry said.

"Yes, Master!" I imitated.

Gilles began with Henry, a more familiar subject. Later I realized that this hesitation was not for the stable master's benefit, but for mine. At each snap of the crop against the flesh so close to my own, my fear and anticipation escalated. I listened to the slap of leather on increasingly raw flesh, the snaps reverberating through my entire body. I could barely imagine what a whipping like this felt like. All I had as a frame of reference was the switching I'd received at Elizabeth's hands. And her dear hands, firm as they were, would no doubt prove gentle compared to the hands of this massively built man who tamed the most wild of beasts.

The cropping went on and on, making my head, which was upside down, swim. I could do nothing but stare at my friend Henry. His head whipped from side to side. His hands were clenched into fists. Tears streaked his cheeks. And yet a look of ecstasy filled his face that spoke to me and dimmed my fears.

Whatever pain he suffered, joy was in equal proportion.

Throughout it all, not one sound had escaped his lips, which astonished me. I wondered if I could be as restrained.

Finally Gilles finished.

"Thank you, Master," Henry sobbed.

My anticipation turned to dread as I heard Gilles take up a position behind me. My body trembled. Already my cock was hot and hard, my balls aching. When the chop lashed me, my juices exploded.

Silence. I lay over the saddle gasping for air. The one small stinging line where the tongue of the crop had licked my behind became my entire focus, that and my release.

I lay in a dream-like pool, wallowing, oblivious to all but my cooling loins.

"Stand down!"

His voice was cold, sharp. Terror streaked through me. I dreaded what would come next.

Instantly I hopped down off the saddle and turned. Gilles' face

frightened me. The look was dark and dangerous and I was amazed at his ability to contain such fury. "Lick it off!"

I became confused. "What? You don't mean the saddle?"

He took a step towards me. Although he was no taller than me, his presence was menacing. I watched the muscles in his upper arms ripple and his hand clench into a fist. Quickly I decided I did not wish to explain to my family marks on visible parts of my anatomy.

I turned towards the saddle. It was wet with my semen, gobs of it adhering to the leather here and there. If the leather had not been protected, likely it would be permanently stained.

Henry propped himself up with his arms to watch me. I closed my eyes and licked at the wetness as I had seen Elizabeth do. The first impulse I felt was to vomit. And yet what overcame that urge was not a fear of Gilles, but the stinging of that one crop lash. The thought that I should receive only one.

That I should never feel the overwhelming whipping that Henry had received. That I should never buckle beneath the firm hand of a powerful man controlling me utterly; I could not bear such deprivation.

My tongue licked the cool gel and my lips sucked my own seed, taking in the gooey liquid. I felt it slide tangy and salty across my tongue and down my throat. When at last the saddle was cleaned of all of my deposit, I turned back to the stable master.

His face looked rigid, set. I knew my failure would be punished further.

"You will lie over this bale, *mon ami*, cock up!" he said. I did as he bid me, the back of my head and the heels of my feet on the straw-covered dirt. My stomach stretched, my crotch prominent, my now deflated cock highest.

"*Attende!*" Gilles commanded.

Suddenly Henry jumped down and straddled my body, his legs spread beside my head so that his thick erect cock hung above my face. His hands gripped the bale and he lowered his lips to my exhausted fellow.

Warm moist flesh slid over me as Henry pulled me up into his mouth. My penis began to firm a bit, despite his recent exertions. Sharp little bits of straw cut into the crack in my backside and irritated that one small patch where the crop had kissed me.

Suddenly I noticed Gilles behind my head. He raised the crop and brought it down hard onto Henry's already blazing bottom. Henry's body jumped and his legs began to quiver. My cock, securely locked in his mouth, felt the pressure as he closed on me. Excitement grew in my balls and they filled and swelled like a cow's udder. Horse manure and leather scents titillated me. I was fascinated: the sound of the crop lashing Henry's behind to a brighter glow. The sight of his massive cock red and bulging, the veins straining from the pressure. My own member pushed and pulled and stroked. I sensed he was about to hurry once more to the point of no return.

While Gilles whipped Henry's ass, he said to me, "Monsieur Frankenstein, you will learn to control yourself here and now. Cherval! The words!"

At once, Henry released my penis, which felt cold and abandoned. Through gasps and pants he managed to utter what Gilles wanted to hear. "Thank you, Master, for permitting one as lowly as myself release."

With that his fat cock spewed its contents over my face. I tried to turn my head but a riding boot jammed against my throat, holding me in place. Henry's cum was copious, enough to paint both me and the stable master's boot top.

While Henry got his bearings, Gilles glared down at me. "Lick your face clean."

The thought of drinking another man's cum was both repellent and exciting to me. Of course, I had so recently drunk my own, that nothing should have caused me to hesitate. Still, I did. I felt the boot at my throat press down. My air was being cut off.

Quickly my tongue darted out and tasted the cooling gobs of Henry's manhood. I licked my chin, my cheeks, up to my nose as far as my tongue would reach.

"Use your fingers, *mon ami*. You will drink it all!"

I lifted my hand and began scooping the creamy liquid down from my forehead and eyelids and nose to my mouth. Again, the nausea quickly gave way to delight. To be made to submit so utterly filled me with a sense of peace that I had not known existed.

When my face was dry, the boot at my throat was held above my lips and my tongue automatically cleaned the sole, the heel and as much of the waxy top as I could reach, the taste of tanned leather mingling with

the wax and dirt and horse manure and Henry's cold cum.

My cock rose to bursting with excitement. Never had I been made to obey another. I struggled desperately to contain my passion. I wanted to please this man and to show both him and my friend Henry that I was up to their standards. But the pressure was so great.

My head began to flap from side to side and I pinched my hips to try to distract myself from what seemed inevitable: again I would ejaculate, unable to restrain myself.

I still lay over the bale, my throbbing cock high in the air, my balls tight, about to pop. Suddenly an idea came to me out of the blue.

"Master, a suggestion. The horses' bits. Is there one that might fit me?"

Without any further explanation, Gilles understood my meaning. He walked to a wall and pulled down what resembled a horse's bit, with the leather straps attached to the rings at each end of the piece of metal. This bit, though, was small enough for a pony's mouth. He carried it to me and stood towering above my trembling cock, so near eruption. I felt the cool metal bit slide under my testicles. My eyes snapped open. Gilles pulled the leather straps tight, crossed them over in front at the base of my cock, then pulled tight again. I cried out. He knotted the leather. This lifted both my cock and balls as one unit even higher into the air. For a moment it was painful, then the pain turned into a pleasurable torment. The pressure was there, a strong pressure for release. But I realized in a flash that this restraint would keep me from emitting. I felt as if I could not contain myself, and yet I could not ejaculate. To test this, I gave myself permission to release all that was inside me, come hell or high water. The release began but was cut off quickly, leaving me with more of that painful pressure, but with my semen yet my own.

Tears of joy and relief washed over me. At last! A means by which I could restrain myself and, hopefully, learn restraint.

"Onto your feet! And over the saddle!"

I stood on shaky legs. My cock and balls thrusting out so far in front of me felt like a proud flag raised to honor a battle won. Gingerly I hoisted myself over the saddle I had so recently soiled, careful to shift around until my pressured genitals were as comfortable as possible in an extremely uncomfortable situation. The position I finally chose only lifted my ass higher into the air, as if it were begging for the crop.

And beg I did. At the stable master's insistence. He gave me the words and I uttered them first through clenched teeth and then through quivering lips until they mingled with my sobs.

"Master Gilles, I need training! Mark me well!" I cried.

The crop lashed my ass to ribbons. Pain exploded each time the strip of leather cut me. I had no idea a whipping could be so brutal, so beautiful. The hand holding the crop was firm and steady, the intent behind it stern. Each lash found a new spot, increasing the rawness of my flesh. Burning pain pounded through my cheeks, pulsing, rippling, driving my mind over the edge until only one thought remained: I would give my all for this virile man who owned my every breath.

The whipping lasted what felt like hours, what seemed like only minutes. My sobs were uncontrollable. My body flailed in agony. My brain had shut down so that I became a being of pain so interlaced with pleasure I could barely contain it. And yet through it all I was aware of my hard cock and tight balls containing my male energy and I felt submissive to this power greater than myself.

I heard the stable master order me down and onto my knees.

I do not recall how I got to the dirt floor, nor how I came to be facing his massive phallus. He was a god, his length and thickness beyond what I knew to be human. Without being told, I took his man rod between my lips and bathed it in kisses. It throbbed and pulsed in my mouth, its salty, meaty taste pure delight. I knew I could have spent my life honoring him, never tiring. And yet as he swelled to even greater heights and the head thrust deep down my throat, he pulled back. A cry of despair burst from me.

"Over the bale!" he demanded again.

I proceeded to lie as before when he stopped me. "On your belly!"

I lay upon the bale, the straw cutting into my trapped cock and balls. Their high position again forced my ass higher into the air than it would normally be. My cheeks burned as if they had been set afire. I did not know how I could tolerate another whipping. But it was not a whip that the stable master intended for me this time.

Only when I felt the thick stick end of the crop probe my opening did I tense. What could he mean to do? Surely men did not enter one another! And yet I neither said nor did anything to stop him.

As he spread my sore cheeks wide, nearly splitting my crack, he

began to enter me, tearing flesh, pushing out my inner walls. His rod moved inward, then further inward. I did not believe he would stop and expected to find him exiting my mouth with such a length. His rod in size reminded me of a stud's cock. I could not bear such a stuffing, yet all within me gave way before him.

My mind shut down completely. I became joined with him, linked. I opened to his every painful thrust, and closed with regret with every more painful withdrawal. "Master, fuck me hard!" I screamed. And he did.

My cries turned into growls and screams and sobs as he impaled me, spewing his powerful juices that washed my insides of their childish ways. It was as though my hole drank him like a mouth, sucking out all that he had given me out of desperate need.

When he was spent and had withdrawn himself, I lay on the straw feeling filled for the first time in my life. My entire body vibrated with sensation. My cock and balls still contained my juices. I knew at that moment my entire life had been affected in a manner that would alter the future.

I heard the beam slide away and the barn door open. Sunlight streamed in and with it fresh air, letting me realize the close air had been saturated with sweat and leather and the sweet smell of man.

"Tomorrow at noon, *mes amies*. Neither of you will be late!"

I turned to look at Henry, grateful to my friend for sharing with me his good fortune which had lead to my discovery. I vowed to him then, "Should I ever be fortunate enough to possess a thing of such value, what is mine will be yours, dear Henry."

Chapter Five

Elizabeth appreciated the pony's bit. She thought it ingenious. She was equally astonished by my leap forward in practical experience. I did not tell her about the stable master. Perhaps it was pride, but I wanted her to believe I had learned all this on my own, without the aid of another, or better yet, that I was highly creative.

In order to keep my secret, I managed to delay our meetings in the gazebo to nights when the moon had waned or was in the process thereof. My new-found mastery meant I was learning to control the game on my own terms. I made a demand, one-sided to be sure, but through charm and promises of delights to come I managed, like Eros, to persuade Psyche that during her most assertive moments, viewing me even in moonlight would be disastrous. The conditions revered, however, when I was in charge. I flagellated her by candlelight, she whipped me only by the light of the moon. Reluctantly she agreed, much to my surprise, when I made a concession: there were orifices of her body I agreed not to breech.

Her hand was not as strong as the stable master's, although she showed more endurance. Still, I scheduled daytime sessions with him regularly, and those nights I spent with Elizabeth. This meant my flesh had been tenderized by the time she took a strap or paddle to it; sensations inflicted on so raw a surface drove me wild with desire. There were one or two nights when my pony's bit proved ineffective in containing the explosion, but for the most part it worked quite well.

I learned much from the hand of my harsh male tutor.

One thing that he had etched into my awareness was the idea that when passions run deep, it is difficult to go too far. This proved to be the case with Elizabeth, much to my delight.

I loved nothing more than experimenting on her behind. Those plump cheeks stayed crimson the remainder of that summer. I delighted in using my razor strop to tan her, the wide leather producing a red-purple shade without the weals produced by thinner straps, which I also employed. And then shaving in the morning, sharpening my straight-edge on that same strop, it would all rush back to me from the night before and my cock would swell with desire. Once I borrowed Gilles' crop, which resulted in peals of pleasure from my lovely's sweet lips. I used switches from the trees liberally, and even her hairbrush on occasion, paddling the nights away under the stars. But my favorite tool, the one which finally opened my beloved to me, was one that came about, like so many of my discoveries, by accident.

Through all our nights of play in the garden gazebo, Elizabeth had insisted on the one thing I respected. Her mouth was the only orifice available to me. I understood the significance of entering her elsewhere, and yet that very prohibition made those two gates all the more desirable to crash, and I found myself pushing her nightly to go beyond her self-imposed limits.

But Elizabeth was stalwart. Nothing effected her to alter her position. I took the matter up with Gilles one day and it was his opinion that I had not penetrated deeply enough into her soul. His offer was generous: if I would send Elizabeth to him, he would determine what she was about and pass that information on to me. Although I appreciated the offer, I decided I must find the key to her deepest passions myself. It was a point of honor.

But the summer was quickly nearing its end. Shortly I would be returning to Oxford and Elizabeth and I would be parted, save for the occasional visit home. If I were to open her treasure chest, it must be soon. And, in truth, knowing Elizabeth's enormous needs as well as I did, I fully expected to find her maidenhead shattered by someone else come Christmas. A fine present that would be! I had invested too much time to hand her primed and ready to another. And she had become dear to me. Of course, the rational thing to do would have been to marry the girl, which I proposed. She was not adverse to the notion. In fact, the

exchange of lickings in a warm marriage bed over the cold winter appealed. But my mother's wish was for a June wedding, among the roses surrounding our gazebo, and because she had been so kind to her, Elizabeth acquiesced.

"Elizabeth," I said to her of an evening when lilac scented the air and the moon was new and we had just warmed one another's behinds sufficiently that sitting through breakfast would surely be uncomfortable. "I've a new element to the game, if you are willing and not afraid."

"Afraid? I doubt you could invent a turn that I could not take," she said boldly.

I smiled into the darkness, glad she could not see the conniving look on my face. "Good. Here's how it will be. Tomorrow evening, I shall go first."

"You went first tonight. That's hardly fair. Why should you go first again?"

"Because I say so!" I informed her, my tone low and dangerous enough to convey my intent.

The mastery in my voice was not lost on her. Her tone became meek as she fell into her submissive role. "As you wish, Herr Frankenstein."

"Good!" I said shortly, imitating in part what I had learned from Gilles. "I will permit you to choose the implement. For this concession, you will permit me to utilize it as long and as hard and in whatever manner I choose."

She paused not even a complete second. "Yes! I love it!" Her voice was full of excitement. Then, in the more subdued manner that befitted her position, "I bow to your will, Herr Frankenstein."

I began to turn away in mock indifference, but stopped. "Oh, and one other thing. I shall be directed by your wishes on our last night together before I depart."

"Meaning?"

"I shall do exactly as you wish. If you ask me to cease, even once, I shall. If you beg for more, you shall receive it, in abundance. Whatever you ask of me, I shall deliver to your satisfaction, stopping only at sunrise, or upon your request, whichever precedes the other."

She thought about this for a moment. Finally she said, "Alright, Victor."

She began to walk past me out of the gazebo. The scent rising from

her body tantalized me and I caught her hair in my hand and twisted it in my fingers, gloating in my role as her overlord. I pulled her back against me. She gasped but submitted. I leaned low and whispered in her ear: "Choose your implement wisely."

A shiver ran through her slender body. The scent from her cunny reached me and I pressed my lips hard against her mouth and filled her with my probing tongue. Perhaps it was my imagination, but her scent seemed stronger. Her mouth admitted me fully, as if this orifice belonged to me completely and was welcoming the master home. My cock, still restrained, throbbed hard. Soon, my faithful friend, I told him. You shall find a warm moist tunnel of your own to call home.

Chapter Six

Evening arrived. The first of September air was cooler blowing down from the mountains, as if the wind carried change upon it. Overhead the clear sky permitted the display of an exceptional number of stars and a moon that, while still but a sliver, glowed magnificently.

I sat upon the table in the gazebo awaiting Elizabeth. The air felt refreshing as a breeze whipped through the screen. Tonight would be our last night together until December, and I intended to leave her with a strong memory of me that connected us heart to heart.

Before I saw her, I heard leaves rustling. A glow of white appeared, like a ghost coming to life. She stepped through the doorway of the gazebo.

Her golden hair hung full about her beautiful waif-face, cascading over her shoulders and falling down to her waist. Through the thin fabric of her nightgown, I saw that her nipples were firm in anticipation and her breasts rose and fell quickly with rapid breathing.

"The implement," I said.

She handed over a simple rod of bamboo, split length-wise.

Half an inch thick, five feet long, I recognized the cane from the workshop where a craftsman was reworking the veranda furniture. Her intent was as serious as my own.

"You recall the rules?" I said.

She nodded, but I repeated them for her anyway, ending with the warning, "Your wish is my command this night, and this night alone. I will give you all that you desire and no more."

"I am ready," she said.

She began to remove her nightdress, but I lifted a hand to stop her. The air was too cool and I did not wish for her to be chilled unnecessarily, although parts of her anatomy would soon be warmer than they had ever been.

Instead of the table, I directed her to a heavy, low German-style stool I'd brought with me. Ironically the square seat was made of cane. "Kneel on the edge and grasp the back of the seat," I instructed.

Once she was in position, I lifted the skirt of her dress from the hem, folding it over her head so that it was covered. I then wound the edges together and tied the corners so that she was caught from the waist up in a bag, as it were. She could hear well enough, and I could understand her, but her vision would be obscured by the cloth.

From my pocket I removed several lengths of braided sash, the type used to hold drapes apart. I tied her wrists to the legs at the back of the stool and her thighs, once I'd spread them, to the front legs.

Her delicious cunny twinkled in the moonlight, already moist with excitement. I used the rounded side of the cane to lightly pat her bottom. My strokes were short and quick. I kept my hand steady and my aim true so that the same spot might be attended to. Soon the multitude of short light strokes created a single line that stretched across the middle of her plump buttocks. Her legs began to quiver and from within the fabric I heard whimpering. Soon her bottom twitched, then twisted and turned, this way and that, desperate to avoid my perpetual strokes.

I understood what she was feeling. Elizabeth had used this very instrument one evening on my shoulders. Without the energy needed for a whip or paddle, a light spanking with this cane, if it continued on long enough, produced a terrible agony, nearly unbearable.

The whimpering turned to sobs, still I continued my easy work. "You may stop me any time," I reminded her. She said nothing, only emitted those deep sounds and kept twisting her bottom futilely.

I worked on that spot for more than an hour. The line was dark, even in the dim light. The skin there swelled and looked about as tender as I expected it could get without splitting. One hard swat with the bamboo would do just that. In fact, had I used the split side, blood would have flowed long ago. As it stood, I expected the skin was now ready to be peeled.

Finally, she could contain herself no longer. "I did not expect you would punish the same place so mercilessly!" she sobbed.

I paused. "Is this a request for me to cease my labors?"

She paused as well, then gasped, "No, damn you!" at which point she began to cry in earnest.

I was tempted to resume my work post haste, but my fellow was complaining. Tonight he was not shackled as usual, but was free to express himself. I ushered him into the night air. It was as if he had eyes and could see Elizabeth's swollen cheeks. He soared to full height.

I walked to the back of the stool and found an opening in the bag I had created around Elizabeth's head. Through this slit I injected my cock. He waited not long before hungry, wet lips found him and began earnest caresses. Tonight I gave myself free rein. As Elizabeth took me fully into her slick mouth and down her hot, open throat, I allowed myself the luxury of ejaculating immediately. Once she had licked me clean, I shut the opening in the fabric, and resumed my stance behind her.

I did not wish to split her skin and when I began the gentle whacks with the cane I choose a new area, above the first, yet still clearly on the fullest parts of her cheeks. Soon she was squirming and screaming my name. Fortunately the fabric muffled the sound, else the family might have been awakened. I asked her once again if she wished me to cease, but she answered in the negative.

I had insisted we meet early, as I wanted this last evening together to be full. My ministrations to her ass produced another swollen purple line that must have been excruciatingly painful. I expected she would not be able to sit for a week if I stopped now. But I had no intention of stopping unless she requested it.

When again I felt her at the point of surrender and I saw and smelled the juices seeping from her, my cock entered the opening in the fabric again and I came in her mouth.

Immediately I resumed caning her ass, in a new spot below the other two. Through the night I repeated my pattern: a long caning until the spot was unbearably tender, then taking her orally.

Each time I began the round again, I questioned Elizabeth to ascertain her wishes. And each time she requested I continue.

But over the hours, her voice had altered considerably and the submission she normally feigned began to take on a true quality.

Now when she said, "As you wish, my Master," I felt that truly she did experience my dominance on every level as her body and mind and soul yielded to me.

I had exerted little overall energy yet when the predawn stillness ushered in over the land, all sound ceased except for the steady thwack of rattan against raw flesh and the muffled cries of pain and ecstasy from my beloved. My cock had not failed me. I had ejaculated seven times, in as many hours, and with each occasion I began to understand the nature of restraint. It seemed to come naturally enough when sufficient energy had been expended. Now each time her lips worked on me it took longer and longer for the climax to be achieved.

But the time was ripe, I felt, and when I finished my eighth strip along the tender bottom that now resembled a swollen red balloon, I leaned low and whispered about where her ear must be, "Elizabeth, what will you have me do to you?"

"Anything you desire, Master," came her sincere reply.

"And if I should want to breech a new opening?"

"Your wish is my wish, Master," she said immediately.

These were the words I wanted to hear.

I look up a position behind her wounded ass. Her cunny opening looked inviting. Liquid, like tears of longing, had flowed out of her all night and over the hours coated the insides of her thighs. Without question, that opening was anxious to admit me, of that I had no doubt. Still, I wished to save something for our future together and instead choose the other entrance.

It lay puckered and eager, too long ignored, pale between the darkened trembling ass cheeks that swelled around it. The scent rising from her cunny filled the air and inspired my exhausted fellow to a second wind. I pointed him in the right direction and the tip of my cock, suddenly alert and revived, nudged her bottom hole.

The tight orifice struggled to open, to welcome me, but it was unaccustomed to visitors and expressed shock that tonight its small room would be crowded to bursting.

I had brought along a small pot of butter from the kitchen and lubricated both my cock and the hole a quarter of an inch in.

Even this little movement caused Elizabeth's ass to wiggle and squirm and the opening to dilate.

I placed myself at the door surrounded by burning walls and pro-
ceeded to push inward. She tightened, then loosened, caught between
the fear of such a large guest inside her for the first time, and the deli-
cious desire I knew she felt at the idea of being penetrated.

"Victor! Oh, Victor! You must plant yourself deep. It is your right.
And my need."

Her words were sweet and encouraged me to ram in fully.

But I wanted both of us to savor these first moments that could never
be repeated in exactly this virginal manner.

Slowly my engineer burrowed through the tight tunnel.

Her moans and cries of being filled and fulfilled lingered in my ears.
I took my time and the sky was light before I was buried completely in
her dark moist passage.

I lingered there, allowing her to understand the nature of impale-
ment, enjoying the tight pressure on my cock and the intense pleasure
of being in charge. She moaned exquisitely, the sounds music to my
ears. My balls were tight against my body, the seed waiting there for the
slightest movement on my part.

I grabbed hold of her wounded ass. Elizabeth cried out in agony
laced with joy. In one quick movement I withdrew and thrust deep and
firm into her. Her anus convulsed wildly around me and my sperm
fired. For sweet moments we were still, joined for the first time. I knew
in my heart it would not be the last, that this was only the beginning of
our delightful union.

Chapter Seven

When next I saw Elizabeth it was the morning I would depart. She was radiant, a glorious blush to her lovely facial cheeks—which no doubt equaled the glow of those not visible cheeks. Her lips full and dark red, her fair hair glittering in the sunlight made her an exquisite cameo. Her eyes sparkled and despite the underthings she wore by necessity in a proper household, I noticed that her nipples were firm against the fabric.

She sat gingerly during breakfast, the act deliciously painful for her, and titillating for me. Whenever I glanced in her direction, she blushed heavily and lowered her eyes. I knew now that she belonged to me completely.

Parting from her seemed an impossible task, but anticipation of when we would be together again and the continuation of our game renewed my energy. And with her bottom so fully conquered, I expected her thoughts would be strongly with me until my return.

My family allowed us time alone by the carriage to say our goodbyes.

"When next I see you, it shall be Christmas, my love. What present would you like from England?"

Her eyes sparkled and she lowered her voice. "Oh Victor, something designed by your creative hand. An object that will bring me a fraction of the pleasure you give me so that I may think of you often in your long absences and be prepared for your return."

This was a difficult request, to be sure, but I promised to give it some thought.

"Something mechanical," she suggested. "And disguised, so that others may think it a practical item, but you and I will realize its true use and the value thereof."

We kissed one another under the watchful eyes of my family. I patted her bottom surreptitiously, causing her to wince and blush. "Remember, Victor, a gift that will remind me of you."

Even before we arrived at Le Harve, a design had formed in my brain. Simple, practical and yet it possessed the potential for pleasuring my Elizabeth. I would set to work immediately so that it would be ready in time for the holidays.

Chapter Eight

The minute I arrived at Oxford, I set about purchasing the parts needed for the equipment I planned to build, for on the long ride to England I had devised an invention which I considered ingenious. School work took up much of my time throughout the fall. The manufacture of this gift for Elizabeth took up any free moments I possessed.

I wandered the hallowed ivy-covered buildings, watching the leaves go from green to brown, then shrivel and finally die.

No doubt it had an impact on my young mind which would not become apparent quite yet. Anatomy was my main course of study at that point, and as I acquired the knowledge of the greatest thinkers in the sciences of the day, it only aided my work on my darling Elizabeth's present. After all, a good grasp of anatomy would make my gift far more wearable as it would accentuate both the comfort required for extended use and the discomfort necessary for enjoyment. The knowledge I was acquiring would stand me in good stead with a greater quest I would embark on in due course.

Naturally letters arrived from my darling regularly. Each grew bolder than the one before, culminating in this missive just before the holidays arrived:

"My darling, most powerful master, who has conquered me so thoroughly. Victor, how I long for your strong, stern embrace, your firm hand guiding and directing my passions, your most forceful aspects demanding an appropriate response from my receptive female nature. I await you, empty, hungry, needy, my strongest and most urgent need

being to submit myself to your commanding presence and to fulfil all your desires through our play. Oh, hurry home, my love. I miss you utterly."

The days until my train left England crawled by. I could not wait to see her once again and resume our game.

By Christmas I had a unique gift created and when on the eve of that holiday I arrived home with my unusually-shaped package wrapped in festive paper and curled ribbons, Elizabeth was aglow with excitement and anticipation.

The living room was warm and cosy, lighted with beeswax candles and a fire in the hearth. Fragrant evergreen brought the outdoors inside. After dinner, as a family we decorated its boughs with chains of popped corn, paper snowflakes, satin bows and a scattering of delicate ornaments my mother had acquired over the years of her marriage and which were preserved during the other eleven months by careful wrapping and storage in the attic. We sat round the fireplace singing Yule songs and Christmas carols as Elizabeth played the melodies gaily on the spinet.

My younger brother, James, retired at his usual bedtime, followed by my parents, who understood that Elizabeth and I required time to renew our budding intimacies.

Once the door to the parlour was closed and locked and Elizabeth had eagerly taken a seat upon my lap before the glowing embers, she asked in an excited voice, "What did you bring me?"

"Oh, something special. You will like it, I think."

"What? Don't tease me, Victor. Won't you show me now?"

I laughed and kissed her full lips, so eager for mine.

"Well, perhaps it would be best to open the package in privacy together, rather than with the family present. For their sakes, I've a more conventional gift you may open on the morrow."

"How clever you are, my darling," she giggled. "I've done the same for you. First, this present."

She handed me an onyx box, prettily wrapped in green cloth with a red ribbon. Under her watchful eye, I untied the bow. Within the stone box was a peculiar chain, approximately eighteen inches in length. Along the chain lay half a dozen silver balls, in gradually increasing sizes, from one half inch to what appeared to be three inches in diam-

eter, with a length of chain dangling at either end. I admitted my confusion to her. "This is lovely, darling, but whatever is it for?"

"Well, it occurred to me that while I waited impatiently for your return from school, you, likewise, must be in agony for your return as well. And the thought of you imprisoned at Oxford and spending all those hours seated upon those hard benches in the lecture theaters, listening to dreary papers written by stuffy old professors... Well, I've come up with something which will solve both problems by freeing your mind to dwell on more interesting subjects."

I was still notably confused, which Elizabeth could clearly see. She took the chain of balls from my hand and stood, then began unbuttoning my trousers. Finally she pulled me to my feet so that my pants fell to my knees.

"Bend over the wing-back seat," she said, which I did, my hands grasping the seat of the chair on the sides. She lifted my shirt tails and pulled down my underdrawers. My bottom waited high in the air, facing the warmth emanating from the hearth. The feeling of exposure at my lover's hands was titillating and my member was swelling with interest in what would follow.

"These were made by our good friend, Gilles."

The notion that Gilles had become "our" good friend did not sit well with me. I was advanced in my thinking, and did not feel that what is good for the gander the goose should not get a whiff of, yet my encounters with the stable master had occurred prior to our engagement. Elizabeth, on the other hand, had obviously encountered him since. I was about to inquire as to exactly what contact she had had with the Frenchman when I felt something cool press against my anal opening.

I confess to feeling a thrill of delight course through me. The pressure she applied felt like great force, and the object bent on entering me I experienced as massive. Yet I realized that Elizabeth must have begun with the smallest ball.

My anus rebelled. Although I willed my anatomy to open, in fact it constricted. This did not deter her. She forced the silver ball inside me.

It was as if the world cracked open at that moment. Light exploded in my head. I realized my breathing was rapid. My underarms and chest were sweating. Although I had entertained a far larger object when the stable master's member had visited this rear room, that experience had

been part of a longer, more energetic encounter. With Elizabeth, this insertion came cold, out of the blue. And at the insistent hands of my beloved.

No sooner had I gotten a grip on my emotions and the energy threatening to expend itself through my cock, than my door was being knocked upon once again. A larger ball, the next in size no doubt, forced its way into me. My legs trembled and my bottom quivered. My mind knew the size was but a half inch larger and yet my anus felt it as ten times that. I could only moan and lower my head and allow myself to succumb to her persistent hand.

No sooner had I accepted this intrusion and made it a part of myself when she was forcing the third to roll into me. Now I could feel the first two entering my rectum, filling me. The metal, cold outside my body, was quickly warmed by my canal. Elizabeth worked the next for some time until my opening would admit it. Being of a scientific mind, I automatically calculated that the fourth was two inches in diameter. I also knew the anus expands automatically when peristalsis occurs, and reassured myself that I could take such objects in safely.

A far greater worry was the explosion that threatened in my groin. I needed all of my concentration to stem the tide trying to engulf me. But my own pleasure would increase greatly with a bit of restraint, and besides, this was Elizabeth's gift; I wanted to accept it graciously. There was also the disastrous thought of ejaculating on my mother's petit point chair.

When she began with the fifth, my body rebelled. Action was called for. We both understood that.

"You shall open to me sir, and I do not intend to wait the night!" she said.

"It is not by choice," I moaned, feeling the cool metal pushed hard against me and my resistant opening tearing in the process. With it came a nearly unbearable urge to ejaculate.

"Then obviously you need encouragement," she said.

I had no idea what she meant. A scarf from her neck was tied around my mouth. Whatever would occur, she was determined to keep my simple moans the loudest noise that would erupt from me. Knowing Elizabeth and her determination, I anticipated the worse. Within moments, the worse occurred.

Something seared my ass cheeks, first the left, then the right. I jolt-ed and screamed. The chair I clutched at hopped twice across the floor and would have toppled if she hadn't held me steady. I smelled burning flesh and knew it to be my own. Tears spilled from my eyes. My screams fortunately were muffled by the cloth. Sweat streamed from my pores. My poor ass shrieked in agony.

"I'll not hesitate to use the hot poker again, if need be," she assured me. I had no reason to disbelieve her.

My anus had tightened, because of the pain. In fact, my entire body had constricted. But this time when she placed the two and a half inch ball at my door, the gatekeeper came to his senses and threw open the portal immediately.

Between my burning cheeks she shoved that ball and it entered eas-ily, swallowed as if I were eager to be spread wide.

The ones before it entered me further and I moaned again.

Oddly enough, my cock was rock hard. Even through the burning it had not lost much and now excelled its previous dimension. Yet I was amazed that he kept his juices to himself.

I knew there was one to follow. Three inches. I felt now that I could take that in, had to take it in, and I was correct. My anus dilated and Elizabeth shoved in one movement. She dropped the end of the chain and I felt its coolness dangle down the back of my scrotum, which lay high and ready for action.

The world became my pelvic region. My mind was gone, relieved of thoughts, worries, speculations. I throbbed with passion, my cock a boulder, pulsing against my belly, my bowels under submission to Elizabeth's hand.

She slid up between my legs, her back braced against the front of the stool so that she faced my groin. Her beautiful lips sucked on my testi-cles and then found my penis.

"Victor, you will remain perfectly still. No movement at all until I permit you release. If you disobey, I shall renew your acquaintance with the poker. Do I make myself clear?"

I nodded quickly, eager to avoid that searing iron, the contact with which had hurt my flesh and would for weeks to come. My harsh mis-tress's mouth surrounded my cock head, then took him in completely. It was agony to remain still, unable to thrust into her, which my mem-

ber was eager to do. My testicles ached and only the fear of the hot iron kept them from following their natural inclination. The silver spheres left me so vulnerable, so open, and the burning flesh reminding me to stay that way.

Elizabeth teased and toyed with me mercilessly, until I cried out in frustration, the sounds muffled. And yet all of these sensations were the most delicious I had ever experienced. I lived in only this region of my body, which had become a volcano, contained by obedience to this force greater than myself—Elizabeth.

I felt her hand fondle my testicles and then scratch along the back of my scrotum. Finally she reached for the chain. Now her mouth worked in earnest. I could contain myself no longer, even if it meant my very death. Every exhale was a groan of agony. The power and pressure in my groin confirmed that I was seconds from giving myself over to what was inevitable.

Suddenly the pressure from her lips increased around me.

At that moment her hand yanked hard and the silver balls began to pop out of my tunnel quickly. My anus contracted wildly. My testicles sent a flood of semen rushing up. My cock pumped hard and long into her mouth. My entire body contracted then released as I became one with Elizabeth, my love, my powerful dominatrix.

Chapter Nine

We lay in one another's arms on the bear rug before the fireplace, kissing, fondling. Warmth enveloped me. I had not ever longed so much for a woman as I did Elizabeth. I knew then that I would do anything for her and told her so.

"I shall keep you to your promise," she teased, a twinkle in her eye.

Once I had recovered, Elizabeth was eager to open the gift I had made her. She tore into the wrapping like a child. The box was long and thick and I know she had no idea what lay within.

By comparison with her gift to me, mine seemed coarse and uncrafted and I felt embarrassed. I had no reason to be. Unlike me with her silver balls, she knew immediately what my contraption was for and appreciated its use value at once.

"How sweet you are, my darling. And thoughtful. I shall wear this walking, and riding as well." She kissed me fully on the mouth and her eyes sparkled.

The word 'riding' brought back to me her acquaintance with Gilles, the stable master. While she undressed, I questioned her about him.

"Have you been seeing Gilles, then?"

"Not often."

"For riding lessons, I presume?"

"That, and other things."

"Such as?"

She was naked now, my view of her from the side distracting me from the answer. Her round ass jutted out behind and in front lay her

flat belly. Above it, those full luscious fruits with the ripe buds extended and tilted upward, as if eager for my lips. A tuft of blonde fur formed an inverted triangle at her crotch, pointing down to that most desired spot.

I helped her step into the braces and strapped them to her legs and the top band about her waist. The metal laced across her stomach, with flat bars attached that traveled down her legs to her feet and back up again, leaving openings for the joints. Another metal bar went between her legs and up between her bottom cheeks. I was relieved that the fit, which I had done without the benefit of measurements, was perfect. And then the *piece de resistance*. Along that corridor between her legs I had created holes, one for the future, one for the present. The design itself, at least this part of it, was based on the old chastity belts from the Middle Ages, modified for my purposes. In mine, the rear-most opening was the one of most interest to me, since I had claimed ownership of that orifice. I moved behind Elizabeth and fitted the final piece of apparatus into that opening. Silently I congratulated myself on a feat of engineering. I had modeled this penis on my own flesh at its best, anticipating that what she had held before she could hold again.

"Will you do the honors?" she asked, blushing.

Elizabeth spread her legs further apart and bent forward to the small extent the metal would permit. I could not tell whether it was the fire's glow that added such a rosy color to her bottom, or if in the light of day I should see that same flesh so pink. It was a question I was determined to find the answer to this night, for what was the extent of her contact with the stable master?

But for the moment, Elizabeth's pleasure was paramount. I crouched down and inserted the phallus up through the round opening I had allowed for it. It entered her slowly, to a chorus of pleasurable moans. Once it fully impaled her, I snapped closed the fastener that would hold the fleshy pseudo cock in place until she was ready to withdraw it. The fit was snug.

Elizabeth walked around the room, the metal clanking. I watched her from behind, that pink bottom riding up and down as she moved. The phallus was imbedded deeply, perfectly, causing constant stimulation, and when she turned her happy face to me I could see the appreciation there as well.

"Oh Victor! I am so pleased! Now I shall have a constant reminder of you when you are gone, and I shall not be lonely."

She hurried into my arms, meeting my lips with her own, our tongues connecting.

My mouth, so full of words that would inquire as to how such a blush had landed on her bottom, became filled with other things.

Kissing her warm receptive flesh, her nipples so hungry for my nips and tweaks, down her belly and to that divine mound sopping wet with eagerness.

My tongue lashed her clit mercilessly, making her quiver and shake and dance from foot to foot. The phallus only added to her pleasure.

Finally my tongue entered her sweet opening, so laced with fluids. The flesh there was new to me—never before had I entered her like this. The scent like the taste was strong, sweet and tart at the same moment. Encouraging. My cock shook away his stupor and reacted to this delicious moist cave, knowing it would soon be his to explore.

My tongue imitated what my cock would do to her, thrusting in and out against her folds, slowly at first, then with more speed, pausing now and again to torture her clitoris with licks and nips.

She stood on tiptoes now, still rocking from side to side, the phallus I'd created impaling her as deeply as my own had and would again. And when I felt her insides constrict, I grabbed her bare bottom and squeezed hard.

Her cries filled the room. Her buttocks tightened. Her head fell back. I felt her anus and her vagina convulse at the same moment. When I glanced up, a pink flush covered most of her chest and belly.

She stood with her head thrown back, her legs apart, impaled by my creation. I could do nothing but lick those nipples thrust so wantonly towards me. Finally, when she had collected herself, she collapsed into my arms, crying tears of joy and release.

"Oh Victor. I cannot bear to part from you again!"

Chapter Ten

The following morning, when the family convened in the parlour, the room now back to a semblance of what it had been the day before, gifts were exchanged and opened amid much good cheer.

My public gift to Elizabeth was an opal ring, to seal our engagement, and hers to me a leather-bound volume of musings by a new writer from France, a nobleman imprisoned during their recent Revolution. The text was an English translation—a language neither of my parents spoke. It was just as well, since a glance told me these fantasies were best left for boudoir reading.

The festivities of the holiday season took up much time. There were visits by relatives and friends—Elizabeth and I had dinner one evening with the Chervals. Henry confided in me that Gilles had returned to his home in Cannes for two weeks and swore his bottom was suffering the loss. On the guise of showing me a new saddle, we were able to spend some time in the barn where I could offer my friend a thrashing that I hoped might see him through those weeks of scarcity.

He lay across the same saddle and I took up the nasty crop Gilles had left behind, lashing Henry's poor white ass cheeks until they turned the color of ripe apples. I must say that the action felt natural enough and it occurred to me that a bottom was a bottom, in the end, and they could all learn to glow beautifully.

With tears of thanks, he sucked my cock in gratitude until I was dry. Time would not permit reciprocation. Besides, all free moments I desired to spend with my Elizabeth. I did, however, manage to wrest out

of him a bit of information: Elizabeth had been seeing Gilles, ostensibly for riding lessons, although as to the exact nature of their liaisons, Henry had not been privy.

Elizabeth and I were forced to snatch our intimacies here and there. The weather bespoke a typical winter at the edge of a mountain, with little chance for meeting outdoors. Because our times together were so brief, and we each vowed to use them to best advantage, we scarcely said a word to one another during those passionate encounters.

Once mother had asked me to find an old family painting stored in the attic, and Elizabeth offered to help me look for it. We had barely climbed the steps when her skirt was up, her bloomers down and my cock nestled between those plump cheeks, stroking her eager rectum. A call from below brought a quick climax to this adventure. I wonder what my parents suspected when their ruddy-faced offspring and his equally blushing bride-to-be returned having forgotten the painting.

On another occasion, she snuck into my bedroom when the sky outside was black. It was like a dream. I awoke to a sensation. Beneath the linen sheets warm lips curled around me and brought me to life in the middle of the night. I have never felt such a joy on waking and, once she departed as quietly as she had come, I fell back into a dream state filled with pleasant images of my beloved Elizabeth.

Because of an examination at the school, I was obliged to return early, which meant the day after New Years. Our seven days together had been far too brief and our exchanges only fanned the flames of desire that we both experienced. I longed for the moment when I would wed Elizabeth that I might take her when and how I chose.

The morning of my departure, Elizabeth silently beckoned me to follow her. We snuck out to the gazebo before sunrise. The air was chilly, the ground covered with snow. The screen of the little hut had icy snow imbedded between the metal fibres and we were virtually invisible from the house, encased in a white capsule.

"Darling, you'll catch your death," I told her. She was wrapped in furs but had already begun to lie across the table and lift her skirts.

"Oh, Victor, you must give me something with which to remember you. The days are so long and the nights even longer."

"What, is your memory so bad, or the impression I've made so mild? And what about my gift?"

"Of course not, darling. And I shall wear your wondrous gift every day. But I simply will not permit you to leave without a lasting gesture that can sustain me."

I knew she had a point. Like Henry, Elizabeth needed some physical display that would carry her through the weeks to come. "Anything you would like, my love."

Apparently she had planned this well. From under her skirts she pulled out a simple wooden paddle, four inches square, with holes drilled through it. The wood was heavy oak, finely finished on one side, rough on the other.

Only her bottom was exposed to the frigid air, her upper body still wrapped in furs, and thick wool stockings covered her legs. Those two rounded cheeks, so pale now, lay shivering with cold. I would be less than a man to not warm them properly.

"Why are there holes in this paddle, Elizabeth?"

"Please, Victor. Time is of the essence."

Of course, as always, she was right. We could not stay here for very long. Without delay, I dispatched the paddle against her goosebumpy cheeks.

The crack was loud and would carry on the air, but hopefully the white-ice-embedded screens would act as mufflers. In any event, I laid it on hard and fast, not wanting her to suffer from the cold. A bloom quickly formed on those pale roses. Soon her twin flowers turned pink then red as they quivered to my rhythm.

I felt heat rising from her cheeks and knew Elizabeth was toasty, which relieved my mind.

The paddle moved vigorously and quickly I worked up a sweat. I had noticed at the onset that a curious set of circular marks were left on her flesh. Being of a mind that dissects such things, it occurred to me that the blows—hard wood against pliable epidermis—would force some of that flesh up into the tiny holes. The edge of the circles would produce the same effect as a thin whip, heating the skin there to a blistering level. In fact, those little circles were soon bubbled.

What a unique item! And once again, it was my clever Elizabeth who had discovered it.

I paddled joyfully, each cheek in turn, the tops, the undersides, each side and especially the centers where the flesh was so plump and alert.

Until then I'd only employed the smooth side of the paddle, but decided I should give the rougher wood an opportunity to see what it could do as well. The initial goosebumps that had coated her chilly bottom had been replaced with more enduring bumps that would hopefully bring her pleasure over the days to come.

When I finished with the paddle, my hard cock slid between her hot cheeks and entered that back door which led to a dark and delightful place. The warmth coming from her behind warmed my belly against the cold air, although I must admit, my ass was freezing. But her hot rectum cooked my rod, and that all but distracted me from the cold. I pumped and ploughed her as she writhed and wiggled beneath me until she spasmed and my cock flooded her with hot juices.

The joining had been exquisite, but we were forced by circumstances to dress quickly and hurry back to the house.

"Victor," Elizabeth cooed into my ear, her face flushed, her eyes bright, "every day I shall write you letters, and you shall know that I will write them with my bare bottom seated on the hard birch desk chair. I will use my juices to perfume the pages, so that you will remember me."

"Remember you?" I'm certain I looked surprised. "How could I ever forget you, my love. Or is it you who is disposed to lose sight of me so readily."

"Never!" she declared.

But the nagging questions that had cropped up over the week now came to a head and could no longer be ignored. "I'm certain Gilles has helped ease your loneliness." I tried to keep my tone even but failed miserably.

Elizabeth stopped. She turned her bright-eyed, pink-cheeked face up to me. Mittoned hands on hips, she asked me sternly, "Whatever are you getting at?"

"Well, I know you've been seeing him. It was clear from the tone of your bottom my first night home. There's no point lying about it."

"Lying? I've no intention of doing that. And I told you Gilles is providing me with riding lessons. I've been skittish since I fell from a horse last year. You know that."

"And what other type of lessons is the good Gilles providing?"

"Only those that will ensure I am more to your liking."

"You are to my liking now. Elizabeth, I am not yet your husband, and you know I am generally open minded, but I insist you cease all communication with Gilles."

"Really, Victor, you are being silly. Gilles only straps or paddles my bottom once a week, as a bit of entertainment. I need something to engage me."

Frustrated, I grabbed her by the shoulders. "Engage you? Do I not engage you?"

"Yes, of course, when you're here. But you are not here. And we shall not be married and together until next summer."

"But you insisted on waiting."

"Your mother's wishes. I should think you would love her enough to comply readily."

"I suppose the paddle with the holes came from him."

"He'd learned about it from a colleague in the United States and designed one himself. Once I'd tested its promises and found them fulfilling, I purchased it for you, fool that I was, believing I would give both of us pleasure. Apparently I was wrong." She turned away from me angrily.

Frustrated, I picked up a chunk of icy rock and threw it across the open snow with all my might. It crashed into an oak and shattered into countless pellets. I felt beside myself with rage. My betrothed! Baring her bottom to a stable master in my absence, as though my own labors were insufficient! I knew I was being somewhat irrational yet I could not help myself.

Elizabeth took my arm and said in a most soothing voice, "Victor, there's nothing more between Gilles and me. He does provide riding lessons as well. I am simply learning discipline on a saddle, at times seated atop the leather, at other times lying bare-bottomed across it. And I am doing this all for you."

"And you receive no pleasure from it? Ha! Well, if it is for my benefit, you may cease now."

"Silly! If I had a way to warm my own bottom at night in your absence, I should not need Gilles."

We were at the house, and my parents were coming out the door; the conversation concluded abruptly. But Elizabeth had planted the seed in my head for a new invention. Once we'd said our goodbyes, and I was

ensconced under furs in the carriage that would take me to the station where I would catch the train for England, an idea began to form in my mind that would absorb my energy until Easter break. And when I presented Elizabeth with this gift, I would hear the last of Gilles the stable master and his marvelous whipping posts!

Chapter Eleven

Letters arrived almost daily from my beloved. They stimulated my creative juices and acted to help refine my latest invention. One letter, in particular, fired my imagination and caused me to work for twenty-four hours solid on this new gift for Elizabeth. But underlying it all, I felt disease.

"My dearest, most darling man," one of her letters began, "your worries are groundless, as I have told you. And, as luck would have it, your brother has been the inadvertent instrument which has made them even more so.

"Recently James has required a tutor—as you know, he enters university shortly and must have help if he is to pass his entrance exams with the same flying colors as you did. Anyway, darling, your parents engaged a Miss Heidi, from Brussels, I believe. She is a stern governess. Of course, corporeal punishment is not permitted as a means of correction with James. However, delivering such punishment seems to be in her nature. We soon discovered that together she and I may be of use to one another. For you see, once her nature is given expression, my own nature is fed in your absence. And since she is a female, you should be relieved. I shall provide you with an example from our first encounter.

"The evening after Miss Heidi arrived, dinner was just ending when she said to your mother, 'I shall clear away the dishes, Frau Frankenstein.'

"'Oh, but the maid will do that...' your mother began.

"'Idle hands make Devil's work.'

"'Let me help you,' I offered. You see, I'd already seen something in Miss Heidi's eyes that was suggestive, if you understand me.

"'I want to show Miss Heidi the back garden,' I said, adding, 'Just a quick tour. While the dessert is being served. Miss Heidi, will you join me?' I kissed your mother on the cheek. 'We'll return with the *gateau*.'

"Miss Heidi and I picked up several plates each and headed for the kitchen. Once we had reached the hallway, I stopped and waited for her to catch up. The woman was bold.

"'I see a crying need for chastisement in this household. Perhaps I can be of assistance,' she offered.

"'Perhaps,' I said cautiously, in the event I had misread her signals.

"'I have taught many over the years. I am strong, and persistent, virtues I possess in abundance. If I may be of service to you...'

"'Yes, I believe you may.'

"We had reached the kitchen. Cook was at the stove, and Anna fussed that we had been doing her work. She relieved us of the plates and I encouraged Miss Heidi to join me for a quick walk through the back garden while Anna prepared the cake.

"Once we were out of earshot, Miss Heidi spoke up, again rather boldly, 'You are a spoiled girl, Elizabeth. I've seen that readily in the day I've been here. I suspect a rod could correct your bad habits in no time.'

"Needless to say, I was thrilled, but cautious. 'Spoiled, perhaps. But I have felt the sting of a variety of rods before and enjoyed them.'

"'No doubt. Your tastes are clear by looking at you.'

"'I am lonely,' I confessed. 'My future husband, who indulges my tastes, and I his, is still at school. We are to be wed in the summer and until then I am bored.'

"This brought a kind of harumph sound out of Miss Heidi. 'You need something to occupy you.'

"'Oh, I have the stable master, who works for Victor's friend Henry. He sees to my needs once a week.'

"'Indeed! And is there a man alive who cannot be fooled by a woman?'

"This gave me pause. I shouldn't admit it to you, Victor darling, but I felt her words to be true. When I said nothing, Miss Heidi took up the slack.

"'Often a woman can see past the games played by another woman,

where men must learn to avoid being manipulated.'

"Her words struck me once again. 'If you can aide me, Miss Heidi, I would be most grateful.'

"We could not spend more time talking just then, but enough of a plan was formed that it could be set in motion readily. We set a time and place of meeting and returned for the *Ste Honoré*."

Chapter Twelve

"Darkness finally fell. The family retired and I headed up the creaking stairs to the attic.

"The tiny round window for air was open and outside an owl hooted. Floorboards creaked beneath my feet, but I knew your parents in their room below would not hear, and your brother, on the other side of the house, would not as well.

"I stood in the small, cedar-scented room beneath the peaked roof. For the first time I noticed the dark wood beams overhead. The attic is as you will remember, Victor. Most of the family heirlooms are stored in steamer trunks and wooden crates. Odd pieces of furniture lay here and there, but the middle of the room was empty. I'd brought a beeswax taper along and held it before me as I turned to examine the dark space.

"Suddenly I saw Miss Heidi sitting in a shadowy corner, watching me. I started.

"'Oh! I did not realize you were here.'

"'You are late,' was all she said. Of course, you, dear Victor, have pointed out to me on more than one occasion my bad habit of arriving after the time of an appointment. If I recall, that habit has earned my bottom extra time under your hands.

"'I'm sorry,' I said, not wishing to begin on the wrong foot.

"'Not as sorry as you shall be,' came the stern reply.

"She rose from the chair on which she was sitting, picked it up, as well as a black bag from the floor beside her. She walked to the middle of the room where I stood and set the bag down onto the floor again.

"She is a tall, slim woman, with piercing black eyes and grey hair which she wears in a bun. Her face can be described as harshly handsome, a no-nonsense *visage*. One look at the firm set of her lips and I knew I was in trouble.

"'Enough!' the tutor said. 'I have been invited here to mete out punishment, and that is what I intend to do.'

"My mouth dropped open.

"'Sit down, Elizabeth,' she said. Her voice was deep and harsh and brooked no resistance. She pointed at the Chippendale she had just vacated with a long thin finger of correction.

"'I prefer to stand.'

"'And I prefer you do as you're told.'

"Reluctantly I perched on the edge of the chair. A shiver ran through me as I stared up at this stern-looking woman towering above. I wondered what I had gotten myself into.

"'Now, Elizabeth,' she began, 'you have already disobeyed me...'

"'But how?'

"'Once by arriving late, the second time by not obeying my order immediately.'

"Well, she had me good and proper there. What could I say.

"'You are fortunate in that I have dealt with overindulged young ladies before.' Miss Heidi crossed her arms over her small chest and stood with legs apart in front of me. 'Stand up!'

"I stood, aware that these simple 'sit and stand' commands were designed to let me know who was in control.

"'Strip off your clothing!'

"I hesitated only a moment. A firm hand smacked my face sharply. The slap rang out in the stillness. My cheek burned, bringing tears of shame to my eyes.

"Partly I felt shocked. And yet my cunny belied this feeling, as I felt a tingle there, and heat rising.

"The back of my hand wiped the tears from my eyes.

"'Would you like another, Miss?'

"I shook my head.

"'I cannot hear you.'

"'No.'

"'No, what?'

"'No, ma'am.'

"Well, this was interesting. She had intuited how to treat me, which caused a thrill to ripple through me, as well as dread. I should not be telling you this, Victor, but this woman managed in moments to understand my greatest fears and deepest longings. I began unbuttoning my dress, interrupted only with a 'Faster!' from Miss Heidi, to which I readily complied.

"'And now undress me,' she ordered.

"Tentatively I reached out and began unbuttoning the simple frock the governess wore, undoing the fasteners and buttons, slipping it to the ground. Beneath, Miss Heidi was naked to the waist. Her nipples were the darkest and hardest I'd seen—not that I'd seen any but my own—stretching out nearly an inch. I thought they invited teeth. I realized I was licking my lips. But when her skirts fell to the floor, I was startled to see underneath that she wore breeches, like a man. Curiously, they were fastened at the hips with buttons, and a series of small buttons ran along the crotch and between her legs.

"The picture before me was a study in firm feminine beauty. Her nipples so long and hard, her hips slim and sturdy, accentuated as she stood legs apart in those tight trousers. She half turned and I saw that the dark fabric did not cover her bottom at all, which excited me. Her low slung, tight cheeks were fully exposed to the air. My, what a sight that was, I assure you.

"'Turn around!'

"I turned my back to Miss Heidi, feeling both fear and anticipation. It was a delicious combination that excited me.

"Instantly I felt her hands exploring my bottom cheeks, sliding over them, lifting them as if gauging their weight, squeezing one then the other. I felt like a fruit being examined for market. Recently I had visited Gilles, and my bottom was still sore to the touch. As she squeezed so hard back and forth, a gasp escaped me.

"'You will remain silent, Miss, if you know what's good for you.'

"'Yes, ma'am,' I answered automatically.

"Miss Heidi rounded my cheeks again and again, her firm fingers squeezing and pulling the flesh. Then, suddenly, her hand slipped down between my crack, past my anus, and to my womanly hole. I bit my lip to stop another gasp from escaping.

"She did not pause, but entered me with several of her fingers immediately. They thrust up into me until stopped by the natural barrier which has as yet to be pierced by you, my love.

"A small whimper did escape me at that point. But another thing escaped me as well, a thick secretion of juices that gave me away.

"Miss Heidi took my place in the chair. In an instant, she pulled me across her lap, bottom rising into the air.

"Miss Heidi opened the suitcase and pulled out a length of hemp. 'You will place your hands behind your neck, Miss. Now!'

"I did this and she tied my hands tightly together, looping the rope around my throat so they would stay in this position or I would choke.

"'Spread your legs!'

"'I really don't see...' I began.

"Miss Heidi grabbed the flesh between my anus and vagina and pinched hard. My hips jumped into the air and my cry filled the air. My legs spread quickly.

"I could feel my glistening pink slit oozing liquid. Above it my bottom hole lay waiting to be filled, and dear heart, how I wished you were there that night to plunger me!

"Miss Heidi searched the case. In a moment she said, 'Since you cannot keep your mouth shut, you will now open it.'

"Again, I hesitated, not knowing what she was about.

I should have known she was about determination. With one hand she squeezed my jaw at the hinges, forcing my lips apart. Quickly she shoved in a round rubber ball. This was followed by a scarf tied around my head at the mouth, presumably to keep me quiet. I had no desire to be caught in an uncompromising position with the governess, and was grateful that she was so thorough.

"For long moments I stared at the floor in the dim room, and at Miss Heidi's leg. Lying across her lap with my legs spread was titillating. Her body felt warm on my belly. The soft hairs at my crotch pressed against her thigh, and my cunny must have been seeping hot moisture onto the fabric of her trousers. Where she had pinched me, the skin still burned, but she offered me no comfort there. My nipples jutted out and soon the slim fingers of one of her large hands reached under and toyed with both nipples at the same time, pulling them out until I felt they should be pulled off, twisting those nubs so far that pain streaked through me.

She squeezed, pinched, rubbed, pressed them inward until I thought I could no longer contain the passion that soared through me. Waves of heat rushed my body. My cunny pumped liquid until I believed the room the room must be flooded. The terrible ball gagging my mouth kept my verbal response to a minimum, but enough sound came from me that Miss Heidi knew when to increase her actions, and which of those actions produced the desired results.

"'Well, Miss, you have earned this punishment, that is certain. I expect Herr Frankenstein has put up with more than enough of your nonsense, more than any man should. I, however, am not so blinded by your charms. Your lesson will be a hard one; all the better. That way you shall not forget as easily.'

"She bent over the case again and I heard her rummaging in it. I admit I was curious to see what tool she would employ. After all, I had already felt Gilles' crop and the paddle with holes, and various birches and even a bamboo cane, most at the hand of you, my beloved. My bottom was no novice to pain, mildly tender though it might be at the moment. Still, what the former headmistress pulled from her bag of tricks startled me.

"I'd expected some object of great torment, but what emerged was merely a leather glove, which she slipped onto her hand before my eyes that I might see.

"I was disappointed, at least I thought so, although my bottom began to quiver as if it understood something my brain did not.

"'No doubt you anticipate a mild chastisement from this glove. But mild will not produce the desired results. You, Miss, are begging for correction. I expect you will continue your misbehaviors until someone takes a stand with you.'

"Miss Heidi lay the gloved hand on my ass and began rubbing gently. Instantly I knew this was no ordinary leather glove, but the palm and fingers were imbedded with pointed grommets. At first those metal bits were cool, and rolled over my skin easily. Soon, however, they warmed, and she began to press harder.

"My cheeks ached still from Gilles' attention, and the harder she pressed, the more they ached. It wasn't unpleasant, though, and I found myself dripping more moisture as she rubbed.

Meanwhile, her other hand had resumed its work on my titties,

coaxing them out far from my chest, twisting and turning, as they thrust straight out like the masthead of a ship, because of the way she had tied me. My body slid and squirmed across her lap and I thought I should go mad from sensation.

"'We shall begin, Miss,' she said 'with a common instruction, although not perhaps as familiar as that to which you're accustomed.'

"All the while Miss Heidi had been rubbing the glove over my bottom. What had been at first comforting had altered and now the sensations had become uncomfortable, so I was eager that she cease. In the candle glow, I saw a shadow on the wall. Her arm lifted. Suddenly she brought it down hard. The sound was muted. The pain sharp. Those cone-shaped grommets dug into my sore bottom. That, plus the intensity of the spank, made me nearly leap off her lap. Her strong fingers gripping my nipples held me in place.

"Miss Heidi is a powerful woman. Although slim, her arm muscles rival a man's. She is also capable of great speed. The pace of those spanks was so quick I could not tell exactly one from another. I knew, though, that the color on my cheeks was altering exponentially.

"Oh, Victor, how can I convey the spanking that followed? Never have I been punished so thoroughly! The woman is a fiend! She has the strength of ten, and the determination of an army. She did not let up. No bottom could withstand such an onslaught, I can tell you from experience.

"Soon, I was beside myself. My poor cheeks trembled in pain. My bottom did not know a woman could spank so hard and fast, so tirelessly, and was startled and ill prepared for what it received. Each cheek accommodated equal attention, one after the other, in blows that virtually rained down. Those small licks from Gilles' crop were nothing compared to the demon glove which covered such a large area of flesh. My legs kicked out uncontrollably as I strove to avoid her resolute hand.

"Her fingers squeezed my nipples harder than before, until they numbed. She held them thus while she whaled the juices from my throbbing cunny. My ass had nowhere to run and hide and soon learned to submit to the blows because it had no other options. But even my submission would not make her cease.

"My poor titties had lost all feeling, or so I imagined. And then, suddenly, she released them from her piercing grip. In an instant sensation returned. Stinging, stabbing, aching, as the blood flowed back in. And

all the while that fierce hand laid on more and more spanks until my bottom turned the tide and no longer remained passive: I found myself lifting into the air, as if inviting the next spank, and the next. When my bottom could take no more, it invited more.

"She worked at my bottom with those horrible grommets until the sky lightened and birds sang outside the window. Victor, I had reached a state I did not know was possible. I had cried a million tears. My body throbbed and pulsed with the universe. It was as though I were finely tuned to Miss Heidi, and all else. I was a receptacle for all that would flow into me. All she could give I would take, gratefully.

"So many tears had spilled from my eyes that a puddle had formed on the floor beneath me. My nipples felt alive, tuned to the air waves, giving and receiving little charges of energy as they pulsed beneath her constant ministrations. The painful spanks had long ago turned to pleasurable spanks. I could not get enough of her hard hand teaching my bottom its place in the universe.

"I could have gone on and on, riding and cresting wave after wave of pleasure and pain, so intermingled that I could no longer tell them apart.

"But, Miss Heidi stopped. She pulled the scarf from my face and removed the ball from my mouth. Suddenly. With a shove she thrust me from her and I landed on the floor on my belly.

"Startled I looked up at her. She was unbuttoning the buttons that lined the crotch of her breeches.

"'Miss, you will crawl to me on your belly and thank me properly,' she said.

"I squirmed around on the floor and shoved myself forward with my feet until my face was at the edge of the chair. I used the seat as a prop for my chin and she eased forward.

"Her dark woman's hairs were like a black jungle, between them a wet path that led to where? Without question, I wanted to explore that path and see what treasures lay ahead.

"My tongue lapped at her sweet juices. The moisture was like honey, thick, yet tartly sweet. I wanted more. She bent to the side, to that black case of hers, and removed something else. While I lapped at those soft lips that guarded her secrets, she flicked a long thin whip against the crack in my bottom. I did not know I could feel more in the area of my

heated backside. Her efforts inspired me.

"She grabbed my hair and twisted, guiding my head and hence my tongue to the right spots. I felt so tuned to her that I understood the whip and my tongue moved as one with it, both lapping, bringing pain and pleasure at the same moments. Which led the other, I could not say, only that we were aligned, both licking as needed.

"The thin whip flicked against my bottom hole, and the slit that leads to my dearest parts. My tongue slid into her carefully, easing along the folds and rippling flesh, so hot, burning, as my ass and my own cunny burned. I felt her constrict and wanted to feel more of that.

"Instinctively instinctively I made my tongue firm and hard as I could. Then I thrust into her, licking as I went along the front of that corridor where I knew from my own experience her most sensitive areas would be.

"I licked. The whip licked. Heat increased. As I rubbed her cunny, I felt the contractions within her begin. They built slowly, then, suddenly, became violent, gripping my tongue hard. Her walls squeezed it and my lips, which were smeared with her precious juices.

"To my surprise, my own cunny contracted violently, sending shudder after shudder of pleasure crashing through me.

"Oh, Victor, it was delicious. I have never been so submissive. I know now of what I am capable and I long to experiment and explore with you all the possibilities that lay within me. I know I am capable of even more, and with you, my love, I hope to realize my potential."

I admit that reading Elizabeth's letter excited me. My imagination had me hearing Elizabeth's cries, and in my mind I could see the red impressions left by the cone-shaped grommets in an ever coloring behind. My nostrils smelled her sex scent on the paper itself, just as she promised.

My cock itched unbearably. I freed him and my balls from the prison of my breeches and attended to their needs.

But later, after several readings, that letter began to disturb me. I became obsessed with building something that would occupy her, for now I knew that my love needed constant stimulation. If I did not provide it, someone else would. Gilles. Miss Heidi. I dreaded to think who would come next. And all, I believed, competed with me for my love's affections.

My school work suffered as I devoted myself full time to creating a dream-come-true for my Elizabeth.

Chapter Thirteen

By the time Easter arrived, a thaw was well underway. The ice and snow had disappeared, although the ground was not quite ready for digging. Clear sky, buds on the willows. And the harbingers of spring sang their delicate songs.

As my coach neared my ancestral home, I grinned foolishly, thinking about the item I had brought home with me for Elizabeth.

"James?"

"What?" my younger brother asked as we rode along, he seated across from me, and next to him the governess of whom Elizabeth had written. Miss Heidi was a stern-looking older woman who had apparently been a headmistress at a school until fairly recently when she decided to go out on her own, a situation unheard of for a woman. I learned that her sojourn with my family was about to come to an end— her contract expired when James received the results of his entrance exam.

This relieved my mind considerably, for I had spent the last three months worrying about what type of relationship would develop between this disciplinarian and my Elizabeth.

Elizabeth. Why had she not met me at the station?

"Where is Elizabeth?" I asked.

"At the house, I expect," James answered.

Thoughts of my intended filled my mind and I must have had a smile on my face.

"What's so amusing?" James asked.

"Only a private joke," I told him. He nodded, apparently knowing he would get no more from me. Miss Heidi, though, looked as though she would like to wring it out of me. She was a tall, strongly-built woman. I could imagine her as a headmistress and suspected that, given the liberty to exact corporeal punishment, she would take no nonsense from pupils. I sensed her predilection for correction, and could well imagine Elizabeth receiving the tanning of her life. This woman had a steeliness about her that even Gilles did not. In a perverse way I entertained the notion of the two of them meeting—Miss Heidi and the stable Master, that is. I had little doubt who would be over the saddle and who would be holding the crop.

Those lascivious thoughts and others kept me in a shiver of delicious eroticism during the twenty minute ride through the countryside. I even imagined myself lying bare assed across this woman's knee and learning a lesson the hard way. As I imagined her hardwood ruler addressing my bottom, at that moment, our eyes met. Her eyes were knowing. I felt my face color and quickly looked away; it was as though she'd read my thoughts.

Once we had disembarked the coach and my bags and the large item I'd brought with me were unloaded and taken upstairs, I ventured down to the parlour to greet my family properly and enjoy a bit of nourishment. Elizabeth had not met me at the door with the others. She was not at the house, and I began to worry.

Tea and a light meal of open-faced sandwiches were served immediately, and amid the chatter of catching up on all the news, I asked again, "Where's Elizabeth?"

"I believe she's gone for her riding lesson, dear," mother said. "If she had known you would be arriving this early, I'm certain she would have been here."

I put my half-eaten herring sandwich down on the plate, no longer hungry. This did not please me. Precious moments of my visit were wasted while Elizabeth was no doubt receiving rigorous training from the stable master.

Fury brewed in me while I sat amid the family and exchanged pleasantries. I struggled to find appropriate answers to questions and a facial expression that would hide the violence that gripped me. I had gone to such trouble to build an item to please Elizabeth. This I had intimated in

my letters to her, letting her know that what I brought home would ease her frustrations and she would not have to resort to the attentions of strangers. And now here she was, unable to wait a few hours for my return when we would be together again and her bottom would be in good, caring hands.

Apparently I did an excellent job of disguising my true emotions. No one appeared to notice the turmoil I felt inside. No one but Miss Heidi. I caught her watching me, another knowing look in those cold grey eyes.

While we were having a second cup of tea, the front door opened and Elizabeth came running in. "Oh, Victor! I saw the coach! You're home, my darling."

She raced into my arms and I held her, enjoying her scent and the warmth of her flesh through the clothing she wore, at the same time aware that I felt angry with her. Her lilac cologne could not disguise the undercurrent, a barn-like smell. Over her head Miss Heidi caught my eye again and this time we shared that knowing look.

The afternoon hours were spent with the family. There was, however, an hour before dinner and Elizabeth and I had time for a stroll outdoors.

"My darling," I said, wrapping her arm over mine and leading her down the path to the lake, "I take it you were enjoying your riding lesson today."

"Victor, forgive me. Had I known you would arrive early, I would certainly have been at the station."

"And yet the trains frequently do not arrive on schedule. I should think you'd have waited for me."

She sighed heavily but said nothing. For what was there to say? Rather than wait for me, Elizabeth had placed herself over Gilles' saddle once again. And, presumably, between her tannings in the barn, she indulged herself with lickings from Miss Heidi. The woman was insatiable, not that I could anticipate being unable to fulfil her on a daily basis. But until she belonged to me in a manner that would permit us to be together each night and day, it seemed I must be cuckolded on a regular basis by both men and women.

"You know, Elizabeth, I'd forbidden you to see Gilles. And now you not only continue with him, but add another factor to this perverted

equation of yours. You have disobeyed me."

"Well, we are not married yet. I'm not certain I must do as you bid me any more than you must do as I bid. At least not now." She leaned up and kissed me on the cheek, as though this would placate me.

"I do not see things that way."

She said nothing.

"Tonight you will meet me in the attic."

Her eyes lit up immediately but then she said, "Victor, dear, is that a good idea? Your parents."

"Father, as always, will hear nothing. Mother sleeps like a log. As you well know."

Her face altered as though she were hiding something.

"What about James?"

"His room is on the other side of the house. You know that also."

She paused. "And Miss Heidi?" There was a hopeful tone to her voice.

"If I did not know better, I would think you were trying to either dissuade me or replace me."

"Oh no," she said too quickly. Then, "I would love to meet you there and have you enter me as always. Nothing would please me more. It's just that..."

"Just what?"

"Well, you must promise we will engage only in that manner."

"We have agreed to save your hymen for our wedding night."

She turned away from me slightly and I felt her body tense. "That's not what I'm talking about. It's the other things we do."

"Meaning?"

Here she paused, searching for the right words. There were none. "Meaning that I have doubled up on my riding lessons. In fact, I've taken lessons every day this week. Those plus the instruction from Miss Heidi, well, they've left me..."

"I see. And you are telling me..." I would not let her off the hook.

She sighed again. "My bottom will tolerate no more attention for a few days. I should be fine by Friday, which will leave us plenty of time to resume our usual activities before your departure. In fact, I've a few games planned to entertain you, and a new surprise, so you won't be missing out on much."

"Is that a fact? In truth, Elizabeth, I intend to not miss out on any-thing. However, if your derriere seeks a respite, I give you my word I shall not lay a hand on you until the weekend. Your rear door, though, is mine to do with as I wish, unless that too is exhausted from riding, or should I say having been ridden?"

"Oh, my love!" She threw her arms around me. "You are so under-standing."

"Am I?"

"Indeed. I shall hardly be able to contain myself through dinner, thinking of your spicy sausage feeding me on two fronts."

"And I too shall hope for dinner to end quickly that we might enjoy a night of foreplay."

Chapter Fourteen

Supper was a jovial affair. The family was eager to hear of the state of things at Oxford. My father had attended there, and was surprised and amused to learn that old M. Waldman still taught, and still horked mightily into his handkerchief at regular intervals through his lectures. We discussed my studies and I confided to all that I was on the verge of new discoveries involving animation.

"You would be astonished," I told them, "of the advances made by science in the last few decades. We have learned much from our work with cadavers."

"Victor!" Mother said. "I'm not certain this is polite conversation."

"Mother, let him speak," my father said, holding the horn up to his ear that he might better hear my words. "We must be up on the latest discoveries, else we shall fall so far behind they might as well show us to our graves now."

"Well, I'm only concerned for our guest," Mother continued.

"Please," said Miss Heidi. "As an educator, I am eager to hear of the latest research in the field of physiology. Be assured that whatever I glean here, Frau Frankenstein, will be passed onto students who are desirous of such knowledge."

I was grateful to the woman and saw her with new eyes, for was she not a free thinker, eager to consider knowledge from every quarter? I proceeded.

"We have learned that the body responds to stimuli from the brain, even after death."

"How extraordinary," father said.

"Yes. Eye movement. Musculature twitches. One could say that but for that spark of life, the dead are living. We are a step away from knowing from whence that spark of life is derived. One could say we are on the verge of reviving the dead."

"That, surely, is an unholy undertaking," Mother said.

"Perhaps," I agreed. "And yet, if we mere human beings have been permitted to discover this knowledge of life itself, does this not indicate that we were meant to know?"

"Were we meant to know of the tree of good and evil?" my brother James pitched in.

"Apparently. And that is precisely my point. Had it not been meant to be, it would not have occurred."

"Point well taken," Father said. "But how close are you to the secret of life? Are you on the verge, or is this another one of old Waldman's fanciful theories?" My father chuckled.

"It's what I am devoting my life to, Father. I intend to carry on the work of those who came before me. If the spark of life can be identified, it can be mastered. We can then triumph over our greatest foe—the scythe-bearer himself."

I admit that my zeal had perhaps gotten a bit out of hand. For all of that, though, none in the family circle seemed greatly concerned. I doubt that any expected much would come of my labors, except to add a few more research papers to the pile of growing literature. And, of course, they had always seen me as precocious.

Still, this was the passion, to which, besides spending time building equipment for Elizabeth, I devoted myself. I felt with all the vanity of youth that if anyone had the ability to identify from whence life sprang, it was me.

We talked further into the evening until, one by one, the family retreated and, at last, Elizabeth and I were alone.

I wanted to introduce her to the item I had so lovingly labored over this past winter and decided that now was the moment. I took her hand and led her to the attic.

Chapter Fifteen

Swat! Swat! "Now, don't you move!" Elizabeth laughed evilly and moved around to my front. I hung suspended from a beam in the attic by chains and leather cuffs, naked, my thighs, chest and rear end stinging from the blows she'd been inflicting over the last hour.

Swat! The infernal leather fly-swatter struck my cock again, harder than the last time. In fact each blow was worse than the one before. Elizabeth was nothing if not predictable: what I might lack in an ability to find her limits, she possessed in abundance concerning mine.

She stood before me, a vision of uncompromising beauty in a sheer night dress, erect nipples poking against the wispy fabric, those bare feet on the boards so tantalizing, her long golden hair hanging about her lovely face in the most provocative way. In the light from the beeswax candles, her eyes shown with what I could only call a demented gleam. Occasionally she would turn and, through the sheer fabric, I glimpsed her darkened bottom, apparently well colored. Had I been a more generous man, I might have entertained the notion of ceasing our role reversals this evening and leaving things as they stood. But I was not feeling in a generous mood. On the contrary, that bloom on my rose drove me to fury, and I longed for the moment when she might finish with me and I could then introduce her to my unique invention. More was the pity, though, that the color I had in mind for her would not be applied to a white wall.

Earlier in the evening, after we'd climbed the stairs, we had enjoyed oral moments together, mutually satisfying; Elizabeth was extremely

receptive and responsive. I began to doubt myself.

Perhaps the lessons imprinted on her behind by others were the best course of action, given my long absences. But then reason returned, setting my mind on a straighter course. If I continued to permit such digressions on her part, it seemed to me only a matter of time before she met someone who she preferred to me. I was no fool, or so I thought. I expected that after my actions of that night, all would be corrected in our relationship.

In one hand she held the end of the twisted wire handle of the fly swatter. She tapped it against the palm of her other hand. This simple everyday object brought pain to my fly, that was certain. Suddenly she snapped it against my cock again, right on top of the head.

I was amazed that he withstood such an assault. I glanced down; he was pulsing red from the swatting, and ached from longing for release, but she would permit none. She had used a corset tie to lace my cock and balls high and tight. Such forced restraint was painful, but not nearly so much as that flat flap of porous leather.

My muscles in my upper arms ached and those in my lower arms and wrists were numbing. Only my toes touched the floor boards, causing the muscles in my calves to contract. They had gone into spasm and I knew I would have difficulty walking.

"Elizabeth, darling, don't you think you should release me, else you will do me real damage?"

I'd said this before, but she only smiled again. She paraded before me like a general examining troops she found wanting. "You are a sight, Victor Frankenstein! A man so weak he cannot stand a bit of pain. Are you more vulnerable than a woman?" Without warning, she slapped the leather flap twice against my cock, once using her forehand, once the backhand. I knew I could not take much more. Soon I would release my pent up energies despite the cutting stays. I didn't know how to tell her this without bringing on more pain. "My darling, if you want to enjoy me at my best, you must do so soon, before it is too late."

Elizabeth laughed harshly and walked past me, slapping my right hip and bottom cheek several times as she went.

This game was getting out of hand. Her cold and calculating manner led me to believe she'd experienced something vengeful and excessive at the hands of Miss Heidi. Not an hour ago I'd confronted her with

this. "Don't be childish, Victor," she'd said, in her new cool voice. The tone terrified me and yet I found its iciness arousing.

In my misery, I watched the light in the room flicker and shadows on the wall before me disappear. She was carrying a candle with her and when she turned in front of me I guessed her intention.

"No! You must not. The wax will be too harsh on my sore flesh. It heats to a temperature of 145 degrees fahrenheit and may cause irreparable damage. Nooooo...!"

My head fell back and I had to bite my tongue to keep from screaming and waking the family. Hot wax dribbled down onto the head of my cock, over the hole, blocking it.

My body twitched and danced and I thrust out at her in a sexual manner, despite the pain. Tears coursed down my cheeks. I groaned as loudly as I dared. Every strained muscle in my body spasmed in sympathy. To distract me from the excruciating heat cooking the tip of my worried member, she began again on my ass and thighs, slapping the wide leather tongue of the swatter hard until my head emptied and the pain in my cock dimmed compared to the constant stinging on my behind. And yet through it all, my penis stood rigid, hard, determined to have his way eventually no matter how she mistreated him.

Once I'd brought myself under control, only gasping for air instead of gulping it, Elizabeth was before me again, swatting my cock in the harshest manner yet. How he stood it, I will never know. Perhaps the wax did act as a stopper, because I could not ejaculate, although the impulse was nearly over-whelming.

"Tell me, Victor, do you want me?"

"Yes, my darling. My desire for you is unbearable."

"Well, then, since you have exacted a promise from me to cease fulfilling my own passions until we are wed, should I not have the same power over yours?"

"Of course. Yes." My balls cried in pain as she slapped them with the swatter from underneath. If they did not release their load soon, I felt they might explode.

"Then you will give me your word now."

"What? You wish me to be monogamous. I can do that easily."

"Monogamy? How dreary. That's your desire for me, but not mine for you. No, Victor, I wish another promise. One which fits my needs."

"Which is?" I was becoming short as agony took hold of me.

"Which is that you shall do my bidding. You are a creative genius, an inventor. Since you have made me swear an oath of allegiance to forsake all other, then you must invent according to my needs."

"What in the world are you getting at?"

"What I am getting at is that I expect you to spend as much time designing and building equipment for my needs as for the needs of mankind in general. In other words, you will ignite my sparks of life with your creations, and I expect something more sophisticated than the leg braces which have proven ineffective. Is that understood?"

I smiled at that. Little did she realize what I had in store for her. And once she did, this promise would be fulfilled.

"Well?" she snarled at me, slapping my cock until I danced like a fool.

"Yes, my love," I gasped. "You have my word."

"Good," she said, dropping the fly swatter and kneeling before me. "And you have my mouth." Cool wet lips slid over my tortured phallus and, despite all the restraints in place, he gave himself freely to his mistress of pain.

Chapter Sixteen

Playtime continued with an argument.

"I did not promise you to stop my riding lessons—"

"That is irrelevant, Elizabeth. Your bottom belongs to me and the sooner you understand this, the better it will be for you."

I stood before her unbound. We had finished with the fly swatter, much to my relief, and my genitals had been liberated. My cock was eager for more action.

"Are you saying you're jealous because of the hidings I receive at the hands of others? That's ludicrous!"

In truth I was jealous of this, but more it was the foreplay I knew she engaged in that annoyed me. "Let me amend that, then, so that all may be clear. Your bottom, your titties, your bottom hole, your lips and mouth, and your soon-to-be-pierced cunny are mine, to whip, lick and penetrate as I see fit."

"Of course they are yours. I fail to see, though, how the attention of these others affects the situation."

"You fail to see it? Riding the saddle while Gilles crop rides your bottom, then his cock rides your rectum—"

"Victor, how unfair you are being...!"

"And now you have employed Miss Heidi's services as well. She licks your bottom, then licks your cunny, and you hers. Where will it end? I have no doubts about Gilles, and from meeting the woman this morning suspect that Miss Heidi's methods, too, are highly effective with spoiled females. But that is not the issue here."

"Victor, you are making no sense."

"I suppose since my own methods have proven ineffective, you'd like me to hire Miss Heidi on to do my bidding. She can paddle you in my presence, and then Gilles can plow you. Would you like that?"

"Oh, Victor!" Elizabeth said, stamping her foot at me. But I had the distinct impression that the idea of being punished by a woman's hand in the presence of her lover and of being taken by another man was extremely titillating. Of course, it would be for me. Even the notion had me excited. "Victor, I refuse to listen to any more."

"Oh, you will listen, Elizabeth. For here is how it will be: for the remainder of this night you will obey me fully. I will approve or disapprove the methods of discipline and you shall do nothing more than submit."

"You gave me your word you would not focus on my bottom."

"I promised I would not lay a hand on your bottom, and I shall keep my word. And one other thing, I and I alone shall determine if and when we finish—"

"If and when?"

"Silence!" My voice rang out in the hollow attic room. "Perhaps what you learn tonight will be retained in your memory. You may think twice before resuming your riding lessons and your private instruction with the venerable Miss Heidi."

I looked at Elizabeth. She feigned a meek face. I sighed, ready to proceed.

"We are ready to begin," I announced. "You may show yourself."

Elizabeth looked at me as though I were insane, for she could not fathom to whom I was speaking.

From behind a large armoir in the corner, Miss Heidi emerged, bare-breasted, wearing those tight men's breeches that buttoned at the crotch, just as Elizabeth had described in her letters.

Elizabeth's mouth dropped open, but her eyes sparkled in delight, for she knew something was afoot.

"Miss Heidi," I said formally, "will you do the honors?"

"Nothing would please me more, Herr Frankenstein, than to restrain this naughty girl," she said.

She'd brought with her leather with which she tied Elizabeth's hands in front of her. Next she stuffed fabric into her mouth and tied a wide strip of leather between her lips, to hold the fabric in place.

Elizabeth's eyes bulged. She looked wary. I imagine that even now her bottom was warning her that further excesses would not be a good thing.

I moved across the room to the equipment I'd brought home with me, covered by a canvas. In one motion I pulled the fabric off, revealing the invention beneath.

"I've brought her a gift, you see," I said, addressing Miss Heidi only, ignoring Elizabeth. A glimpse of the flash in her eyes told me that my love did not like the turn the evening was taking. "It is a gift I hope will fill her hours."

"Yes, I saw your equipment and deduced its use immediately," Miss Heidi said. "From our brief but intense dealing, I should think Miss Elizabeth would be wise to readily employ such a tool on a regular basis."

I was impressed, for I had carefully disguised my invention so that its true purpose would be known only to Elizabeth and myself. "The 'equipment,' as you call it, will most likely solve the problem of her wanderings. Still, I am troubled that Elizabeth has so disregarded my feelings. I hesitate to offer a reward..." I paused.

"...when a punishment is more called for," Miss Heidi filled in. "Severe punishment. Else how will she learn to keep her wanton desires private?"

"Miss Heidi, it would please me if you would assist."

The tall slim woman nodded towards me, her thin lips turned down slightly at the corners. Her nipples stood erect and so firm I expected they would be rock hard to the touch. Unlike my beloved's breasts, this woman's aureoles were dark and the nipples themselves closer to black than to purple. Her arms were well-muscled, and I must admit, seeing a woman in tight breeches, her bare ass plumping over the fabric that cut along the crack separating her cheeks inspired me.

Miss Heidi stepped to Elizabeth and pulled from her pocket a small and evil-looking knife. I saw Elizabeth's eyes widen and for a moment I hesitated. What was this woman's intention?

She pulled the neck line of Elizabeth's nightgown out and away from her body. Then she used the knife to slice the tatted band around the top. Once the cut had been made, she returned the knife to her sheath.

Miss Heidi grabbed both ends of the split fabric and pulled hard. The

sheer cotton split down the middle, exposing full, ripe breasts, very round, with those pink titties thrusting forward as if begging lips to enjoy them.

As the fabric was torn from her body, Elizabeth looked stoic. Whatever we had planned, she suspected it would be a waste of her time. For what stood in the corner but an ordinary-looking bicycle, howbeit stationary. If she had been permitted to speak, I would have expected a verbal dressing down.

Once Elizabeth was naked, I said, "Turn her and let me see what we are working with."

Miss Heidi did as instructed. Elizabeth's behind was a red sea. From the surface of this hot ocean welled tiny dark islands that I knew would be painful to the touch. Gilles had done a thorough job, as usual. Added to Miss Heidi's apparently steady hand, my own work was cut out for me.

"Place her on the bike," I said coldly, imitating the voice I'd learned earlier from Elizabeth herself.

Miss Heidi dragged the struggling Elizabeth to the very low-to-the-ground bicycle and helped her onto it. The seat had been especially designed so that it was far shorter and narrower than was normal. The effect was that it fit snugly into the length of her vulva, and yet did not pierce the opening. Another feature of this contraption was the handle-bars. They were farther forward and lower than was normal. Much farther and lower.

Miss Heidi knew what to do. She pulled Elizabeth's bound wrists towards the bars and tied them there. This had the effect of forcing Elizabeth down, so that her fully-exposed bottom lifted into the air.

"Place her feet on the pedals," I instructed.

Again, Miss Heidi did as requested, a task made difficult because Elizabeth was not helping. The pedals were actually buckled stirrups, so that the feet would not slip off in this awkward position, although they too were much farther forward than on an ordinary bicycle. Rather than pedalling up and down, they had been designed to be pushed forward and back, more like a pump.

Now that my darling lay with her bottom so prominent in the candlelight, I took the opportunity to examine it thoroughly.

I recognized Gilles work at once. He was meticulous, as I imagined

Miss Heidi to be. Those cheeks had been well flailed. They were painted with tiny criss-crossing red lines from Gilles' crop, so close together the effect was a brilliant hue. The thought did occur to me to forestall planting any further kisses on those wounded globes; how could they tolerate more? And yet with Miss Heidi present, I felt that to back down now would show me as weak where I must be strong. And more. If I did not live up to my threat, Elizabeth would think me weak.

Parts of the machine were still missing, and I hastened to the corner to retrieve them from where they'd been hidden.

Elizabeth turned her head and watched in confusion as I attached the series of bars with leather flaps—much like the fly-swatter she'd used on me earlier though larger—to the spokes of the rear wheel.

All in all I attached four to each side of the wheel, adjusting as I went. I instructed Elizabeth to pedal very slowly, which she did, so that I might make certain of the angle.

When all was set, I ordered Miss Heidi to her station.

The headmistress took up a position at the front of the bike, sitting on the floor so that she was low enough. From there she had easy access to Elizabeth's nipples which, oddly enough, appeared to have been ignored of late by both the stable-master and she who instructed indoors.

From her little bag, Miss Heidi pulled out a wide, thick school ruler, about eighteen inches in length, the very type which I had fantasized as smacking my bottom in the coach. The birch was smooth on one side, beveled on the other, and I found looking at it stimulating.

"Begin slowly," I said, "that she may grow accustomed to the angles involved, but I expect the pace to quicken in short order. Is that clear?"

"Very clear."

Without further ado, Miss Heidi used the ruler to smack the left side of Elizabeth's right breast. The breast jiggled and swayed under the assault. Within two sharp strokes the skin had reddened.

She began at a reasonable pace. Elizabeth, however, looked startled, not knowing precisely what was expected of her.

I raised a hand and Miss Heidi paused. "You are to pedal," I informed Elizabeth, "keeping time as instructed." She hesitated momentarily, until I said, "Continue," and the stinging ruler moved to her other breast and smacked the outside of it. In the dense attic air, the crack of

hardwood against a swaying body part was crisp.

Elizabeth finally got the idea. Her left leg began to push the pedal forward until it stretched straight out in front of her. Behind, a flexible leather flap came up to meet her right buttocks. She now stretched her left leg forward. The flap on the right brushed her cheek smoothly and passed, while another on the left came up.

Yes, this was proceeding nicely. Elizabeth turned her head to look at me with both hope and horror. I sensed she had not envisioned what I'd prepared for her. In fact, my invention seemed the answer to all her prayers. That was her hope. The horror, though, came from her understanding that my promise had been a deception. I was not directly laying a hand on her bottom, and yet she was being spanked when she thought she had so cleverly escaped it.

I made a mental note to myself to find a way to duplicate Miss Heidi's mammary ministrations mechanically. That done, Elizabeth would have the perfect spanking machine.

"Faster!" I said.

Miss Heidi now used the ruler from underneath, slapping up with great force onto the right nipple. From that action, and the exertions, Elizabeth's breasts bobbed delightfully. I watched that nipple redden and harden. Elizabeth's eyes were wild, unfocused with lust. I bent under her and bit her free nipple. Instantly her body convulsed in orgasm.

The ruler sped up and with it Elizabeth's legs. Now the large flaps slapped her ass cheeks quickly, alternating, left, right, left, right. The bottom receiving those smacks quivered helplessly, which delighted me.

The air in the attic became warm and more close. I felt my cock rising, the skin surrounding him becoming taut from the pressure. I opened my trousers so that I might give him all the space he demanded. The room was saturated with the smell of sex, which only provoked him to greater heights. I caressed him, which felt so good, all while watching my beloved's behind jiggling to escape the spanks, and her nipples punished at the hand of the stern Miss Heidi.

Elizabeth's ass took the smacks because it had no alternative. Her face, though, showed some strain because of the pedalling. Her body had broken out into a sweat, as vigorous exercise is wont to produce.

"Faster!" I demanded. Miss Heidi switched to the left nipple, spanking it as hard but far faster. Dear Elizabeth struggled to pump the ped-

als in time, her breasts swaying and jumping as the hard wood ruler gave them their due. The leather spankers struck with machine precision, and I knew my darling had never experienced such strict and repetitive attention.

Now Miss Heidi produced a second ruler. I was most impressed to find that the woman was truly ambidextrous. Her left arm seemed as powerful as her right. Each breast was paddled into submission in turn, and Miss Heidi was even skilled enough to coordinate her actions with the flaps spanking Elizabeth's bottom so well. Left breast, left cheek. Right breast, right cheek.

And spank her well my machine did. I was so pleased with myself. What had been a red sea had now turned to a boiling purple, and the dark swelling islands were black. Elizabeth pedalled furiously, and the leather walloped her furiously. It was as though she could not stop had she wanted to, but I could tell from her face that she did not want to.

Tears streamed down her cheeks. Her body glistened with perspiration. Her nipples looked ripe to bursting. And her bottom glowed, a purple sunset, on fire, alive.

We continued thusly until I noticed that several of the little welts had broken open, at which point I ceased this exercise.

"Alright, that's enough." I instructed Miss Heidi to put away her tools of learning, and Elizabeth to pedal down until she came to an easy stop.

Miss Heidi looked disgusted, as though I were an imbecile. "You are halting this too soon. She has barely mastered the basics. Correction must be meted out with a firm hard that is not swayed by silly sympathy, else how can a lesson be retained."

"It may be as you say, but there are other concerns here."

Miss Heidi looked down at my crotch and snorted.

My cock could not wait to get at Elizabeth. As I entered her, I noticed Miss Heidi removing the gag from Elizabeth's lips, and exposing her own nether lips by unbuttoning the crotch of her trousers. She kneeled close to my darling's face. Elizabeth turned her head and her mouth went immediately to that opening. At the same moment, my cock barged through her rear door.

To enter such a well-whipped ass was divine. She quivered at the feel of me, virtually pulling me inside her, devouring me with those anal

lips. The ass I pressed against was nearly black with bruising and emit-ted the heat of a coal fire. I suspected that only later would my dearest feel the consequences of too many riding lessons.

I entered her deep. Her walls were lubricated and parted just enough for me to tunnel in. They hugged my cock lovingly. She was hungry, that was clear, and wanted feeding. I impaled her with my full length, lin-gering, and she surrounded me tightly, gripping me as though she would never release me.

In truth, I could not wait long. The evening had been too full, and my sacks needed unloading in her welcoming cave.

While I pumped her from behind, Elizabeth ate the fruits of that dark feminine forest. Earthy scents filled the air. Miss Heidi's nipples pointed and thrust at me, inviting me, and I wondered if they would taste bitter or sweet, tart or salty.

The spanking had been too erotic. I rode Elizabeth with a few long strokes. One final thrust and the juices blasted out of me. Her rectum convulsed around me. At that moment, I heard moans from the other end, both women sighing and crying out release.

There was no question in my mind that Elizabeth's ass was sore, more so than it had been hitherto. I expected that this time the memo-ry of my company would stay with her indefinitely. And if it did not, she could alleviate her own loneliness and refresh her memory with daily bicycle rides in the attic. I made a mental note to recommend mother's metronome as an aid.

When we had finished, Miss Heidi, who showed no signs of tiring, untied Elizabeth and lifted her off the bicycle as though she weighed next to nothing. She deposited her ass down onto the bare floor. She then proceeded to work Elizabeth's delicious nipples, licking, sucking, biting. Sweat poured down Elizabeth's chest and her legs spread wide. I found myself growing erect again. But this time I wanted to be an observer only.

While Miss Heidi further tortured those sensitive little beauties, Elizabeth squirmed, no doubt adding to the discomfort of her bottom by rubbing it into the rough hardwood floor.

Her cunny hole was pink and bright with moisture, the liquid actu-ally dripping from her soaked hairs onto the rough floorboards.

I spent the remainder of that night watching my beloved orgasm

again and again under the skilled lips and fingertips of Miss Heidi, who knew just what slippery areas of Elizabeth's cunny to rub and pinch, and when. I learned much that would stand me in good stead once we had married. I looked forward to exploring that deliciously sultry cave myself, as often as I wished.

Chapter Seventeen

Miss Heidi departed just after sunrise. Mother and father came to the door to bid her farewell. I, however, felt it my duty to see her to the station.

"You are lax," she chastised me immediately when we were alone in the carriage. "I suspect you will rue the day you did not welt that girl properly. She needs reining in."

"Marriage itself is enough reining in. Once we have walked to the altar together, life will become stable."

She shook her head as though I were a fool intent on stepping over a precipice. "You have much to learn, Herr Frankenstein. Would that I had the time available to teach you just how ignorant you are about the so-called fairer sex. Now is the time to mark your territory."

This conversation continued in a like vein the entire ride to the station. I began to weary of her constant harangue. Her mouth was as steady as her hand and that iron will guided both. Eventually I simply sat back and let her unwind, a clock cranked too tightly and hence unable to tick off the moments at the proper pace.

Still, while all this occurred, I did have a fantasy or two. Seeing Miss Heidi controlling Elizabeth so, I entertained a daydream of a type of *ménage à trois*, as the French would call it. This little group was composed of myself, Elizabeth and the steadfast Miss Heidi, with only our roles reversed from the night before, or at least some of them. I could see Elizabeth giving this slim headmistress a taste of her own medicine, while I discovered the dour Miss Heidi's more feminine mystique.

Finally we reached the station. I loaded her baggage onboard and helped her settle into a first class compartment. "I expect you're all set, then," I said. She caught my arm.

The woman's face had turned inhuman in its grimness. I flinched naturally from such a demeanour, although at the same time found it such a fascinating sight that it held me captive, as it were. The result was that I allowed her to rise up and whisper in my ear with a hot, enticing breath, "The breaker of rules is meant to be broken. Best you take this as a wedding present, as I expect you shall have need of it."

What she surreptitiously slipped into my hands was the very glove of which Elizabeth wrote me. I thanked her profusely.

At that moment the whistle blew, and I was forced to disembark.

We waved goodbye, I from the platform, Miss Heidi from the window. During this brief farewell, I thought I detected a sign of regret in her eyes, although it might just have been the steam rising up that, ultimately, blotted her from view.

All the way home I contemplated that strange message, and the unusual gift she bestowed upon me. She'd got me wondering and worrying as to whether or not I was being too easy with Elizabeth. But ultimately I assured myself that any problems between us were now in the past. The impact of the previous evening would be with Elizabeth for some time to come, and then there was my gift, which would see her through the spring. My invention would not only assure Elizabeth of my affections, but provide her an alternative; she would be entertained at home, thinking of me.

I settled back, quite content in the fact that life was proceeding as it ought. Ah, but what a naive fool I was.

Chapter Eighteen

I returned to university with Elizabeth reminding me of my promise to do her bidding ringing in my ears, for she re-exacted that obligation from me before I left.

It seemed to me then that the flurry of courtship activities had reached its zenith and that now we would coast into the summer with wedding preparations on the agenda. Elizabeth and my mother would take care of most of those. My job was to finish my studies for the year, please my professors, and return home to marry my sweetheart. From then on we would enter a life of connubial bliss.

I intended to take on an assistant teaching fellowship at the university, and Elizabeth would join me in the pastoral setting. We would set up housekeeping amid the Gothic buildings, our own love nest in which we would please and be pleased by one another. There would be no more need of stable masters or headmistresses, and the only inventions necessary would be those that enhanced our pleasure.

I continued with my studies under the tutelage of M. Krempe and M. Waldman. The former was a modernist of the top order, shunning all the theories that had gone before, except where they fit into his own philosophy. The latter encouraged me to study the ancients and to question from whence the principle of life proceeded. I applied myself to serious study, now that my primary relationship seemed to be running smoothly.

Physiology was my main subject under M. Krempe's direction. Through his lectures I came to understand the concept of decay and corruption, while at the same time I observed as much concretely with the

cadavers retrieved from the gallows. I was a serious student, meticulous in most things, but my work with the cadavers excelled solely through the private instruction of M. Krempe.

Many evenings, in his personal laboratory, I aided him in the dissection process. He was a strict teacher and I found my own careful methods sharpened considerably by attending carefully to his instruction. He was quick with the strap, and I learned *tout de suite*, as the French would say.

One example comes readily to mind. We were working late, dissecting both an orangutan from the London Zoo which had succumbed to old age, and a murderer who had killed indiscriminately and suffered strangulation at the hands of the state for his misdeeds.

"Science," M. Krempe said, "has no limits. Is it not fortuitous that we are born in this century when we may experiment so boldly? You see before you two entirely separate species. I say to you now that they may be as one."

I did not follow readily, and that confusion apparently appeared on my face.

"Hands!" M. Krempe demanded.

In trepidation, I held my hands out to him, palms up. From the hook on the wall he removed the black leather strap. The thing was two inches wide, and half an inch thick, and long as a ruler. I braced myself. Soon the leather whacked my palms, first the left a dozen times, then the right. It left my hands stinging mercilessly, and tears forming at the corners of my eyes.

Still, though, his method of instruction was effective on me, which he had learned early on in our relationship. The pain drove me from my head immediately, where the confusion reigned.

On a second look, his meaning regarding the ape and the murderer became apparent to me.

"I see, sir, what you are getting at. Parts from one may be transported to the other."

"Yes, and it is only animation with which we must deal."

The stinging in my palms was subsiding sufficiently that I was again trying to make sense of his words, rather than just allowing them to wash over me. "Animation, as in making the parts function, as we do when a segment of brain tissue is pressed." I was thinking how when

areas on each hemisphere of the brain are pressed, eyelids flutter, and muscles twitch. Apparently I had not caught his meaning.

"Hands!" He demanded.

Although the pain was dimming, I did not relish another assault. Still, I was his pupil, there to learn. If I were being thick, it was his job to thin out my mental blocks that I might see what is obvious.

I extended my hands again. The leather smacked harder than the previous occasion, and I received more, a dozen on each hand. Tears fell shamefully down my cheeks. My palms throbbed.

Ironically, my cock had stiffened this time, as it did on occasion when M. Krempe punished me. Through it all, though, I found myself more receptive.

He said, as though I were a dolt, "I am talking about what I have been talking with you about for the last year. Life. Creating life. Our job is first to forestall decomposition. Once that has been achieved, and fresh cadavers are no doubt the answer, we are then in a position to work on reviving the patient."

He was, of course, brilliant. I saw that in a flash. In a moment of gratitude for his insightful instruction, I fell at his feet and kissed his boots, licking them in the process, feeling my cock growing more solid and sure of himself.

The professor permitted this act, for he seemed to understand that I needed to express this to him. Suddenly he said in a low voice, "It is the intensity which will recreate that which has been snuffed out. Can you follow my meaning, Frankenstein?"

A chill ran through me. I had no idea what he was getting at. My palms burned and I feared the strapping I would receive if I could not follow his logic here. Still, there was no point pretending. He would then proceed and I would be hopelessly lost. Not only would I fail in my lessons, but I would receive a strapping in the end anyway. Still, I did not relish one again so soon.

"Sir," I said hesitantly, "I regret that I cannot decipher your meaning."

A stony silence filled the room. He removed the dreaded black strap from its hook on the wall, then said, "Come with me."

I followed him through a small arched door which he unlocked with an enormous copper key. We went down a narrow curved staircase. The

air began to smell dank and I felt a chill.

At one point he picked up an oil lamp and lit it with a stick match. I followed into the gloom, fearing the worst.

Eventually we reached a small room with a long narrow table that sloped. "Undress," he said in that stern voice.

I did as instructed, for the room was hot and already I'd begun to perspire. My cock was at half mast, yet I did not feel embarrassed before this man, my master.

"Lie on the table, head down," he instructed me, and I did as ordered. Along a panel running down from the high end of the table were large beveled plugs, like doweling, that were smooth on the top, but went through underneath. When I had positioned myself, and the professor rearranged me so that my derriere was sloped over the high end of the table, he removed one of the dowels beneath me. Immediately my cock felt air rush in to greet him.

The professor used a pair of tongs from his wall of equipment that I had just become aware of to reach into the hole and pull my penis and balls through. I felt him attach something to the underside of the table that hung below my member, the cool feel of metal touching my shaft.

He then tied my wrists to the low end of the table, and each of my legs to that same peculiar panel from the high end to the floor. My legs were together, thrusting my genitalia forward. Next he fixed a strap around my waist, securing me so that I could not move.

"Sir," I ventured nervously. "If there is something here I should be understanding, perhaps you would enlighten me."

"There is always something to learn, in every situation," he said. "I think the lesson will be made clear by tomorrow evening."

Tomorrow evening? It was barely nine p.m. Whatever he was planning would take twenty-four hours? A quiver of fear and fascination ran along my spine, and my cock, no doubt prominently displayed through the hole, jumped in anticipation.

The professor was at the wall, lowering something by way of a chain. I heard him behind me moving equipment, and turning cranks, locking things into place, as it were. I tried to look behind me, but the room was so gloomy that the lamp could not penetrate the dimness. All that I saw, or thought I saw, was a large machine, built of sturdy metal, the height of a man.

I wanted to ask to what am I about to be subjected? But felt that silence was golden in this situation. I heard cranking, as when one winds a clock.

Suddenly my ass exploded in pain. Then again. My rear end jumped, but there was nowhere to go. The explosions kept coming, split seconds apart.

Leather—and I knew it was the black strap—whacked across my ass so quickly I could not catch my breath.

M. Krempe came to the front of the table and spoke, although I could barely follow his words. My thoughts were decidedly elsewhere.

"You are familiar with clockworks, and many of the German mechanical sex toys of the fifteenth century. I have taken those concepts a step further. Behind you, or, I should say, attending to your behind, is a mechanical creature, wound like a clock to tick out the seconds in two parts. And, like a clock, the winding will last approximately twenty four hours, until the gears wind down. By then the concept of ignition should become clear to you."

Already I was groaning. The strap had been ingeniously placed so that the hand of this mechanical monster apparently moved up and down. In other words, the strap caught my ass from the top and moved two inches or so at a time down, to the middle of my thighs, then back up again.

The pace was frightening, for the thing behind me tick-tocked like a clock, each tick-tock heralding the strap that followed immediately.

"I shall leave you now to contemplate your studies," M. Krempe said, and with that he departed, taking the lamp with him, plunging me into hot darkness and leaving me to the mercy of what was merciless by nature.

Since I was alone, safely hidden from the eyes and ears of others, no doubt, I gave myself over to howling. I could not believe that the professor would abandon me here for twenty-four hours solid, and yet with each crack of the hard leather strap that reality seemed more and more certain.

I do not know how I lasted through that strapping. At first I resisted such awesome pain. The leather bit me again and again, and I struggled to avoid it, squirming this way and that to the extent my restraints would permit, hoping to shift just enough that it would not further heat

a spot already blazing. But the restraints held me fast. There was, in truth, nowhere to move to.

This reminded me too much of my own invention, although the professor's was superior in that I would have to do nothing but receive the strap, whereas Elizabeth must pedal in order to work the leather flaps against her bottom.

In the few thoughts I could hang onto, I realized that this machine could be programmed with not just strap, but paddle, cane, whip even. The possibilities were endless. I only hoped to survive intact to investigate its possibilities.

About survival, I quickly had my doubts. I had never endured the lickings Elizabeth had. For all her ministrations, mine had been mild, while hers, at least in my eyes, severe. And now I was being subjected to what she herself had not endured. A solid day of strapping.

I prayed my behind would numb. But the diabolical design ensured that it would not have such an opportunity. The strap must have struck a dozen places on its route up, and those same dozen down. My right cheek and back of that thigh were fairing slightly worse, it seemed to me, the edge of the leather cutting there the hardest. But when I'd decided that, then the left cheek became prominent in my awareness, and the pain there and in that thigh immense.

I cried as I had not done since childhood, shameless, completely. It was inevitable that my resistance would give way, and it did. At some point, indistinguishable from all others, I began to accept the strap. It had become my entire reality. It was all I knew. The heat it produced on my ass made me think of a tree struck by lightning once in a storm. The lightning sizzled the trunk, and steam rose from it, crackling. And then the sparks, followed by small flames that grew larger, until the tree became engulfed by fire.

My bottom felt on fire. And yet did I not move once again, from accepting the strap to longing for it? If only the flames would rise high enough, I would be engulfed like that tree. I tried to raise myself into the air, as I had seen Elizabeth do. I now understood her desire for chastisement. I wanted the strap. Longed for it. Needed it for my fulfilment. If only it could work double time, singeing me until I burst into flame.

The hours were spent moving back and forth from resisting to wanting, to needing, and back around again. Throughout all this my cock had

reacted. The professor had apparently attached something to him that would catch his emissions. And emit he did. Again and again. I had never orgasmed so often, or so frequently. Between the agony inflicted on my backside, and the constant ejaculations, I became soon overwhelmed.

I lost track of time completely. My thoughts dissolved. I could not recall what I had not understood in the first place which had put me in this position, nor whether or not I now understood it. My world became ass and cock, beating and coming. Resistance, wanting, needing. I took on machine-like qualities. When the pain built sufficiently, my cock would thicken and elongate. As he thickened, the pain increased, as the pain jumped a notch, my cock pulsed harder and faster. Ass, cock, ass, cock. And, when the crescendo had been reached, my jism spilled from me, as copious as the tears spilling from my eyes. For the first time in my life, I lived entirely in the moment. An eternal moment composed of alternating pleasure and pain.

When M. Krempe returned the following evening, the machine was already winding down. My bottom and the back of my thighs were tender as a newborn's scalp. I knew the skin had suffered, but I no longer felt it. Long ago it had numbed. In fact, I suspect I slept for a brief time through the strapping, although I may have just entered a daydream state.

When the professor released me from the table, he helped me stand. My legs were weak and, with his aid, I managed to climb the steps and fall into a bed on my stomach in one of his rooms.

He carried with him a bucket of sorts and, when he saw me looking at it, explained, "Your seed should not be wasted. I have many experiments which can make use of such potent energy."

I nodded, knowing what he meant without really understanding. It was as if the mysteries of the universe had unfolded to me and there was nothing which did not make sense.

"Have you discerned the concept of intensity as a spark which will ignite life?"

"Oh yes!" I cried. Understanding had reached deep into my cells. Change was fostered by intensity. What I had suffered was intense. Because of that, I had altered. I was more in tune with life. With the

magic moment on which all life is founded. I knew suddenly the secret of regeneration, and the professor could see that on my face.

"Good, than the lesson has been effective. You may rest now. This evening we shall proceed with our studies, now that we are in accord."

I drifted off in a stupor of euphoria. Still I heard the tick-tock, and, the way it is when one has traveled by train or boat for a long period of time and still feels aboard after disembarking, I felt the strap striking me, stirring me anew.

I doubt I have ever slept so peacefully. For the first time I understood what Elizabeth craved, and I was determined that she should have it.

Chapter Nineteen

A week later another letter arrived from Elizabeth.

"Victor, darling, your machine is wonderful! I use it daily, a hundred strokes, like brushing my hair. And like the hair on my head, my bottom shines all the time.

"Oh, my love, how can I ever thank you for such a considerate and caring gift? I hardly miss Miss Heidi, although there is something to be said for a hand holding a hard wooden ruler which will not be stayed. And, as you requested of me, I have ceased my riding lessons. There, too, a crop that is out of my control has a certain appeal. If there is one drawback to your spanking machine it is this: because I can control the machine, I am not at liberty to give myself over to the power controlling me. To counter this, I frequently set goals for myself. I have increased the rotations of the pedals five per day. I began with forty, then forty five, fifty... You get the idea. Now I've reached a hundred. Who knows how far I might go? And the beauty of your invention is that I may do my sessions quickly, before bedtime, or first thing in the morning. The effect lasts until the next session and provides a delicious stimulation throughout the day or night.

"Oh, Victor, how can I ever repay you? My own little teases are but mere flirtations, whereas what you have given me speaks of an intensely erotic experience. I long to play with this machine under your command. I can see you now, strapping me down, instructing me to pedal until you say stop! And I, your little rebellious angel, resisting yet eager to please you, pedalling until my heinie burns and my little cunny

weeps with desire for you.

"Victor, when will we be together? I fear that summer is approaching rapidly, but events here at home are not going as planned. Your mother is talking about delaying our nuptials until fall. It seems a cousin of yours is marrying, and—you know how given to appearances your parents are—this cousin made her preparations in advance of ours. Your mother thinks it would dilute both occasions to have them occur in the same month. She is writing you today to persuade you to postpone the event. Of course, we must bow to her wishes. But oh, my darling! How can we wait? I throb and pulse for you night and day! What will we do?"

The letter disturbed me on several counts. I had already read my mother's letter, which arrived the day before. As my parents were paying for the wedding, I knew that the control I had over the preparations and the date were minimal. My parents were given to holding up appearances to a degree with which I did not agree, but with which I could respect, given their generation. And, as it turned out, my studies with M. Krempe were taking an important turn. Since my lesson in his basement, I had come to see very quickly many of the concepts which he had been working with, the same concepts with which I'd struggled for the past year. Together we moved his experiments along far faster than he had anticipated was possible and, as well, we ventured into the new and exciting territory which I had envisioned. Our work was innovative and indispensable. This meant I would likely still be at university until the fall, finishing up what we had begun.

I had not, of course, told this to Elizabeth as yet. I think in the back of my mind I planned that we would wed in June and honeymoon later. I felt certain I could make her see things from my position. She could move to Oxford and live off-campus. But if we had not as yet wed, the impropriety of that would be obvious. She must stay with my parents until I finished school. Delaying the wedding would be a better answer, though, all the way around.

All the way but in one instance. Elizabeth. I did not wish to distress her further. The long wait for consummation of our love on a most basic level would be extended. And while my invention occupied her, she was honest enough to convey its limitations. Had I not experienced M. Krempe's machine, I might not have known what Elizabeth meant. And yet now all was clear to me. I could not allow her to suffer with inferi-

or equipment when I had the means at my disposal to create something superior.

I wrote to her immediately and told her the reasons why the wedding must be delayed. I also promised to send her something which would make it up to her until that night when my own member could impale her for the first time and possess her completely.

Chapter Twenty

The idea came to me in a dream. I expect I'd derived the dream material from real-life events. Wherever this notion stemmed from, actualized it was to be both a blessing and a curse. At the time, though, I was single-minded, in that I felt I must respond to Elizabeth's crying need in short order. And in fact, this invention would kill two birds with one stone, as the British say: I would prove myself to both Elizabeth and M. Krempe.

My friend Henry Cherval arrived for an extended visit, which turned out to be fortuitous. I needed more hands than my own to build what I had envisioned.

When I first told Henry of my intention, rather than being a nay-sayer, he virtually jumped with joy. "Victor, you truly are a madman, but one in tune with my own madness. Of course I shall help you build this. I would be a fool to miss out on such an adventure."

My other conspirator was, of course, M. Krempe. I knew that my professor had skills and knowledge which I myself did not yet possess. However, I approached him carefully. Our experiments had been along the mechanical lines. What I was endeavouring to create would, if I were successful, put his own inventions to shame; by comparison they would seem primitive and coarse. Egos were at stake here and, as he was master and I the student, I knew I must tread gently.

As it turned out, I had little cause to worry. M. Krempe readily agreed to help me and, in the end, I found his efforts invaluable.

Prior to that time, the professor had derived all his dissection sub-

jects from the local crypts and mortuaries. He studied human anatomy, then transposed these structures onto mechanical parts, attempting to recreate within metal what had heretofore been human. The corpses he retrieved, when living, had been base creatures, many felons of the worst sort, derided by society as being sub-human. The professor quickly informed me that for my undertaking, fresh corpses would be required, and nothing but. This I knew, yet did not have a clue as to how to obtain them.

"You are trying to do what is nearly impossible, and to accomplish that you must have the best ingredients in your mix," he reminded me. "A fresh body will provide skin and organs which have not yet begun the decomposition process. The fresher the better."

All well and good, but how could we obtain such bodies? That was our dilemma.

The gallows was our answer, that and ice. For it occurred to me that packing human parts in ice was a way of delaying the decomposition process. A recent invention in society—the ice box—had made us familiar with keeping large blocks of ice on hand. Since meat, the muscle of animals, was kept fresh for days at a time in this manner, why not human meat?

M. Krempe had already used ice as a retardant himself, and agreed that the preservation of bodies on a large scale would best be accomplished in that way. The other ingredient for our experiment—fresh corpses—was more of a problem.

As it turned out, Henry's new eye was just the ticket. He formed a scheme to bribe the undertakers. Those pathetic souls who had committed crimes against mankind that resulted in their death by hanging were to be brought straight to M. Krempe's laboratory, rather than the funeral parlor for preparation for a pauper's burial. We soon had our first corpse and began work in earnest.

Creating a human being is no easy task. We worked night and day. While Henry had neither the knowledge nor the skill to be useful in either the conceptual or practical aspects, he was good for the heavy labor.

I recall that first corpse in particular, a male of twenty, a strapping lad with a mop of red hair, had to be carried in from the foray. Henry devised a dolly of sorts which made the process simple, for we wished

that the corpses be held upright, to forestall blood congealing along the trunk. Upright meant that the blood would drain to the feet, which were expendable, at least for the present. I appreciated Henry's contribution incredibly.

As executions in this part of England were rare, work progressed much slower than I wanted it to. Indeed, our subjects were often decrepit and diseased, none of which would do. Still, they proved excellent for experimentation. There were many things which needed to be done again and again, until we had it right. Sewing, for one, stitching fine enough that the connections made were nigh on invisible. And the parts from one corpse might not fit as easily into the framework of another, for we could not use all from one, but were forced by time and circumstances to mix and match.

Finally, a stroke of luck came our way. I was grateful for it, as we had nearly reached June, and I knew from Elizabeth's letters that she was less and less enthraled with the spanking machine. And I could not fault her. The design was poor and, now that I knew better, wanting.

Towards the last weekend in May, an execution was scheduled to take place in a town not far from the university. As luck would have it, several large blocks of ice had been delivered that morning. Henry volunteered to take a cart with the ice in tow and make a deal with the morticians.

M. Krempe and I waited in nervous anxiety, for what we had heard about the corpses to be hung by the neck until dead was exciting: they were twins, evil to the core, who had committed a series of crimes that had led them to the rope.

When Henry returned, it was well after sunset. His face was set as he climbed down from the wagon, his eyes dull.

"What? Were you unable to get them?" I asked, the disappointment growing heavy within me.

His face broke into a boyish grin as he pulled the canvas from the back.

Standing upright, encased in blocks of ice were two beauties. But if they were twins, they were of the fraternal variety, for they did not really resemble one another in major ways, although I could not see the details through the blurry ice.

Together we hauled them into the lab. While we chipped away at the

ice which had adhered to their skin, M. Krempe entered.

"Well, indeed, we have fine subjects to work with. This is not what I expected. They are far more attractive and will produce a fine result. I think the time has come that our testing must end and the real project begin."

I looked at him stunned. Of course, he was right, and yet I wondered if we yet had the skill. I voiced my concerns, perhaps a bit too gruffly. "Sir, if we fail, we shall destroy two excellent subjects. Should we not continue our trials and errors, keeping these divine creatures frozen until we are certain of what we are doing? After all, the heart is the major problem we've encountered, and I, for one, am not certain we are ready to transplant one."

My professor's face turned dark. He reached for the leather strap. I had not felt its impact since the night I'd spent with his machine. Seeing it brought back to me all the pain and pleasure of that evening when I was utterly helpless before its constant attention. Of course, I knew he would not send me down to the clock-works for a strapping—we could not afford the delay. Still, he had a more diabolical plan in mind to make me see things his way.

"Down with your trousers, Herr Frankenstein." I glanced at Henry, who was all smiles. There was nothing for it but to do as instructed. I could not risk a falling out with the professor now. After all, I needed his laboratory and his equipment, to say nothing of his experience and skill. And Elizabeth was waiting.

I dropped my pants and stood before the two men naked from the waist down. My fellow was at half mast, and their scrutiny encouraged him.

M. Krempe place a block of ice on the floor. With the ice pick, he gouged a long hole in the frozen water, then said, "You will lie with your cock on the block. Now, sir!"

I did as he instructed. The ice cooled my genitals quickly and pained me in a burning way. My cock and balls lay there in the groove made for them, getting the brunt of the freezing, until they were nearly numb.

I watched M. Krempe hand the strap to Henry. "You will give him one hundred on the ass."

Henry took the strap eagerly, for I knew that since his arrival on campus, he had enjoyed neither giving nor especially receiving—his favorite activity—a thrashing.

Henry began work at once in his direct and down-to-earth manner, laying the thick heavy black leather firmly across my ass. I jumped and buckled beneath it, soon allowing the tears to pour from my eyes. Beneath me, my cock and balls felt frozen, the former in an erect position, the latter high and tight. The sensations there were non-existent, leaving me only the painful burning on my bottom, with no refreshing excitement in my groin to compensate. And because Henry was a strong fellow, and no doubt had learned well at the hand of Gilles, I received more than I bargained for.

The fact that I could not feel aroused in my genitals made this strapping utterly painful. I heard M. Krempe say, "Fifty," and could not believe we were only half finished. How could I take fifty more?

But take them I did, until my ass felt torn open, as though Henry were strapping raw muscle and not skin.

When the punishment had ended, M. Krempe had me kneel before Henry's crotch. Henry at once opened his fly and removed his thick penis, hard and pulsing. Immediately I did as ordered and took the length into my mouth until the head slid down my throat. The taste of him was pure manliness, salty, tart. I let my throat open and he jammed in further. I became aware only of that marvellously thick cock feeding me, and the pulsing pain in my ass.

All the while the feeling was returning to my cock and balls, a horrible pins-and-needles as blood flowed into this area from which it had so recently retreated. The stabbing of the little pricks on my large one was excruciating. Yet it made me suck harder on Henry, for the comfort his enormous cock provided me. And, for some reason, my cock swelled, rather than shrank beneath the pain.

All of a sudden, behind me, a large smooth sliver of ice was shoved up between my scorched cheeks, past my anus and into my rectum. My body convulsed. Henry shot jism into my mouth. My own cock braved the pain and shot into the air. My rectum spasmed.

I stayed there, kneeling on the floor, feeling contrite. My ass blazed, my rectum was frozen, my balls and cock still stinging from the returning sensation. I licked my lips, savoring Henry's juices, and thought about what M. Krempe was proposing.

"Of course you are correct," I finally admitted to him humbly. "It was my fear only that kept me from wishing to plow ahead. We must try

now, else we should forever be stuck experimenting, the curse of the dry old university researchers."

M. Krempe nodded. He hung the strap back on the wall and turned to Henry. "Take care that you keep these beauties upright, to insure the blood drains to their feet. You will find meat hooks in the basement, hanging by chains from the rafters. It is cool enough down there that the ice will not melt for several days. By then we should be finished our preparatory work."

He looked at me as I pulled the rough fabric of my trousers over my sore bottom and stinging genitals. "In the meantime, Victor and I shall plan on how we will proceed. We must draw sketches which will represent the result we are aiming for. We must also outline how we should begin, and who will do what."

Henry pulled the dolly with the two corpses encased in ice to the door and down the narrow cellar steps. We could hear him cursing the tight space, but from the sounds I imagined he was nearly to the cellar. M. Krempe had a peculiar look on his face. "Victor, begin the outline, if you please. I shall return shortly. We shall not need Henry's services until tomorrow evening and I suspect he is in need of a change, which will restore him as well as a rest could."

He took the strap again from the peg and headed down the stairs.

I began listing how we should proceed, and which spare parts and organs we had on hand, in the event we needed replacements. From the open cellar door I heard the tick-tock begin, and soon thereafter Henry's sobs of pain and joy, interspersed with the slap of leather on flesh.

Within moments M. Krempe returned and closed the door to the basement, drowning out all sound. Still, though, I could imagine it very well indeed. And where my brain fell short, my hot bottom continued to feed me memories of that strapping from the relentless mechanical hand.

Chapter Twenty One

With the preliminaries out of the way, we began work on the bodies. The twins were in their late twenties, a perfect age physiologically, and attractive. The dark-haired, beautiful female was as tall as her brother, far taller than most men. The male was handsome, with red hair and a fair complexion. Both had pleasing torsos. The girl's hips were rounder and her breasts possessed a fullness to them which excited, even in her icy coffin. The brother had broad shoulders, and an enormous cock, caught in erection at the moment of death.

We began with the female's body, which was less scarred than the male's, adding organs from the male which seemed in better shape, keeping those that were healthy and which rightfully belonged to her when we could. A spleen in stock, belonging to neither of them, seemed fresher, and we used that. As well, the hanging ropes had damaged the hypothalamus, the more primitive part of the brain located at the stem, in both twins. We were forced to use that brain part of another, although I do not recall the corpse from which it was derived. This worked, with the inclusion of a metal plate at the base of the brain—M. Krempe's specialty.

Besides these alterations, we stuck with our two subjects. Our aim was to create a being that had the best chance of survival.

Along the way, the professor and I ran into another dispute. Although the creature we were endeavouring to create was of my design, and to my specifications, he was adamant that I expand my original concept. At first I did not see things his way. A session in the base-

ment with the mechanical arm that could not be stayed helped open my mind and heart and I began to see that the professor was right once again: we should create not just a replica but a superior being.

The work went well and quickly, with three sets of hands seeing to the variety of the tasks involved. At times the minuteness of the parts posed a problem. And again, some of the finer sewing—I felt clumsy.

There were, of course, mishaps. While working on the eyes, Henry accidently gouged one. This forced us to take an eye from each. To my horror I discovered they were of different shades. The dark-haired girl used as our base had blue eyes, the red-haired male brown. At first this odd combination made me uncomfortable, but as M. Krempe pointed out, we were doing what had not been done before. We wanted a being that would not look like any other.

Added to this was the devastating discovery that when the professor's idea for the superior being was carried out, we ended up with a red-haired crotch. It was that or replace the entire pelvis, which would have been more time and trouble and may not have worked aesthetically.

What we ended up with was essentially a woman with dark hair on her head, and red hair on her Venus mons. Of course, bowing to the professor's superior arguments, the red hairs had a cock and balls planted in their midst as well. Internally we had implanted the tubing and sacks necessary for this being to function properly in its capacity as a male as well as a female.

It made for a peculiar yet arousing look. By the time we had finished the mixing and matching patchwork, we had before us a striking hermaphrodite.

It was now time for the most crucial phase to begin. We were ready to bring our frozen being to life.

Chapter Twenty Two

Timing was everything. We had to coordinate two very unpredictable events: the occurrence of a thunderstorm, and the melting of ice.

The barometer outside the dwelling which housed M. Krempe's laboratory indicated to us that the pressure was rising. This was good. We all felt the approach of the storm. In anticipation of its arrival, we brought our frozen vixen up from the cool basement where she had been stored in her ice sarcophagus. We had naturally begun talking about her as 'she,' perhaps because of the face, although that was not a very scientific stance, as the professor was quick to point out. She was composed of the female parts, it was true, but also those of her male twin, plus bits and pieces from the cadavers of strangers. And then there was the metal plate at the base of her brain. Still, we mere humans do tend to personify, and whatever our creation was, she became a 'she' to us.

The ice was melting nicely, on schedule with what we felt was a general stifling of the air, and intense humidity.

We brought Crea, for this is the name Henry came up with, and one which suited our new being better than the awful name of creature, out to the woods behind the house. The ice surrounding her was now just a thin coating, allowing a good view of her lovely face, with those startling eyes of different colors. She was naked, exposing the buttocks, breasts and vulva of a woman, and the broad shoulders and enormous penis and testicles we'd severed from the brother, who, apparently, had been a renowned fighter who had fought one too many rounds. Strangers had contributed the odd internal organ, and the feet, for the

blood congealing there had ruined those of the twins. The stitching was nearly invisible, although on either side of the throat one could see sutures from the large opening where the professor and I had installed the metal disc in back.

Henry, bless him, had devised a kite-like apparatus, with wires attached to a tree. To this we bound Crea about the waist, shoulders and forehead, her arms behind the trunk and her legs wide with that delightful cock thrusting forward and her cherry nether lips spread. The thin coating of ice only added to her charms in the moonlight, covering the firm nipples with a slick, come-hither glaze, and the double genitalia with moisture.

We waited, each of us nervous, pale. Over the several months of our project, we had neither time for much sleep nor food and the three of us had grown thin and pallid. This was apparent to me as I looked at my co-conspirators, now pensive.

Our main worry was that the ice would melt too quickly, before the storm arrived, and there would be decaying flesh bound to the tree and nothing more. And then there was the grim possibility that the storm would pass us by. But beyond that lay our main fear—that we had come so far only to fail. That even if all the ingredients were right, the corpse would not revive, and we would be back where we began.

I confess that over the months of building Crea, muscle by muscle, stretching skin taut where it should be taut, moulding and shaping her to the image in my mind, I had come to think of her as a new species. I had no doubt that on awakening, she would be happy and excited and grateful to me. I expected her worship even, bowing on knee before her master and creator.

The storm did not pass us by, but arrived quickly, and it was violent. We were instantly drenched in the chilly fierce rain. The winds were gale force, shaking the leaves of the trees, and snapping branches. Thunder broke and lightning lit the sky. Henry had attached his kite to Crea and run the wires up the tree, awaiting a bolt of lightning.

She stood, completely thawed now, slick with rainwater, her bare feet, or at least those of her donor, planted firmly on the ground, passively beckoning a miracle. In the silvery moonlight, as the lightning lit her flesh, I found myself become erect in anticipation.

The storm was at its zenith and would, from this point on, dissipate.

But for the moment, lightning struck all around us. Trees. Shrubs. The house itself, deflected by the lightning rod. Time was running out. I wondered if that rod would have been a better attractor, and was about to voice my concerns, although there was nothing we could do about it now.

Suddenly a thought occurred to me. I pushed my way against the strong winds to Crea's form, bound securely to the tree. "What are you doing?" M. Krempe called, but I ignored him. Instinctively I disconnected the wires attached to the tree and fixed them securely one each to her nipples, one to her clitoris and one to her erect cock. The last I placed at the back of her skull, where the metal plate lay just inside the skin.

Suddenly the kite flapping in the wind above and the tree was struck. I shielded my eyes from the pouring rain and the illumination. The electrical energy travelled down the wires in a second. Crea's body was lit by the power. She jerked and trembled, her limbs flailing, hips thrusting hard. Her torso convulsed as in an unearthly orgasm while Zeus' rod of supreme power rode her body.

It seemed to last forever, and yet I knew that only moments had passed. And when the lightning bolt finally settled into the ground, all came to a stop. It was as though the storm itself had come here for this purpose and now that it had completed its task, departed.

The rains slowed to a trickle. The thunder and lightning were in the distance now. In the near darkness, we brought our lamps closer to Crea to see what, if anything, had transpired.

Each of us waited for our submissive creature to show signs of life.

"Crea, can you hear me?" Henry said. The plea in his voice was painful, for it reflected what we all felt.

"You must come forward," I said, my voice a bit firmer.

"Open your eyes!" the professor demanded, his tone harsh and filled with implied consequences.

Suddenly her eyes flashed open. The two colors were eerie to gaze at in the lamplight, now that a spark of life glinted behind those pupils.

She opened her luscious mouth tentatively, then grew bolder. "Master!" she said, looking at M. Krempe.

Demurely she turned to Henry and said again the word— "Master!"—this time with a more alluring tone to her voice.

Finally those eyes rested upon mine. Her tongue flicked out of her mouth and ran slowly across her bottom lip. Restrained though she was by the ropes, she thrust her titties out at me and said wantonly, in a deep, throaty almost male voice, "Master!"

A cry of victory rose from the three of us. We had succeeded. And now it was time to enjoy the fruits of our labor.

Chapter Twenty Three

"We'll draw straws, then," said M. Krempe. We could not decide who would enjoy what, and this seemed the ideal solution.

Now that Crea had been brought indoors, bathed, her hair shampooed with a pleasing rosewater, and her body powdered and perfumed and her nipples rouged, she stood naked before the large fireplace, awaiting our instructions.

"The one who has the longest chooses first," the professor went on. "He with second longest chooses second, and so on."

"Agreed," I said, and Henry nodded.

M. Krempe tore three straws from the broom, broke one in half, the other half of that. He walked to Crea and said, "My dear, will you do the honors?"

"Of course, Master," she said demurely.

Fortunately the brain, parts of the original woman, parts from her twin, and the base of metal, seemed to have survived the experiment—we did not need to teach her basics like reading and speaking.

She played with the straws behind her back, so that we might not see what she was doing, which action thrust those delicious nipples at us. I knew the other two were as anxious as myself to suck and bite them. My only hope was that she was both receptive and yet able to instigate pleasure, for I needed her to function on both counts if she was to be a suitable gift for Elizabeth.

When the straws were brought out in front, it was impossible to tell the length of any from the way she held them.

She walked across the room, those hips swaying, breasts bobbing, cock nodding up and down. I must admit that the erect cock jutting out looked a tad out of place. But, as the professor had pointed out, one had the option to use whichever sexual avenue one preferred, which certainly made sense to me now, and it is always good to have choices.

Henry drew first. His straw looked long, until the professor drew his. "Hah!" M. Krempe shouted, showing us that his was the longest. Until I pulled my own, the longest still.

"Fine," I said. "I shall enter Crea from behind."

"You mean the anus," the professor clarified.

"No, I mean the vagina. I shall break her maidenhead."

"Good. Now that that is settled," and here he turned to Crea, "you shall use that mouth and those lips well on my member, or suffer for it."

Her eyes flashed, and her pelvis thrust forward slightly in a note of defiance or lust, I could not tell which. "Yes Master, as you wish."

"Well," said Henry, "I'll take the cock in my bottom hole. It's what I'm used to, so I shall know if it's doing the job it should."

Each seemed satisfied with his choice. Henry lay on a low cot on his stomach, his legs pulled up under him to expose his hole. Crea wasted no time. She moved to the cot and squatted down. Her cock found his opening without being guided. She leaned forward and lay over him as she entered deep.

Henry emitted a low moan, then a cry of "I'd not expected this!" for the length was enormous. To say that it was in proportion to Crea's excessive height was not an exaggeration. We had only just begun and Henry was already twitching in orgasm.

M. Krempe was disgusted with Cherval's lack of restraint. "You do not have the makings of a scientist," he assured my friend, waving me forward impatiently. I had never entered a woman's cunny before and had no idea what to expect. My cock, though, seemed to find the notion to his liking.

Crea's ass cheeks were spread as wide as the circumstances permitted; I could see the dark bottom hole, which I would explore another time, and below that the red slit leading inward. I stood behind her naked, and guided my member to that slit.

It was like a mouth, moist, opening at the slight pressure. My cock slid in with no difficulty, to a point. The woman we'd had to work with

was not intact, so we had taken the opportunity to manufacture an artificial hymen. Now that I had reached the barrier, I felt a determination in my groin grow to pass it.

At her other end I watched the professor's cock slide quickly into Crea's mouth. Her head fell back, the long black hair dangling down almost to Henry's back. I could not see her lips but from the slurping noises and the look on the professor's face knew that Crea was attending to him properly.

Crea began to move, thrusting into Henry's behind, using her mouth as a tube to rub along the professor's shaft. All that remained was for me to tear open her door and impale that canal.

Heat rose through my body, and my balls tightened with the pressure I felt in them. My wad of juices was ready to expel once entry had been made.

I grabbed her thrusting hips and pulled my own hips back the few inches to the edge of her opening. The area was moist and warm and surrounded me in a caress like a kiss. With great vigor, I thrust hard, forcing the stitches apart. A long and low moan came from Crea. My cock traveled the length of her tight tunnel, grabbed and tugged enroute by the marvelous folds of flesh.

This was too exciting, and I came at once. I needn't have worried about being premature. Crea seemed to have been designed to come at the mere thought of a command. And come she did, jerking and spasming around me, her mouth sucking the liquid from the professor, and fucking Henry's asshole to orgasm.

When this first endeavour had been accomplished, we cracked open a bottle of champagne. M. Krempe half filled four flutes and we toasted success.

Crea lounged on a chaise sipping the sweet-tart wine, her eyes wide like those of a virgin tasting it for the first time. I found the look delightfully endearing. Henry sat at her feet on the carpet, and the professor stood by the blazing fireplace.

We four were naked as newborns. My eye could only see beauty of form that night, and indeed Henry's fair, freckly skin, M. Krempe's tanner hide, and my own middling complexion all glowed beneath firm muscles, our bodies full of vigour. Crea lay with her long legs stretched out, slightly parted. Coquettishly she had loosely hung a wispy scarf

about her throat. One end dangled between her breasts and brushed the ever-erect cock, the other end had been thrown back over those broad masculine shoulders. Her dark hair framed those rosy cheeks. Her breasts were full and firm, the red nipples as constantly erect as the penis. Beneath a flat stomach raged that enormous, beckoning hard on, and below that, barely hidden in her red forest, a delicious moist cave of love.

She smiled demurely about the room and turned slightly, more onto her hip, showing the slimness of her waist and curve of her buttocks.

"Tell us, Crea," I said, wondering if it would be rude to pull out a paper and quill and record her first statement, "how did it feel to be born? Or was it more re-born?"

"Oh, Master Frankenstein, we felt drawn from a dark well towards a sharp and painful white light. We did not at first wish to move towards that burning glow, yet knew it was in our best interests to do so. And we also understood that the singeing would not only be painful but pleasurable, in equal proportion. It was as though the light took us and shook us until we might burst from pleasure."

Well, I thought, this is curious, and M. Krempe mirrored my thoughts with his words. "You speak in the plural. Do you feel the presence of more than one being within your skin?"

Her blue eye looked innocent enough, but the brown one appeared cagey; at the time I though I must have misread that. For what would there be to be cagey about?

She glanced down at the carpet, tilting back, it seemed to me, those pert little nipples so that they jutted so prettily up in the air that I was tempted to cross the room and take one between my teeth. Before I could move or banish the thought, the professor continued.

"Here, girl, my question requires an answer! You will speak when spoken to. After all, you are our creation."

"Yes, Master Krempe," she said, but we all heard the petulant quality to her voice.

"Well, here's a wrinkle," said Henry. "Or is it?"

"We shall indeed find out directly," M. Krempe said. He walked to the wall and took down the black strap, saying, "if a wrinkle it be, this should smooth it out."

Crea watched him with those wide round eyes, the blue one normal

enough, the brown one revealing a glimmer of excitement.

M. Krempe pulled an Ottoman into the middle of the room. "Crea, you will lie across this and I will strap your ass until you are repentant for your audacity. Impertinence will not be tolerated. Do you understand?"

"Yes, Master Krempe," she said, although her tone now expressed a pouty quality, and her full bottom lip stuck out. She picked her long lean frame up from the chaise and unnaturally slowly it seemed to me, sauntered across the room. When she reached the Ottoman, she stared at it for a long while, then took her time lying across it and rearranging her body.

For a creature who had never felt the strap before, she managed to end up in a position where that delicious plump ass was very well displayed indeed, and lifted so that the angle for contact with the hard leather would offer the hide the largest area with which to work.

M. Krempe was not one to waste time. He lay the leather on her three times in quick succession. Her bottom jumped at each strike and delightful little cries emerged from her lips.

He gave her three more, and she sang the same tune. Her bottom blushed, and I was glad we had decided to keep the female cheeks, which were fleshier and more prone to color.

My member rose to the occasion, hoping to see all there was to see, no doubt. Crea reminded me of myself not one year ago when my own bottom had first been trained by the discipline inflicted on it by Elizabeth. I knew the startled delight Crea felt and envied her that. But at the same time, I felt excited. Watching that virgin bottom highlighted so aroused me. A quick glance told me that Henry and the professor were likewise affected.

"Have you learned your lesson, then?" the professor asked.

Crea said nothing. Very slowly she turned her head and looked behind her, at me, then Henry, then directly up at the professor. Her eyes expressed both lust and playfulness. And more insolence. I knew in that second that she wanted more.

"Yes, Master Krempe, we have," she said, the tone so filled with deception that the lie rang around the room.

Rather than fall for the ploy to whip her more, as she was no doubt eager to have him do, the professor merely crossed his arms over his

chest. "I see," he said. "Then we are finished."

Her face all but fell. She struggled to maintain that mask which said she could take the strap or leave it, as any of her masters saw fit.

"Now," the professor said, turning his back to her, "are you aware of more than one personality within your heart and mind?"

"Oh no, Master. That would be impossible, for we are but one flesh. How could we be more within?"

"Indeed. Then why do you use the plural?"

"In order to please our three masters, Master Krempe. We address each of you at once and bring to each fresh bits of ourselves. Did not each of you enter or be entered by us in a different location, claiming ownership there?"

"And do you believe that only I own your mouth, and Victor is the sold proprietor of your cunt, and—"

"Oh no, Master Krempe. You each own all of us."

"I see. Then this avoidance on your part to explain the use of we is not a deliberate ploy to gain attention that will focus on that same spot of your flesh which even now seems to crave a licking."

Well, this obviously stymied her. If she said no, it was not a ploy, the strap might be hung back on the wall. If she said yes, it was, then she might not receive that which she asked for because it would be her will, and not the will of one of her masters. For by asking, it would cease to be punishment but a reward.

Finally, when the dilemma within her could not be resolved, M. Krempe decided for her. I imagine from the state of his cock, which Crea could not see, it was more his desire to watch her bottom blaze and to see how far this type of foreplay would take her. Just how far could our creature be aroused? And what was required to bring her to her knees, as it were?

These were questions I would need answered before I shipped her off to Elizabeth. For this prototype had been designed with the needs of my loved one in mind. If Crea could be sated with the strap alone, this would be a success. If, on the other hand, the strap only fanned her flames and those same flames needed additional fuel, then this could be a flaw. I wanted a human machine that would occupy Elizabeth, yet not fuck her. That was my job, and I wanted no competition. Elizabeth wanted lickings, and she wanted them badly. That I could provide, in person,

or through my inventions. But the licking of cunts and receiving of cocks in her anus was another dimension, one which would draw her loyalties away from me, and one I would not stand.

Still, though, the notion that Crea was excitable was appealing. It was a question of directing her abilities to the person she served. With the professor, Henry and I, it was one agenda, with Elizabeth, I intended to train Crea to perform differently.

M. Krempe lay the strap on enthusiastically now. He was a powerful man, who had sculled in his youth. The sound of leather smacking quivering flesh and the little moans and cries delighted my cock, who shot his load instantly.

I needn't have worried, for the strapping took the better part of an hour, and my fellow revived almost immediately to shoot again.

For how could he not? That plump, eager fanny turned from pink to red to crimson, to scarlet and still showed no signs of tiring. Crea squirmed, but not to escape the leather, more to help it reach those spots least affected.

Never have I seen a bottom delight so in a licking. From my position I saw the moisture glint between her legs. That fanny rose into the air, kissing the strap as it was kissed by the strap.

M. Krempe had worked up a fine sweat. His upper body glistened, and muscles rippled along his back and shoulders, making him appear exceedingly handsome in my eyes. His eyes looked feverish and his cock muscle strained against the skin encasing it. He had gripped his cock in one hand, while lashing Crea with the other, but this apparently was not the most satisfying route.

At last he needed a reprieve. Instead of giving it up entirely, though, he handed the black strap to Henry with the command, "Continue, and make her scream."

A large smile spread across Crea's face. While Henry took his place I watched her rub her cock and clit against the Ottoman for relief. I felt I should be keeping a record of this experiment, but for the life of me I did not wish to divert my attention into a mental activity.

Henry's style was not the long, wide swing of the professor, but shorter, sharper strokes. The leather cracked faster, though perhaps not as hard. Still, quantity probably equaled the careful quality of his predecessor.

Henry strapped away, thoroughly enjoying himself. My cock burst its juices again, and I noticed that the professor had merely to touch himself below the waist and he, too, was shooting white cream into the air.

Crea grew ecstatic under Henry's strapping. She began to cry out, "Oh Master Cherval, Master, blister my bottom, Master."

Henry obliged her.

When he tired, it was my turn. Both M. Krempe and Henry were left handed and had taken up a position next to and behind Crea's right hip. I took the opposite side, being right handed, and also seeing that the end of the strap had marked her left cheek with harsh red lines running up and down. The poor right one had only the solid scorching red and nothing more. I aimed to alter that.

My own strokes were somewhere between the professor's and Henry's. I strapped her slowly, throwing my arm back behind me, but then increased the speed and shortened the strokes until they were nearly as quick and snappy as Henry's had been.

Crea loved it. She squirmed and sang my name and begged me to lick her as hard as I liked and as long as I liked, so that she might learn my ways.

I managed to utilize the strap on her purple derriere until the clock struck three, which was also the number of hours she had undergone her first punishment.

I then ordered her onto the floor. Henry took her anus, M. Krempe her womanly opening, while I allowed her to eat my member. He lolled in her mouth, letting her slippery tongue slide over him in an adoring manner. Then, when she began to draw him in, he thrust hard and deep, assuring her that he had his own plans.

The others came as quickly as I. And Crea came once for each of us.

While we three rested and planned our next game, I thought about the turn this experiment had taken. Crea, like Elizabeth, seemed insatiable when it came to both climax from the whipping and from penetration. I needed to talk with the others at length in order to ascertain just how best to channel her passions. With both a phallus and a vagina, I did not want to send this being to my Elizabeth without feeling assured that the one desire—for the external warming—would supersede the desire for internal warmth.

M. Krempe was questioning Crea about her experiences. She told

him how the transit back into life felt familiar to her, although the shock of the lightning took her by surprise, particularly as it coursed through her nipples, her cock and vagina, jolting them in orgasm after orgasm. She determined that she needed to obey us in order to feel fulfilled, to which I noticed the professor nodding his head while he jotted down notes.

I watched Crea lying on the chaise on her tummy, knees bent so that her legs were up in the air, her raw fanny displayed proudly. She was propped up on her forearms with those hungry titties hovering there as if waiting for attention. And yet even as my gaze wandered back to those ass globes red as pomegranates, I had the feeling they demanded more.

When the clock struck five, and we knew we must finish for the evening, I took the black strap down from the wall. M. Krempe raised an eyebrow, but that was all.

"Come, Crea," I said. "A session with the machine will entertain you while we sleep."

She followed me quickly like a pet, as if eager for further stimulation. I bound her to the table in the basement, feeling the heat from her bottom as I adjusted it so that the mechanical arm might best apply the leather. I wound the clock mechanism as tightly as possible without overwinding, then let the professor's machine do its job.

Her groans and little cries of delight followed me up the steps, and the words, "Bless you, Master Frankenstein. Bless you for understanding my nature."

Chapter Twenty Four

"Dearest, darling Victor," came the next letter from Elizabeth. "I am forlorn and forsaken. Why, Victor? How can you bear to be apart from me an additional four months? My poor cunny cries itself to sleep each night, longing for your rod. And yet you do not seem to feel this lack. Oh, woe is me!

"I suppose you will say I am being selfish. Perhaps so. I shall ride the bicycle this night, imagining it is your hand doing the spanking, and attempt to turn my way of thinking here. But truly, I feel abandoned by you. Perhaps you do not love me.

"If wait we must, than wait I shall. There is nothing for it but to content myself with your gift. I am losing some weight, though, as I must pedal furiously in order to reach the level where I can let my thoughts, my worries and my fears go and give myself over to the pleasure you have provided me with.

"And yet you have promised me a new toy. Well, at least that is something to look forward to. When will it be ready? Already we are approaching June. Oh Henry, please send it to me at once!"

I hastened to write Elizabeth immediately and to reassure her. In my involvement with my work I had been lax and of course she felt that. I told her that the major portion of my project had been finished and was now undergoing experiments. Once I felt assured that it was up to my rigid standards, I would be sending it on to her immediately.

Perhaps I boasted a bit, for after all, had I not created life? And more than that, had I not created the perfect human machine? But although I

presented my most potent face to Elizabeth, I had begun having misgivings. Crea worked well as a submissive. We had experimented on her night and day for over a week, so much so that her bottom required a grafting of flesh onto it. We had taken to using a cat on her back and her thighs, giving that ass time to recover, while still continuing our tests.

Crea wallowed in the pain. It brought her to ecstasy every time. I found her extremely submissive to our collective will, as well as to each of us individually. But, would she also assume a dominant role? And more, for my purposes, could she preform without sexual fulfilment?

I decided to spend time alone with her each afternoon, seeing if I could channel her into different venues from those to which she seemed naturally inclined. On the one count, as it turned out, I needn't have worried.

"Crea," I said, handing her a cat with nine tails. "I want you to whip me."

She took the black handled whip from me and ran the nine short strips of leather at the end through her fingers again and again. "Yes, Master Frankenstein," she said.

"Tell me, how do you feel about whipping me?"

"If it is your wish, it is our wish."

This was not good enough. I sighed, and she stared at me with a confused look.

"Very well," I said. "We shall proceed."

I lowered my trousers and lay over the dissection table. I did this because of Crea's great height. Had I positioned myself over the footstool, the whip would have come at me from a great distance, and the ends certainly cut my flesh. I had many experiments to perform and did not have the time to devote to recovery.

"Proceed," I instructed.

The cat whistled through the air and struck me gently. It was as though the leather strips were feathers. "Harder," I said, struggling to maintain my patience.

Again the cat sang through the room. It struck a bit harder, but not enough to cause pain. "Are you deliberately disobeying me?" I said through clenched teeth. Perhaps she wanted an ass warming and this was her way of getting it. Well, she would not feel my hand until I had felt hers.

A battle of wills was underway, and I was determined to win.

"Harder," I said.

Again, the cat barely made contact.

"Harder." A bit harder, but not enough to make me flinch.

At this rate we would be here all day.

I stood and turned and looked up into Crea's beautiful face. That blue eye looked sorrowful, as though it felt badly for not being able to perform to my specifications. But the brown eye! What was in there but defiance. This would not be tolerated!

"Crea, I will tell you now what will happen to you, should I not be satisfied this day with your efforts. Rather than receiving the food you relish, you will not be whipped, spanked or paddled by any of the three of your masters."

Her jaw dropped.

"Further, until you prove to me that you not only can obey my commands but can ascertain my limits and stretch me to them, you shall receive nothing further in the way of the delicious punishments you crave. You will merely sit on the chaise and watch and listen but not partake. Do I make myself clear?"

Even the brown eye had turned a corner, as it were. Now it took me seriously. "Yes, Master Frankenstein," Crea said, in the most submissive tone yet from her perfect mouth.

"Good! Now I expect a proper thrashing, and if I do not get it you will pay the price I have outlined."

I turned and bent over the table again, lifting my shirt tails so that my bottom was exposed. I waited, but as yet nothing was happening. I was about to turn around and lambaste her again with the seriousness of my threat when she appeared before me.

Silently she bound my wrists together with a rope and stretched my arms across the table, where she attached the rope to a hook on the far side. "Very good," I said, encouraging her.

Next she removed the long scarf she always wore about her throat and began tying it around my mouth.

"Now, just a minute..."

But I was already gagged. I was happy for this show of initiative, and yet worried. How could I control this experiment if I could not speak? And further, Crea was a large and powerful being. If she had misunderstood my comments about pushing my limits, I might be in big trouble.

I glanced at the clock. Henry and the professor would return in two hours. The longest this whipping could be carried on. That gave me some measure of comfort. But two hours under so large and strong a hand... My penis grew in anticipation and my bottom twitched and tensed at the whipping he was about to receive, a whipping that he could not control.

Crea took up a position behind me. A glance showed me that she was many steps back, which would allow just the tips of the cat's whiskers to brush me. Given the distance she stood, and her long arms, then the distance between she and me, I knew that the cat would swing at the maximum length. I did not know the effect this would have until I felt it.

Brush was the wrong word. The tips of the nine leather thongs cut into my backside like sharp little knives. My body bucked and jerked and my head fell back. Instantly my cock shot his wad.

Crea had learned her first night to persevere, and this she did. The cat kept coming and coming, only the sharp tips digging into my ass, which I knew was already bleeding.

I tried to gain her attention, but from the look of determination on her face, I could see that all was lost until the others intervened.

The cat cut me to ribbons. My bottom danced to this enforced tune, bearing the lacerations because it must. Tears leaped from my eyes. Despite the excruciating pain, my penis swelled and released several times. And still she whipped me as though there would never be an end to this.

At moments I became lightheaded, hovering at the brink of unconsciousness. But the severity of the pain kept me awake, and the arousal coursing through my genitals always returned me to the land of the living.

By the time M. Krempe and Henry arrived, I had nearly lost my mind.

I saw them standing by the door as in a fog, observing this scene. Crea ignored them, but kept the lash coming. I had moved into a state I had never before reached—the pain had become unadulterated pleasure. And I made no signal to the two men to intervene.

For the first time in my life, a whipping became wholly enjoyable. I longed for the cutting leather to slice me anew. Each time the nine tips slashed me open, I felt ecstasy soar through me. It was like a vibration, rippling from my ass through my genitals, up my chest to my head.

With each lashing, my cock swelled and swelled until he reached bursting, then he shrank and began to swell all over again. I longed for that feeling of connection, to the cat, to Crea, to the universe, and Crea provided it. It was so perfect, so delicious, I could hardly bear it. And yet I wanted more.

When M. Krempe and Henry finally made her stop I sobbed anew, but not with relief. The whip halted, I felt the absence of my fulfilment, leaving me empty and cold, with only the blazing fire of the past two hours telegraphing from my bottom.

They unbound me. I continued sobbing. "You are foolish, Victor, experimenting alone like this. Bring me the mercurochrome," M. Krempe said to Henry. Hope revived in me, at least a little, for the red disinfectant would sting.

And sting it did. He doused my bottom liberally, and it jumped under this new and shocking pain. My cock, nearly exhausted, struggled to his full height again, and expressed himself freely one last time. That is all I remembered until I woke the next day, unable to move, my buttocks raw meat screaming as it crackled in the flames of an open fire pit.

I was a happy man. Crea proved herself capable of much more than we had anticipated. And she did not need sexual gratification. Fine tuning was required here, so that she could sense human limitations better.

I understood that day as I lay in agony on my belly that Crea had merely assessed my endurance by her own. She had assumed me able to sustain the whipping she could. And she was not far from wrong. She had moved me to new heights, for which I was grateful. She might need a bit of realignment before I sent her to Elizabeth, but that would be all.

Assured that she could deliver as well as receive chastisement, I had merely to adjust the dials, as it were, and then send this delicious gift to Elizabeth for her enjoyment until our nuptials.

After that I would spend the remainder of the summer and fall working with the professor in writing up our research notes and publishing them as a paper in one of the journals. This work would ensure that both our names went down in history, and our fame and fortune were guaranteed.

Chapter Twenty Five

We worked with Crea for another week, instructing her in the subtleties of dominance. The fact that she was not exactly human proved to be the stumbling block. Things human beings normally sense about one another were foreign to her, and I began to question the nature of the twins and others whose body parts had been the source from which our creation sprang.

For example, Crea did not notice things like trembling, and how it could increase to quaking. Nor did she seem tuned to perspiration, nor pupil dilation. Verbal messages are, of course, unreliable—often when one wants more the opposite is stated. There was no way of explaining this to Crea.

Because she did not respond by instinct to physical signs which normally tell one when to slow up and when to speed ahead, we were forced to teach her to be aware of these signs.

Henry was a stalwart fellow, offering his flesh as a practise target by which the instruction might proceed. We would stop Crea whenever Henry showed signs of moving beyond his capacities and point out to her the telltale symptoms.

Slowly she learned this skill. I was impressed with the patience for the task M. Krempe showed, for in most matters he was far from a patient man.

"You've one other thing which must be established," he warned me one evening.

"And that is?"

"Crea may dominate without her sexual functions gearing up to the point where expression is necessary, but we have yet to ascertain that a limit can be imposed when she is receiving."

I knew he was right. It was a thing I'd hesitated dealing with, the barely hidden fear within me telling me that this might not be possible.

"Come," he said on impulse. "I have an idea."

I followed him into the laboratory where Crea waited for us, as always, lying nude and sensuous on the chaise.

Her peculiar eyes followed us as we moved about the room. "Where is Master Cherval?" she asked, assuming we would be requesting her to perform her skills on his hide once again.

"He is resting," the professor said. "Tell me, Crea, if you had to live as either a dominant or a submissive, which would you choose?"

She thought about this for several moments, the pale eye deep in meditation, the dark one cagey as always. And I had come to view it as such, for I had seen too many occasions where that eye had aligned with rebelliousness.

"I suppose," she began slowly, "we should choose to receive."

"And why is that?"

"Because it excites us so. But, on the other hand, wielding the crop is so stimulating."

"Has it occurred to you," the professor said, sitting on the chaise with her, running his hand over her ample bottom, "that you could remain in a state of perpetual excitation?"

"No, Master Krempe, that has not occurred to us." She spread her legs without being aware of what she was doing. His hand drifted over her thigh and between those long legs and up into her. Her head fell back and her eyes closed. She thrust her hips forward and that erect cock pointed outward for any and all who could make use of it.

"Well, there is a way, my dear, but you must trust me."

"As you say, Master Krempe."

"Good. For I will exact a promise from you that you must not break, for all your future joy depends on it."

Breathless, Crea panted, and a pink rash covered her chest and cheeks. Her hips rocked back and forth in tune with the professor's thrusting fingers.

We had already learned that Crea was most receptive to learning new

things when in a state of arousal. Once she learned something, it seemed to be retained. In that manner, she was like an animal, learning tricks. And tonight the professor had the reward dangling before her.

He thrust in and out of her cunt. Her long thick cock strained so that the veins stood out against the skin. Her nipples appeared to ache for want of attention. My own body was responding, yet I kept my distance.

When M. Krempe had her on the point of orgasm, he withdrew. A small cry of despair escaped her lips. Her eyes fluttered open.

"Victor," he said, "bring me the paddle. The leather one."

I walked across the room and took the paddle from its hook.

Once I had handed it over, the professor pointed to his lap. Crea had never lain across a lap and been spanked before—here was something new and titillating.

She crawled forward and positioned herself for the paddling.

"Now, Crea," the professor said, running his hand softly over her sweet bottom. A bottom that had enjoyed a reprieve of late while the bottom of Henry took the heat. "I am one of your masters, am I not?"

"Yes, Master Krempe."

"And as I order you, so shall you obey." His fingers slipped into her cunny and his thumb into her anus.

"Oh yes, Master."

"And you obey happily, do you not?"

"We obey you out of love, for we love to please you." Her voice had become husky, male-like.

"Then the command I shall issue at this moment will stay in effect until further notice, is that understood?"

Her bottom rode the air, longing for those fingers to finish her off, but he now kept them still, not thrusting, simply holding them there. "Oh yes, Master."

"I command that you will not orgasm, neither your female parts nor your male sexual organs. You will remain in a perpetual state of arousal but will not permit yourself to sate your appetites."

A sob issued from her, but her voice rang out clearly, "Yes, Master Krempe, as you wish."

With that he withdrew his fingers and began with the paddle. He paddled her left cheek only, hard and firm. Her body hopped and jumped into the air from the stinging, but she took it, as always, because

she enjoyed punishment so.

That one cheek was ablaze quickly, and I was happy we had added a second layer of skin to the derriere, for intuitively I knew that tonight those cheeks would endure what hitherto they had not.

The paddling lasted two hours or so, on the one cheek only. In the meanwhile Henry joined us and to the sound of moans and cries and hide slapping hide, I briefed him on what was underway.

At one point, M. Krempe nodded and Henry joined him. Immediately the professor ceased paddling Crea's one worried cheek and turned her over Henry's knee.

Henry warmed to the task instantly. His finger rode her cunny and her rectum, charging her up again. We watched her body take on the electrical tension of sexual stimulation. Once he'd brought her to the edge of fulfilment, he withdrew.

He went through the same questions and Crea answered him in the same manner, promising to do as commanded. Only then did he give her what she craved.

He took advantage of the fresh cheek, bringing the flexible leather paddle down with much energy. Quickly that cheek turned color, although it would be some time before it reached the same shade as the other.

As with the strap, Henry's strokes were short and sharp compared to the long and precise work of M. Krempe, but the results were the same in the long run. When the hour chime had rung twice, Henry nodded and I stepped forward.

"Stand up!" I ordered, and Crea did so.

Her face was flushed and ripe, reflecting the heat of sexual passion. She was a being a man could do with as he wished. Juices ran down between her legs and the large cock throbbed with desire, but I could see that she had not climaxed.

I walked to the wall and removed a pair of dissection clamps. As I questioned Crea in the same manner as the others, and as she moaned out her answers, I attached one clamp to her left tit and tightened it until the nipple looked about to burst.

The scent of cunt juice coming from her was overwhelming and my cock wanted a ride on her river.

I placed her on the chaise on her back and pressed between her legs.

My cock entered her deep. Her own cock pressed hot and firm against my stomach, and I found this extremely arousing.

As I impaled her without moving, I gave the same command as the others, "You will not climax, not now, not ever, but will ride the wave of excitement forever. Is that understood?"

"Oh yes, Master Frankenstein!"

I had seen too much this night to deprive myself. I fucked her hard and quickly, spewing my juices up her cunt while those folds gripped me tight but did not spasm.

Once I'd had my way with her, I attached the other clamp to her right tittie, again turning the knobs until the nipple was a brilliant cherry about to burst its juices.

Crea moaned in ecstasy. "Yes, Master Frankenstein," she cried. "You may do with us as you wish, as always. And we beg of you to take us as many times and in any manner you like!"

I turned her onto her tummy and used the nine-tailed cat on her back, the one she had used on me so well. First I worked her back down to her waist, then her thighs and the backs of her calves. She begged me all the while to whip her harder.

When my arm gave out, I entered her behind and took her that way. This tunnel, like the other, closed around me and held me while I took her roughly, but she did not come.

I handed over the whip to M. Krempe, who had revived and used it on her bottom, flailing with renewed energy. He, too, took her in both places, and when he was finished, Henry took over.

We proceeded in this manner for nearly twenty four hours.

Crea took it all as no human could. Her derriere had long ago turned liquid. We had to turn her over and whip her front.

The clamps had been removed and reapplied several times.

All of our penises had entered her mouth as well as her cunny and her rectum, and we had each permitted her cock to enter us orally and anally. By the end of the next day, Crea was in a state of bliss. Her body emitted a powerful sexual odor. How she restrained herself, none of us could establish, and questioning her could not produce answers either. We were left with the knowledge that she had incorporated this lesson as she had the others. She could punish or receive punishment, but she would not climax. Finally, as morning arrived, I felt it was safe to send

her to Elizabeth.

"There is one other thing which must be done," M. Krempe stated.

"And that is?" I asked.

He opened an ice box he kept in the laboratory, where he stored body parts, and removed something.

"Bring her to the table," he said.

Henry and I walked the moaning Crea to the dissection table. Her body seemed to vibrate with sexuality. Every touch from one of us brought cries of delight from her smiling lips. At one point she grabbed my hand and began sucking my middle finger suggestively.

Crea lay back in a lascivious manner, spreading her legs, and the professor strapped her down. I had no idea what he had in mind, but knew that his ideas were generally good ones, or at least had learned that the hard way, so I acquiesced to his authority.

He lifted a scalpel and immediately cut a line across the base of Crea's cock at the top, under her stomach. Interestingly enough, very little blood came from the wound, but then Crea was not strictly human. Yet even this sharp instrument produced another gush of moisture from her soaked cunt.

I watched stunned as the professor began forming a crater of sorts in the spot where he had made the incision. What he had removed from the ice box was a cock complete with its own set of testicles. This he fitted into the groove he had made. At first I was speechless as I watched him folding and sewing and reconnecting the skin, making fine sutures that left the impression of dovetail joints. Crea's crotch above her penis was a mortice, the bottom of the prepared penis a tenon. Those two parts fit together snugly and, with the addition of small metal bolts and wingnuts that had attached the tubes inside to the new cock, it all stayed attached.

After the professor had finished, he turned to wash his instruments.

While he worked, he said, "Victor, you are likely wondering why Crea needs a second phallus."

"The thought had occurred to me, sir. Especially in that now that we have reprogrammed her, neither of them will ejaculate."

"Well, it dawned on me recently that if our experiment is to function in a superior manner, there should be a removable part or two. Crea should be more than any mere mortal. What a normal woman and man

are capable of, she should be capable of twice that, or more. We have no more time, but I think this experiment will suffice, at least in the short term. This phallus can be removed or added at will, like an extra leaf at the dinner table."

"Then perhaps we should remove it for now," I said, but he didn't answer me.

I understood his logic well enough, but what I worried about was sending Crea to Elizabeth overprepared, as it were. Considering that Crea's functions as a temptress had been altered and precluded copulation and all its various offshoots, neither she nor Elizabeth would have need of this extra appendage. Still, the professor had been more than generous with his time and energy, and the use of his facilities. What he had done was open a new door to the experiment, one that we could examine at greater length later, once Elizabeth and I had married and there was no further need of Crea, at least in my regard.

Chapter Twenty Six

In the morning we dressed Crea in the smartest fashions of the day. Her corset was raw silk, and her petticoats ruffled fine-weave cotton. Henry had picked out a tight-fitting traveling suit with a velvet collar, and a matching hat with a large red feather protruding from the brim. Gloves, purse, boots—she was ready to travel.

We took her to the station with the instructions to change trains in London, which she said she understood. In a sealed envelope, I stuffed into her purse a note of introduction to Elizabeth.

I had one serious regret: if only I could be there when my darling received her "present." I knew she would be thrilled. I longed to watch the two of them playing together. Well, I expected I would be home and the wedding would occur in four months time, which was not forever, and would have ample time before the festivities to observe.

Before we departed the train car, I handed over a gift-wrapped box. "Give this to Elizabeth," I said. "She will know best how to use it."

Crea sat, her face aglow, her bottom I expect rivaling it. And yet it seemed to be sadness I detected on her face. Even that treacherous brown eye appeared to have a tear lurking in its corner. When I questioned her, she threw herself into my arms, and grabbed onto the others as well.

"Oh Masters, do not abandon us! Have we not pleased you? Have we not meted out and borne punishments as none other is capable of? Have we not contained our own release that we might better please you? And all willingly, and with the utmost pleasure. Do not send us away!"

"Here here!" cried M. Krempe, uncomfortable with public displays. "You knew the purpose for which you had been built. Do not carry on so."

"I shall be returning home shortly," Henry assured her. "We shall see one another as frequently as your new mistress permits."

"And don't forget, you will have a new mistress. One not as faint-hearted as we three put together," I assured her.

That gave her some hope.

"Is she pretty?" Crea asked, wiping the tears from her eyes with the lace handkerchief with a 'C' embroidered in one corner.

"Very pretty," I said. "And stern. You will soon forget about us as she paddles your bottom briskly morning, noon and night."

This brought a smile to her lips. "And will she want the same?"

"Undoubtedly," I said.

With that the whistle blew and we were forced to depart.

The train pulled out and we all waved goodbye. It was a sad and touching moment, for we were losing our playmate.

"What shall we do for relaxation tonight," Henry said, asking the question I myself had been thinking, for we had been hard at it for a month and needed some diversion.

"Curious you should ask," M. Krempe said. "I have modified my basement machine and believe it now capable of attending to two bottoms at the same time."

Henry and I looked at one another. We were both in for a fine, full evening.

Chapter Twenty Seven

"Victor, oh Victor. What can I say? You have for once left me speechless."

I settled myself under an ancient oak in full leaf and with a self-satisfied smile upon my lips, read Elizabeth's letter.

"Crea is wonderful, so full of life, so versatile. But I shall tell you everything, as I know how you love detail.

"She arrived on June first, the day originally scheduled for our nuptials. Naturally I was feeling gloomy. Your parents and brother had left for the wedding of your cousin, and I—feigning a summer cold—was alone in the house with the servants and my misery.

"In truth, I doubt I could have restrained myself from enjoying the company of Miss Heidi or Gilles, had either been available to me. Miss Heidi, bless her, is gone, although I have had one letter from her. It seems she has taken another position, as headmistress at a finishing school in Marseille, blistering the rebellious behinds of French debutantes. And, as you know, for I expect Henry conveyed this when he joined you at Oxford, Gilles has returned home to France. Wouldn't it be curious if the two of them met? But, I digress.

"I'll admit it to you now, Victor: I've become bored with the bicycle. It has severe limitations which I discovered immediately, but I did not wish to wound your feelings entirely, so I tried to keep my complaints to a minimum. In truth, though, that machine lacks finesse. The flaps paddle one spot only, which for a time can be enjoyable. After all, to have just one area of the fanny heated to boiling, well, I'm sure you

find the notion titillating. But there was so much more of my bottom left unattended to. And I could not think how to alter the machine to my needs, although I did try. But the fact remains, those flaps were ghastly repetitious, and dully predictable. To know exactly which spot will be smacked and how hard, well, where is the novelty in that? There was no surprise.

"Still, on that morning, I planned to take an extended ride, hoping to distract myself from the misery I felt. Suddenly a knock came at the door.

"Anna was busy in the garden weeding, so I opened the door myself. On the other side stood an astonishingly tall and beautiful woman with handsome features and shiny black hair. She was heads above me, dressed in fine clothing, with a jaunty feather in her hat. Obviously she had been traveling for some time, for her outfit had the dust of the railroad and coach clinging to it.

"She eyed me insolently from head to toe, pausing about chest level before returning to my face. The fact that her eyes were of different colors unnerved me at first. Silently she handed over a note from you. Well, I was surprised at best, terrified at worst. Silly me, Victor, but it flashed through my poor brain that you had found another and had the bad manners to send her to me with your apologies that you no longer loved me. Oh, I know that is a ridiculous thought, deserving of a sound thrashing, which I expect I shall receive at your hands when we next are together, or at least I hope so. But you must understand, darling, I was in such despair that day, and the world looked to me to be coming to an end.

"Once I read your card of introduction, and an explanation as to how Crea came to be, my mood lifted remarkably. Of course, I pulled her into the house at once and brought her to the parlor.

"'Sit,' I said, then, 'let me offer you refreshment. I'll ring for tea.'

"'Oh, don't bother, Mistress Elizabeth,' she said demurely. 'We need no food, only a little water, and no sleep at all.'

"'My!' I exclaimed, not knowing what else to say. I confess, I found the use of the plural charming, and I did like hearing the words 'Mistress Elizabeth' on her lips.

"We talked at length and Crea painted the broad strokes of her story, of how you three had formed her, trained her, and finally programmed

her specifically for me. At the time I did not pick up all the nuances, but later, of course, all would become apparent.

"I could not have been more delighted. I hugged her to me, and she returned the gesture, our bosoms touching. I assured her, 'Crea, we shall have such fun together! I can hardly wait to begin. But we must find a way to bring you into the family.'

"I thought for a moment, then it came to me. 'I know, I shall introduce you as a childhood friend. You were visiting your brother at Oxford and introduced to Victor, who mentioned his bride-to-be. When you learned I was here, you came straight away.'

"Well, Crea thought this a wonderful idea. We hugged again in solidarity over the lie. This time I was acutely aware of her firm breasts pressing into my own, nipple to nipple as it were.

"'We shall get to know one another now. There's no time like the present,' I told her. Those delightful eyes twinkled, and the brown one especially seemed excited.

"'Oh, Mistress Elizabeth,' she said in her delightfully innocent way, 'We very nearly forgot. Master Frankenstein has sent you this gift.'

"The package was the worse for wear from her travels, battered, the ribbon and paper shredded in one corner, the box itself mashed in. Still, the contents were in perfect shape. I held it up to her. Her blue eye rounded with wonder. That brown eye glided over the leather in the manner of a tart. Both reactions pleased me, for they initiated our first game.

"I grabbed her arm and jerked her to her feet. 'That's enough of that, Miss. I may introduce you as my long-lost friend, but in reality I am mistress here, and you my obedient and humble servant. It appears your trainers have been lax, but I shall forthwith correct the flaws in their efforts. You will come with me.'

"I reached up and grabbed her earlobe and pulled her out of the parlor and up the steps, and then up the narrower steps to the attic. Her resistance was mocking, but then, she had not felt my hand yet and could afford to resist.

"Once we were in the attic I commanded her, 'Undress at once, and be quick about it!'

"Those full lips formed a self-indulgent pout and I snapped the object you'd sent me in the air, which got her attention.

"Slowly she began removing her clothing. I watched as she unbuttoned the suit jacket, one button at a time. The pressure against that heavy fabric from her breasts made it part further with each button. I watched as the sheer blouse came further into view, and the swell of breasts.

"Once the jacket had been unbuttoned completely, she removed it. Now I could see those breasts with their firm nipples through the thin white cotton, swelled over the top of a white corset, seemingly eager to be sucked. I must say, that was a pretty sight indeed.

"I cracked the leather again, letting her know I was in no mood for this snail's pace.

"She unbuttoned her skirt and let it slide down to the floor. A peculiar bulge beneath the petticoats caught my eye, and I said, 'Off with those.'

"She slid the petticoats down one at a time, tantalizingly slowly, until all three had fallen to the floor and what lay beneath was exposed.

"Well, Victor, I was flabbergasted. Ripe breasts swelling over the top of the corset and two erect penises jutting out from below the bottom of it! And that red hair at the crotch! Again, all I could manage was a feeble, 'My.'

"Crea had a smirk on her face, as though displaying herself was much to her liking. Since it pleased both of us, I pulled over a chair and sat down. 'I shall enjoy this entertainment in a relaxed manner,' I told her. 'And entertain me you shall.'

"This, of course, brought another smile to her lips, more full and open-mouthed. I saw her tongue dart out and ride those thick lips and I imagined tasting it. Of course, there would be time later.

"She now wore only her corset, the white woollen stockings rolled with garters, her black boots and that black hat with the red feather attached. No bloomers whatsoever. This I pointed out to her. 'Be you lady or gentleman, you will not again venture out of doors without your bloomers. Is that understood?'

"'Yes, Mistress Elizabeth.'

"'You have not been in my home for an hour and already you have shown yourself insolent on several counts. Do you think I should simply put up with such misbehavior?'

"'Oh no, Mistress Elizabeth. Our Masters would not, and we do not

expect you should either, although you are a woman and perhaps will be more lenient.'

"I snapped the leather hard in the air. The sharp sound rippled through her body. I watched both cocks tremble in excitement. 'We shall hear no more about your masters, for they are gone. You are here now, under my charge. And as far as my being lenient, you will soon learn that it is not in my nature. My duty is clear: I must discipline you, for apparently your training has been sorely lacking, and fulfil my duty I shall.'

"'Yes Mistress,' she said a bit more humbly, although an undercurrent of excitement was clearly in her tone.

"'Alright, then, over the knee at once!'

"I had learned this no-nonsense approach from Miss Heidi, to whom I shall be forever grateful.

"The command worked like a tonic, rejuvenating Crea's mood. Eagerly, it seemed to me, she came to my right side and crouched down, then crawled across my lap.

"As she did so, she rubbed her breasts along my thighs. Would that I had been naked! I longed to remove my own clothing, but this first time I wished her to know who was in command here, so I stayed dressed.

"Crea is exceptionally tall and her elbows and knees rested on the floor. Her derriere, though, was properly positioned; obviously she had been in this position before. I felt both penises pressed against the inside of my left thigh, their heat, their determination.

"Before proceeding, I needed to investigate her possibilities. I ran my hand over the broad, masculine shoulders, down her back, and my palm rounded her juicy plump bottom cheeks. Her legs parted slightly in invitation. I slid my forefinger slowly down her crack to her anus. The moment I touched that hole it seemed to open like lips parting to allow insertion of a tongue or penis.

"I entered her anus an inch or so only. Her head reared back and her bottom lifted higher into the air. 'That's enough!' I ordered sharply. 'You shall remain still until I have given you permission to move.'

"'Yes, Mistress,' came the submissive reply.

"I felt cantankerous for some reason, and kept my finger just inside her anus for a long time, wiggling it a bit, teasing her. The heat sur-

rounding it increased, as did the pressure. I began to detect an odor and recognized it as feminine juices.

"When I removed my finger, it was quickly. She moaned, and tried to stifle it and the quivering in her bottom. 'I'm adding this disobedience to my list,' I assured her.

"Beneath that bottom hole I was delighted to find a woman's mouth. The slit was large and hot and moist to the touch. This time I used my middle finger and ran it around her vulva many times. The moisture increased, as did the scent. She struggled valiantly to remain still, although I knew the sensations coursing through her body must be very difficult to contain.

"Eventually I inserted my middle finger into her vagina to the second knuckle. I felt her desperation to avoid the natural movement that would follow such penetration increase. Around my finger warm wet folds of skin closed. I tapped against them from all directions and, like lips, they contracted around me further. At the front of her vagina, where the inner skin is smooth, I rubbed that spot of pleasure like a match striking a flint, until I felt her flintstone cooking beneath my fingers.

"Crea showed remarkable restraint, and silently I thanked her makers for a job well done, although I would not tell her this.

"Now the juices virtually flowed from her cunny. When I had her hot and bothered, I withdrew. This time she could not contain her feelings, and cried out, 'Oh Mistress!'

"'One more black mark,' I assured her, as though I'd added another tick in a ledger of her crimes.

"From there I moved down between her legs and grasped the first set of testicles. They were hard and high, filled with pleasant juices. I manipulated them for a time, then went further to the enormous cock I had seen when she first undressed. It stood stiff and ready, hot, skin taut, veins prominent, a drop of moisture lying at the tip. I fondled him for several minutes, which I think drove Crea crazy. Secretly I wished to taste him, as I had longed to drink in her cunny juices. As you know, Victor, restraint is as difficult for the one who dominates as it is for the one who submits. I managed, just barely, but she could not contain herself and moaned forlornly. I assured her that such moaning would cost her in the end.

"Finally I found that second cock. Although smaller by far, he was not small by ordinary standards. The testicles there were difficult to fondle—they seemed not apart from but imbedded in the skin, with pieces of metal holding them in place. This cock, too, seemed receptive and I gave him his due, using my hand to ride up and down the shaft like a tube encasing him. He bulged merrily, loving the attention.

"Crea was beyond herself now. All restraint had gone by the wayside. When I ceased touching her, she emitted the most piteous groan.

"'Your restraint is on the one hand remarkable, and on the other wanting. You need the finer points of submission impressed upon you, Miss, and that's a fact. Are you prepared for your lessons to commence?'

"'Yes, Mistress Elizabeth.'

"'And do you see the need for correction?'

"'Oh yes, Mistress, for we have failed you.'

"'Indeed you have, Miss, but you shall do better next time. My stick shall ensure that.'

"Here her bottom trembled in anticipation.

"I examined the leather cane you sent me, Victor, swinging it through the air so that it made that terrifying whooshing sound until I thought the air might have been sliced into sections. I tapped the cane against my palm, then a bit harder. It produced a nice bite, similar to that of a bamboo rod, with the refined burn of a strap. I knew instantly that it was made of strips and strips of sewn leather, a cane within a cane, within a cane. I'd learned about such tools from Gilles, and was delighted to own one. Victor, you are a lamb!

"I grabbed the hair visible at the front of her head and forced her head back so that our eyes met. 'Now, Miss, you shall beg for your supper.'

"She took to the metaphor instantly.

"'Mistress Elizabeth, please, ma'am, use your rod of instruction liberally on us, for we have need of correction. And Mistress, we beg you, do not spare the rod, else you shall spoil us further.'

"'I have no intention of sparing the rod,' I reassured her, to which she replied,

"'Oh, thank you Mistress Elizabeth.' She grabbed my left hand and kissed it lovingly.

"'Enough!' I said, pulling my hand away. After all, we could go on

and on verbally and waste the day. 'As I tan you, I expect a word of thanks now and again. Is that understood?'

"'Yes, Mistress,' she said quickly, and I began.

"That first stroke of the leather cane on her bottom fell hard, for I was excited, and my hand eager to produce results. Crea did not disappoint me. Her bottom jumped into the air, and a gasp escaped her lips. Her double cocks jabbed against my inner thigh. I think she expected something softer from a woman. And yet have I not had a wealth of experience?

"She turned her head, wisps of black hair escaping the prison of that hat and lying across her now damp cheek. She looked at me with tears welling in her eyes. 'Thank you so much, Mistress Elizabeth. We are in your debt.'

"I lay the leather cane on religiously now, whacking her fanny mercilessly while she hopped on my lap. Those penises jabbing into my leg inspired me.

"The cane left bright red lines across those fleshy cheeks. At first I simply walloped her hard, the lines falling indiscriminately. I was having such a good time, my own cunny juices flowing, that I simply did not pay much attention to what patterns I was creating.

"Finally, though, I noticed that I had colored mostly the middle of the cheeks, and left the top and bottom without marks to speak of.

"I bent a little to the side and whipped the spot where the leg meets the heinie, in that crease. Crea danced a new step now. Her cunny was slick with juices, and the lower set of balls tightened and reddened considerably.

"I beat her there until her sobs rang throughout the attic, then I switched to the top of her ass. The sound of the cane, the feel of the hot leather in my hand and the tension of my muscles as they swung the rod, the sobs and moans and 'thank yous,' those plump cheeks submitting to me so eagerly, the tart-sweet scent of her sex, all of it was highly erotic to me and I soon found myself overcome.

"'I should punish you further, and shall, but for the moment I have other desires. You will mount me from behind, using the larger of your cocks to enter my anus.'

"I think had I not been a virgin in my other place, I should have wanted both of them inside me. But I am saving myself for you, my

love, and Crea's biggest member would more than satisfy me, of that I had no doubt.

"I lifted my skirt, pulled down my drawers, and knelt on the floor. She took up a position behind me. That enormous cock paused at my opening momentarily while she inquired, 'Mistress Elizabeth, we exist but to please you. How do you wish to be entered?'

"Well, I'd never had anyone ask me that before. I was tempted to say, 'As you like', yet felt my position of authority would be compromised. 'You shall enter me deep, and quickly. I expect you to fuck my bottom until I climax. And, Miss, you are not to climax before I do.'

"'Indeed, Mistress, we have been taught to not climax with this phallus at all. Rest assured, your wish shall be fulfilled.'

"With that, her enormous cock rammed into my bottom, jolting me. I had never felt the like. It was so much larger than any I'd experienced, including yours, sweet Victor, although size is not everything, as we women know.

"Crea went in so deep I felt she had reached my stomach. I could only wait on my hands and knees, submitting to that giant, and receiving all that it offered me.

"She withdrew almost completely, then rushed in again. I could feel the other cock sliding along the crack between my sweaty ass cheeks. My mind failed me completely. I felt entirely under her control. This procedure was repeated again and again, punishing my poor rectum in the most deliberate and delicious manner. It did not take many strokes for my hole to lose control completely.

"I contracted sharply around that phallus, again and again, crying and screaming out my pleasure. It seemed to be endless, which was the perfect length of time for an orgasm to extend. Eventually, though, my contractions ceased and I became aware once again of the room, the birds outside chirping, the scent of lilac in the air.

"We remained as we were, I on my hands and knees, Crea imbedded deep inside me, awaiting my full recovery.

"Once I'd revived and permitted her to withdraw, we both dressed and I showed her to the bedroom adjacent to mine. She had no baggage, and I suggested we take a trip into town that afternoon, for she would need several changes of clothing.

"She drew me a bath and while I soaked, Crea massaged my breasts,

rubbing and twisting them until I orgasmed again.

"Victor, what can I say? She is delightful. I know that our encounters will be many and enormously rewarding for both of us. You are a darling. I can never thank you enough. Of course I await your arrival this fall with eagerness on many scores."

I folded the letter and placed it in my pocket. My cock was hard. The picture she had painted had been vivid to me.

On the one hand, I was more than pleased that Crea had worked out so well. Elizabeth was happy, and more importantly, distracted until we could be together. But the fact that my love was being plowed by my creation I found worrisome. Of course, I had expected Elizabeth would take this route. That was why I had worked so diligently with Crea to make certain she would not climax. And my work seemed to have paid off. And yet I felt oddly disconcerted. Crea was functioning properly. She received the rod willingly and gained much pleasure from it, as much as Elizabeth enjoyed applying it. Crea provided the sexual stimulation Elizabeth craved without needing reciprocation. Why, then, did I feel uneasy?

I reread the letter and could find nothing there to identify from whence my dis-ease originated. I did, however, ejaculate in my trousers. That should have been enough to calm me, but it wasn't.

I hurried towards the laboratory, hoping that Henry was not making use of the machine in the basement. We had both discovered that the need to be restrained had virtually disappeared. We could, in fact, position ourselves properly and wind the clock for whatever length of time we liked. Many days when my studies had wearied me, I found that a session of an hour or two in the bowels of the professors house was as refreshing as a Turkish steam bath. And now that the machine possessed two hands which could be adjusted, one could have both cheeks attended to simultaneously, or alternatingly.

Fortunately the machine was free and I set it up to my specifications of the moment—alternating cheek and cheek. Thoughts and worries about Elizabeth and Crea quickly dissipated into a cloud of pleasurable pain.

Chapter Twenty Eight

Letters came regularly over the summer from Elizabeth, each following closely on the heels of the one before, all detailing the Mistress/Slave relationship that was developing. Elizabeth had taken to one side of the equation, it seemed, like a duck to water, which made me happy, for I felt she would get into less trouble that way. The family had welcomed Crea, and accepted her as Elizabeth's dear friend, with the "peculiar pronoun problem," as mother had confided to Elizabeth. All seemed to be going according to plan.

Early August another letter arrived from my darling. I sat perspiring in the library, although the windows were open, and read it slowly, for I had learned to savor the details of Elizabeth's experiences with Crea. They were stimulating, to say the least.

Elizabeth began by assuring me that Crea was a never-ending source of pleasure, and discovery.

"Every day I unearth new and exciting possibilities with her," she wrote. "Today I learned that Crea has both the capacity to give as well as receive pleasure. Before our outing, I'd found her ability to satisfy herself limited. But still, I thought, what a remarkable creation. I expect I might have built her differently, had I your expertise, Victor. It is lost on me why you did not imbue her with the ability to climax. And yet today I discovered that you had kept the best for me to find on my own."

I sat bolt upright, forgetting about the heat.

"We spent a wonderful afternoon picnicking and boating on the lake. The weather was fine indeed, not a cloud in the sky, and the shores

deserted, as always. We both stripped to our birthday suits and lay in the hull quite naked, allowing the sun to scorch those parts that are forbidden by convention from experiencing warming solar rays.

"Crea's skin heals remarkably fast—I'm envious. It has only been two days since her last thrashing and there is not a mark on her, as though that most recent caning had never taken place. I myself, at least in the past, wore my stripes well and long, if you will recall. But since Crea's arrival, I have even forsaken the spanking machine, and in the brilliant sunshine my derriere lay white and vulnerable.

"Oh, and Victor, before I forget, that leather cane you sent me? I find it invaluable. It is so easy to use, and I love the feel of it in my hand. Equally, I adore the look of her bottom striped with lovely red marks. I'm getting quite proficient at placing them where I want, as you shall see and feel when you return next month.

"In any event, this afternoon I was sorely tempted to redden her creamy bottom cheeks anew, and yet I so wanted to test her boundaries.

"I'd brought along a large oval hairbrush—the one your mother gave me last Christmas. 'To help your crowning glory shine,' she'd said, as I recall. I decided that my crowning glory was in the eye of the beholder, and a shine might be just the thing I needed. Besides, it was a perfect opportunity for me to see how Crea functioned at the other side of the stick, as it were.

"We lay in the boat, I on my stomach, and Crea on hers, side by side. 'Here,' I told her, 'brush my hair.'

"I handed her the large oval brush and she examined the polished hickory back for a moment, then began brushing my hair, which hung loose and spread across my back.

"The warmth of the day, the heat on my body, the scent of fish and the sound of birds overhead—it was all so peaceful and relaxing. I quickly fell asleep as the boar's hair massaged my scalp.

"I had no idea how long I slept, but when I awoke I felt that tautness on my skin which told me I had acquired a sunburn, enough of one that I knew I would be suffering that night.

"'Oh, Crea! You've left me to fry. Of course, how could you know? You are not acclimatized as are human beings. Your own flesh will revive overnight, while mine shall suffer for days.'

"She looked at me with those startling eyes, but said nothing. Her

lips, though, seemed to twist into a smile that held some contempt in it. Finally, she said, 'Mistress Elizabeth, is it us you hold responsible for your condition and are we to receive punishment?'

"'Of course not,' I reassured her. 'I hold myself responsible, and none other. Why should you be punished? I am the one who has had to learn a lesson today and, I might add, the hard way.'

"'And have you? Learned your lesson, that is?'

"At first I felt this question to be impertinent in the extreme. And yet I was not inclined to be active that afternoon, but to be receptive. And, in truth, I was the guilty party, to my own detriment.

"'Perhaps not,' I said hesitantly.

"'We imagine it is difficult, being Mistress, and having no one who will bring you to task when the need arises.'

"'Oh, it is,' I agreed readily.

"'Perhaps you would be the better for a firm hand guiding you in a way that leaves a lasting effect.'

"'Undoubtedly,' I said lazily. All the while the hot sun beat down on my bottom, and along the backs of my legs—fortunately my long hair protected my shoulders and back—but I was disinclined to move. I could feel the skin's tightness and knew I would regret the sluggishness that had permitted me to overindulge. Little did I know that I would regret it even more than I had anticipated.

"'Mistress Elizabeth, do you give us leave to punish you for your foolishness?'

"I knew then that if we were to have the more equal relationship I'd been secretly hoping for, I must give over power to her. The notion filled me with exhilaration. I looked into that lovely face and saw a sternness there I'd not seen before. It affected me deeply and I felt my nipples ache, and my insides heat.

"'Crea, I do give you leave to punish me until you judge I have learned my lesson.'

"'And you shall not interfere?'

"'I shall not interfere. For this afternoon, you are mistress and I the one in need of your solid scolding. Now, would you hand me my skirt and stockings?'

"A delightful smile creased her face. She sat up immediately and moved so that she was at my head, her legs spread, my face and nose

right at her cunny beneath those two heavy cocks.

"She handed me my stockings and from my awkward position on my stomach, both of us giggling, she helped me slip them over my toes and up my legs, then used the garters to hold them in place. She did not, however, offer me my skirt.

"Crea is so tall, and her arms long, that she did not need to even stretch, really, to reach her target, a fact that would be reiterated in my awareness very soon. In all things, she took her time; apparently you three men had instilled this virtue of patience to the core of her being, for she knew her lines by heart and she was in no hurry to deliver them.

"'Elizabeth, we are most dissatisfied with you. You have proven yourself a naughty girl, lying in the sunshine naked until your bottom is cooked like an Easter ham. Another girl might learn from the effects the sun produces, but we doubt you are capable of making the necessary connections. From what we have observed about your nature, and from what information Master Frankenstein passed on to us, we expect only one approach will reach you and prove meaningful.'

"'And that is?'

"'And that is a good hiding, of course. On the bottom which is already suffering. You shall be beaten until you cannot sit. Blistered, to be precise.'

"Her words filled me with excitement and terror. Of course, I've taken many lickings, at your own hand, dear Victor, and as you know, at the hands of Miss Heidi and the stable master. And then there was your marvelous bicycle. And yet something in Crea's voice told me that this would not be an ordinary spanking. For one thing, it was obvious she had the strength of several people. For another, I had the notion that her hand would not be swayed by either my words or actions. In all things she was not only patient but persevering. And clearly this day, she possessed an agenda all her own. I only wondered if I were brave enough to give myself over to that agenda.

"Hither to now, I had controlled all that had occurred, for the most part. Oh, there have been moments—in the gazebo with you, when you whipped me so well all night long with the bamboo, once with Gilles when we had three hours at our disposal and I lay over the saddle tasting his nasty crop, and that time with Miss Heidi, when she tortured my nipples until sunrise. The machine, of course, does not count, as it has

been entirely under my control.

"So those few occasion were in my memory, to remind me of submitting to the will of another so utterly that my own will was temporarily submerged. I knew this could be good. And yet, were not all of you human? What Crea is, I do not know. I am not even certain of her gender, let alone her species. I know her capacity to receive punishment is beyond that of anyone I've met, certainly beyond my own. I wondered how she would function with the implement in her hand instead of on her bottom. Would she be relentless in her punishment? And would I be able to bear it? And what if I could not get her to stop? Yet that was silly. Wasn't I still Mistress here? A word in a firm voice would reverse our roles instantly.

"And my curiosity was getting the better of me. That and the hunger raging inside my hole. I wanted to experience something that would surpass even the power that the sun had to favor me with a kiss that would last beyond this afternoon.

"I looked up past those two cocks and caught Crea's eye. This time I saw something I had not seen there before. Could it be her will was far stronger than mine? It took my breath away for a moment. And yet I could not trust my intuition and needed to find out if it was so or merely something I wanted to see there. In short, I wanted to test her as much as I wanted to test myself.

"'If you are planning a hiding, I suggest you get on with it, lest the sun do the entire job for you.' I was intending to make her angry with my sarcasm, and I succeeded.

"'Miss high and mighty, you shall be biting that sharp tongue of yours in short order. We shall begin when it pleases us, and cease when it pleases us, and for the moment it pleases us to let the sun burn a bit deeper into your derriere until it is properly glazed, which will make your licking all the more distressing.'

"Here she slapped the back of the brush against her palm a dozen times, letting the sound reverberate through my body, and echo over the lake.

"She instructed me to pull on my blouse, as I likely would be jerking about soon, and she did not wish my back to burn. That, she said, would dilute what she had in mind. I lay now on my belly, with only my bottom and the tops of my thighs uncovered, the sun's rays cooking

the skin so that it prickled, my lips inches from her delicious-smelling cunny. I admit, the idea of lying under the sun any longer did not appeal to me. It was not the punishment I had in mind. I knew, though, that at any moment I could reverse our roles.

"'Put your hands behind your neck,' she instructed, and I did. They were immediately bound with coarse rope from the boat. She then made me bend my knees until my legs were brought up one at a time beside my hips. She tied each ankle to my waist at the sides. This spread me wide, and was also uncomfortable because it stretched my thigh and calf muscles. 'Keep your knees apart, Miss, if you know what's good for you.' Of course, that was redundant, as I could not have closed my legs had I wanted to. I assumed she was nervous and that this was all new to her.

"She then used more rope, securing my ankles and wrists, crossing the hemp, and pulling tight. My bottom cheeks were left fully exposed, the gluteus straining from the tension of this position. Beneath, my pubic bone pressed into the hull of the boat.

What she did next startled me. She wrapped that same piece of rope around my throat.

"'Now just a minute!...' I began in some alarm.

"'Silence! You will speak when spoken to and should you disobey us again and attempt to utter a word, we shall gag you in short order.'

"Suddenly I became fearful for my safety. I was out on a boat alone, on an isolated lake, with what was essentially not a human being.

"The rope about my neck was scratchy and uncomfortable as it pressed against a tender area. My head was forced back, else I would choke. My legs had been pulled so taut, and my wrists, that I knew the muscles would cramp when I was untied. The crisscrossing of ropes left me lying mainly on my belly and groin, my titties lifted and pointing at her cunny, my two holes in full view, my ass burning more each second from the blazing sun. And now I could feel that sun penetrating beneath the first layers of skin to scorch deeper.

"This entire rope trick had me utterly helpless. I could not bend my head down or I would choke. I felt like a turkey, trussed and ready for stuffing.

"One thing that calmed me, though, was the proximity of her sweet cunny. The red forest I stared into showed me the opening of a cave slick with juices I longed to taste until I reached the source. The longer I

stared at that entrance and sniffed it, the more I wished my lips and tongue to explore it and what lay within. The scent filled my nostrils with her dark perfume, and made me crazy. All that kept me from darting my tongue forward were two things: in fact, that lovely cunny was just out of reach, and also, the pain the sun was causing my bottom. Both captured my attention.

"Crea is nothing if not patient. We stayed in the boat, I helplessly sniffing her feminine odors and suffering the solar lash, Crea seated before my hungry lips, that cunt and those two cocks pleasure points just beyond my grasp.

"I soon felt my bottom to be as red and burning as a lobster dropped into boiling water. I was afraid to speak, for the last time I tried, Crea said we would wait a bit longer and give the sun more opportunity to work its magic. And yet the pain was becoming unbearable. My ass cheeks and the tops of my thighs were the parts uncovered, the parts left to cook. I felt desperate and was afraid that Crea could not understand the limits a poor mortal could take. Tears leaked from my eyes as the pain became too intense.

"When the hairbrush landed on my backside, it was none too soon. A hard flat brush like that striking from such a height—and I know she brought it down from high above her head—could only startle my buttocks already damaged by excessive sunburn.

"She is not a light spanker, but fast and hard. And thorough. The pain had me howling within a minute. Tears soon flowed from my eyes and washed down over my aching titties as she whaled my bottom to the tune of two spanks per heartbeat. My cunny flowed freely with juices and my hips rocked against the hull, although I could not avoid the blows.

"Beneath me, I felt my nipples hard and scraping against the wood. I struggled to wiggle so that I might increase that pleasurable sensation by rubbing them against the rough boat bottom. And I could not restrain myself in other ways. My tongue flicked out, desperate to reach that source of cooling refreshment.

"She spanked away, meting out blows to the center of my cheeks until I felt I could take no more. Over and over I begged her to cease, until my throat was as raw as my bottom, but it was as though she did not hear me. Suddenly she moved the hairbrush down and applied it as

firmly to the undercheeks, then to the sides and finally to the tops. My position tightened my gluteus muscles so that they bunched and plumped for her, and the hairbrush cracked soundly against such well-displayed globes.

"Finally I managed to inch myself forward, which just made the paddling worse. I've never been spanked by a hairbrush and had always wondered what was the attraction. It's the heaviness, Victor, the sheer weight of such inflexible wood cracking against vulnerable flesh. It's insidious, actually, which makes it all the more appealing.

"My bottom had started out on the verge of blistering. Crea saw to it that the blisters blossomed forth like flowers, from seed to bud to full bloom.

"Finally I had managed to move myself so that my lips reached hers, but the nether ones. To do this I had to lower my head and risk suffocation, but it was worth it. Instantly I gratefully kissed that red jungle with its hidden treasures. I drank in her moisture as if my life depended on it. While she paddled away, I played happily with her magic button, licking, sucking, nipping at it until it firmed as much as the penis pressed to my forehead.

"Yet all the while I sobbed uncontrollably, for the pain was immense, like nothing I had experienced before. I knew deep inside me that I was utterly helpless and be she woman or man or both or neither, human or other, Crea would only cease this tanning when she felt my hide was properly cured, and not before, even if it meant there was no hide left on me.

"I soon reached a delicious state where my entire world became the blazing heat raging like a forest fire across my bottom and down through my cunny lips and up inside me. My own dear cunny spasmed again and again. I had not known I could orgasm so often and so fully without even being touched there. And orgasm through my entire body. And all the while my tongue licked and massaged the tender tight folds inside Crea's cunt, eager to please her. In fact, I was so eager now to please her, my bottom seemed to lift to meet the back of the hairbrush, and my tongue struggled to get deeper inside her.

"I wallowed in ecstasy, balanced on a thin line between pleasure and pain so great they threatened to drive me insane. It was only by staying on that line that I could hope to survive the clutches of the extremes.

"I no not how long this excruciating therapy lasted, only that the sun was setting when Crea put down the hairbrush and moved away from me.

"Now that her cunt was no longer mine to enjoy, I felt desolate, and nearly succumbed to the torture emanating from my behind.

"I cried out her name again and again, begging her to let me pleasure her more. But she did not respond. At least not verbally. Soon, though, I felt her between my legs, probing with her finger, and knew that she would enter me.

"In truth, Victor, I must confess this to you: In those moments I wholly belonged to her. I am ashamed to say this to you, and yet I must be truthful, as always. I recognized my own being crying out for her. If her desire was to break my hymen, I would not stop her, but offer it willingly to be shattered. All that she commanded, I would strive to comply with. In fact, I heard myself screaming for her to do just that.

"What Crea did was unexpected. She lay on her back and slid me on top of her, so that I now lay face up towards the sky. From this position my anus would be plugged with the cock in front. At first I felt a bit of disappointment that she had not chosen the larger one, the cock that normally filled me so completely, and yet as she jammed me down onto that erect phallus at the forefront, all disappointment evaporated.

"I was so excited I came instantly. Crea, though, stayed inside me. Thrusting from such an awkward position was impossible, even for her, what with her being beneath me, and my back to her chest. Her large hands encircled my waist so that gripping me tightly she could ram me down onto that hard member as she liked.

"My agonizingly sore bottom slid against her sweaty stomach, and that friction only increased the heat on my raw flesh until I thought I could tolerate no more.

"It was miraculous, the afternoon. For as the sun set in the sky, I orgasmed again and again, my cries rising up in the air and carrying on the wind like the calls of some primitive animal until I should think you would have heard them in England.

"And finally, when Crea ejaculated, the game was over. We dressed properly and rowed home, I paddling from a position on my knees, staring with love and gratitude at my new mistress.

"All evening I have remained in a state of bliss I thought I should

never experience until our wedding night. I stand here at my desk, for I am incapable of sitting and shall be for many many days to come. Crea awaits me in the attic. She told me as we disembarked that my tits have been ignored far too long, and she would see to them later. But I felt I must write this letter to you at once. I am the luckiest woman alive. Oh Victor, you have made me so happy. What a wonderful wedding present!"

By the time I finished her latest epistle, I was trembling with rage, confusion and lust. I hurried to the professor's house and there found both he and Henry engaged in a bit of paddle and scamper—Henry, on his hands and knees, raced around the carpet while M. Krempe paddled his bare ass red with a cricket bat. I was in such a state I interrupted their play.

Hands shaking, I read them the letter, particularly the part about Crea ejaculating. "What could this mean?" I demanded.

The professor said at once, "I see our mistake. We added the second phallus after extracting the promise from Crea. Apparently she felt honor bound to fulfil the promise only in regards to her cunny, anus and the larger cock."

"Well, this is not the worst of it," I said, trembling so much that the professor poured me a glass of absinthe, which I drank down at once. As he refilled my goblet, I cried, "I am losing Elizabeth! She nearly permitted her maidenhead to be broken. And she is in love with Crea! What am I to do? If Crea is ejaculating, and performing in such an extraordinary manner that Elizabeth loses her mind completely, I will not have a virgin to break on my wedding night. There may not even be a wedding night!"

My words sounded foolish in one way, yet quite desperate in another. The two men tried to calm me, to reassure me. The professor suggested a session with the clock-machine, but I knew there was nothing to be done to ease my mind but to hurry home and marry Elizabeth immediately, before it was too late. Then Crea would be returned to M. Krempe and his experiments might continue safely away from Elizabeth. My darling and I would be on our honeymoon, where I could give her the attention she deserved. And in truth I was, at that moment, so angry I felt I was more than up to the task of making blood flow from more than her shattered hymen.

Chapter Twenty Nine

The sun was setting behind the Frankenstein estate as my coach approached the gates. Candles and lamps had been lit and the first floor of the house was aglow. It looked like a house of cheer. Roiled by the twisted emotions within me, my body felt imprisoned by tension; I felt like an enraged beast, ready to devour any in my path. I was not suited to enter such a normal environment.

As I disembarked the carriage, Elizabeth, who had heard the horses hooves and looked out the window, rushed through the door she had thrown open to greet me. Indeed, this response startled me somewhat. She threw her arms around my neck and kissed me shamelessly on the mouth.

"Oh Victor! You've come home early! Oh, my love, how I've missed you!"

Her face was flushed, her eyes bright and shining. She had never looked more lovely. I held her to me, feeling her sensuous body moving into the grooves in mine so that we fit like two halves making a whole. My member had already hardened and her crotch seemed to press against him. Her eager nipples dug into my chest. Her body seemed alive, vibrating with eroticism. "I shall plow your fields this night," I assured her, pinching her nipple until she took in air between her clenched teeth.

Her lips parted and her eyes shone, as if she would like nothing better. This energizing scene shifted dramatically, suddenly, when out of the corner of my eye I noticed movement.

I looked up to find Crea waiting in the doorway.

Elizabeth turned her head. "Oh, Crea. Look! Victor is home. Come, say hello to him."

Crea stepped down from the door. Her tall, graceful form moved over the lawn and when she reached me she stopped and said, "Welcome home, Master Frankenstein."

"No, Crea," Elizabeth told her. "You must call him Victor now."

"In public," I clarified, a dangerous undertone to my voice. "In private I am still your master and you will still do my bidding."

"Yes, Master Frankenstein."

"Oh, Victor, come inside," Elizabeth said, drawing me towards the door. "Your parents will want to see you before they retire. It is late. They will be in bed soon. Then we three can play in the attic to our heart's content."

As we walked up the steps, I thought, 'we three?' Obviously she intended to include Crea in our loveplay. Well, I would see about that!

My parents and brother were glad to see me, as always. We sat round the fire eating sugar cake, and chilled mint tea. I told them of my studies, of how M. Krempe and I, with the help of Henry Cherval, had worked on an experiment that would assure our fame and fortune, which pleased my mother greatly, and brought out from my father a gruff, "Well, you are a Frankenstein." My brother wanted to know the nature of our experiment.

"It is of a delicate nature, having to do with the essence of existence itself. We have achieved our goal, to a point. Our notes have been sorted and catalogued, and M. Krempe is already working on our research paper even as we speak."

"You've been successful, then?" my brother asked.

Crea caught my eye.

"Indeed," I said, an edge to my voice, "although there are a few minor flaws which shall be corrected in short order."

I told them that as my work had been finished ahead of schedule, I was home early and hoped that Elizabeth and I could marry sooner.

"What?" my mother demanded. "But that's not possible, Victor, as you well know. It is just not done. The invitations have been sent out, the date all arranged. Surely three more weeks will not make much difference."

"You'll be together a lifetime," my father said. "What's the rush? You must please your mother in this."

"Elizabeth, talk some sense into our son," mother said. It was clear they would not budge.

I had expected resistance from Elizabeth. "Herr and Frau Frankenstein, you have been more than good to me," she began in a passionate voice. "I would not for the world wish to wound either of you. And yet I find myself siding with my husband-to-be. Would that we could marry this night!"

The room filled with silence. Mother looked affronted. Father made an annoyed sound and cut himself a second slice of cake, mumbling something about in his day brides and grooms would get cold feet and wish to delay the ceremony, but he had never run across either who longed to hasten it. My brother, of course, only laughed.

Tension hung in the air. Suddenly Crea spoke up. "Well, isn't it natural for young people to want to be together. Of course, being apart for this past year has taken a toll on you both. Still, Frau Frankenstein is correct in this matter—propriety demands that you wait."

I was speechless. "I think this is not your business!" I said rather loudly.

"Victor!" Mother said in a shocked voice.

"Darling!" Elizabeth clutched my arm. "Please. Calm yourself. Of course they are correct. Much as we long to be together, we owe it to your parents and our friends to do the proper thing."

I stood. "If you'll all excuse me," I said. Then, "Elizabeth, I wish to speak with you in private. It is urgent. Come, we will walk down to the gazebo."

"Of course, darling," she said, standing immediately.

Crea looked angry, but there was nothing she could do, under the circumstances.

Elizabeth and I took the path to the gazebo at a fast clip, or rather, I did and she struggled to keep up as I pulled her by the upper arm. Once we reached the screened-in porch, I climbed the steps with her on my heels and stopped.

She came right up to me, her arms encircling my waist. "Victor. Darling." She stared up into my face, hers a mask of confusion and pain. "What is it? You've acted strangely since your arrival. Is there something

you're not telling me?"

"Elizabeth," I said, drawing her tightly to me. "If you love me at all you'll run away with me tonight, just the two of us."

She pulled back. Her face was a mask of horror. "Run away? From what? Victor, what are you talking about?"

"I'm talking about marriage. We can leave this night and cross the Alps, where we can marry on the morrow."

"What?" Now she broke away completely, as if a madman had gripped her and she was fearful for her life.

"Let us cross the mountains, marry in a chapel and honeymoon in a spot where none can find us and tamper with our happiness. Oh, Elizabeth," I cried, grasping her hand. "Pack your bags!"

"Victor, you can't be serious. Inside, when you suggested we marry sooner, well, of course I was all for it. But not to run off, to elope and leave everyone high and dry."

"Everyone! And who might that be?" I demanded.

"Why, your parents, of course. The wedding party. Our friends."

"Friends? For example?"

"Well, Henry, for one. And Gilles, who is coming here expressly to function in the capacity of groom—regarding the horses, of course. This was to be a surprise for you, Victor, which you've forced out of me with your peculiar behavior."

"Henry, Gilles and who else?"

She was silent for a moment. "Miss Heidi. Crea..."

"Aha!"

"What are you getting at?"

"Crea! She who is in your thoughts night and day, who fills and fulfils you—"

"Victor, stop this nonsense. If I didn't know better, I would think you were jealous."

"She who no doubt by now has stolen what is rightfully mine, like a thief in the night. A thief invited by me, to desecrate my own possession!"

"Oh no! This I will not stand. You are acting foolish and childish and..." She was so angry and frustrated with me that she stamped her foot. "Stop it, this instant. Crea is nothing but a creation, yes of your invention, but closer to being a machine than to being human, which

is what makes her so valuable. She can perform in more ways than any single man or woman, and her abilities are almost limitless, not to mention her energy, which seems boundless. Isn't this why you sent her to me? To entertain me while waiting for your return?"

Her sane words had a calming effect on me. I felt my shoulders relax a bit. "Then you don't love her?"

"Of course I love her. Why shouldn't I? But I'm not marrying Crea, I'm marrying you. Crea has delighted me and challenged me and taken me closer to my limits than anyone before. And for that I am grateful. Grateful to you, Victor. You designed her. It is your hand controlling her every move. I know that all she knows is the sum of your own knowledge and I shall soon be the beneficiary of that from a human hand."

I was beginning to see that my vision had been distorted.

I sat on one of the gazebo chairs and my head fell into my hands.

"You poor darling," Elizabeth said, falling to her knees before me, taking my hands in hers, kissing my cheek. "You've been under a strain lately. Overwork is all. Your experiments must have taken up all your time and energy, with no real way to release the tension you have been storing."

I allowed my head to fall forward and her small hands to run through my hair.

"I think, though, I know what you've been missing, and I promise that you shall be restored fully before the wedding," she said.

I looked into her blue eyes, feeling forlorn. I saw there only love, and longing, and knew then that I'd given way to madness. "Oh, Elizabeth, can you forgive my display?"

"Of course I can. And so can your parents. Come. Let us go back and reassure everyone. And when they have drifted off to their rooms, we shall meet in the attic and I'll see what I can do about relieving your stress."

"Alright," I said, kissing her warm, soft lips. Suddenly I felt tense again. "But just the two of us. Not Crea."

"Just the two of us, my love. In the attic."

Chapter Thirty

A strangled cry came from between my teeth, clenched around a wad of fabric stuffed in my mouth.

The leather cane whacked across my shoulders again, first one, then the other, repeating what had been going on. The skin stung, the muscles beneath ached, and twitched from the strain. My arms felt heavy, stretching straight out as they were to the sides. Elizabeth had ordered me to stand that way, with my legs spread, balancing on my toes, and take the cane.

She whacked me across my ass hard six times, along the top of my cheeks, the same spot where she had been striking for the past hour. My body was coated with sweat. My cock stood straight up.

The skin at the sides of my cockhead had been caught in a type of painful metal clip, one on each side, to which leather cords had been attached. The cords were nailed to a beam in the ceiling, as were the two ends of another cord that had been wrapped around my balls tightly. This pulled my cock and balls up high. The effect was an agony that kept me from ejaculating. But I found it oddly stimulating at the same time. It was an interesting balance of voluntary and compulsive submission.

She cracked the cane across the top of my ass another seven times. More tears leaked from my eyes. My, but she had learned a few tricks! I wondered if it had been Crea who developed this system of torture or if Elizabeth had come up with it on her own.

Those thoughts gave way as new bursts of pain exploded through my shoulders. Seven strikes on each. The worst part was hearing that

damned cane sing through the air before it made me sing.

The cane returned to my ass, that same sorry spot, now thrashed another eight times. The skin must be raw, ready to peel off, surely blistering. Eight to each shoulder. I had to admit, despite the agony, I felt that the tension I had walked in the door with had been transformed into another type of tension, one more to my liking.

I hung by my heavy, full cock and balls, screaming into the gag, feeling the complaints of my cramping muscles, the searing pain of the cane as it struck again and again, increasing by one strike each time, those same pitiful spots.

Each whack felt like a searing iron, and yet this was just leather. I'd not had a hiding like this, so focused on one spot; the closest had been M. Krempe's clock-machine, but then I'd been lying comfortably. This caning was taking it out of me.

We were up to twelve, across the top of my ass cheeks, a dozen each, the left, then the right shoulder. My balls wanted to shoot their fire through my hose and into the air, my cock cried to be the conduit by which that fire singed the sky. But the only singeing I was permitted was that being inflicted on my sore flesh.

I cried. I begged her through my garbled words. Several times I nearly tore the leather thongs from the ceiling beam. After all, I was not bound in a way I had no control over.

And yet I did not. I submitted to her. What Elizabeth was doing was just what I needed. She was drawing me to the limits of the pain and agony and worry that had consumed me for months now, whipping it out of my body in the most severely loving manner.

The last number I recall counting, and I seemed to be obsessed with keeping track of the numbers, was twenty five. The stinging blows of the cane across the tops of my ass cheeks sent me over the edge.

My body buckled and that is the last I remember until I found myself lying on my back, Elizabeth's cunt above my lips which ate her as though she were the rarest, most delectable fruit, while at the same time her mouth tightened about my liberated cock.

We came together, our bodies convulsing, twitching, our mouths full enough with the other that the cries of joy were muffled. I held her plump ass and felt her cunny contract sharply around my tongue and I swallowed her juices hungrily. My cock shot from deep in my testicles,

more cum than I recall ever producing, as though it had been stored up for this moment.

The release was wonderful. I cried again, now tears of joy and relief. Elizabeth and I clung together and slept intertwined on the floor of the attic until the sun's rays poured through the window and the birds began to sing.

Chapter Thirty One

I wish I could say that my suspicions and resentments dissipated completely and that over the next three weeks all was well. All was far from well.

I found that despite Elizabeth's constant reassurances, I still resented Crea. In fact, one morning I dismantled her second cock, the one that seemed so eager to ejaculate. This was an act of sheer retribution on my part, and loosening the bolts and screws afforded me a great deal of pleasure.

Elizabeth, however, discovered what I had done and she was furious. She insisted I replace the object of desire immediately. "Victor, I see no sense in this. Please, replace Crea's member at once."

"I will not. As it is, I should have sent her back to M. Krempe already. If you had not talked me into allowing her to stay for the wedding—"

"Not stay, darling, participate. After all, she is my maid of honor."

"Stay, participate, what's the difference. You no longer need her services, so this phallus is no longer useful," I said, waving the organ above my head. "At least as far as you are concerned."

Elizabeth gave me a look that said I was being silly, if not naughty, and she followed it up with, "You are becoming wilful. Replace that pipe and then leave Crea alone this instant. Then I shall see you in the attic. Tonight. And you will receive a good strapping."

I was about to protest, ready to keep my side of the argument buoyed, and yet a session with Elizabeth was too enjoyable to pass up, so I said nothing, only nodded, and grudgingly replaced that insurgent

item which I had just unscrewed.

We had been meeting daily, mainly the two of us, but it seemed every other night Crea joined in. This was never to my liking, but Elizabeth demanded it. She seemed to thrill at having Crea whip me nearly senseless while Elizabeth sucked my cock dry. A whipping at the hand of my creation whom I now felt estranged from was difficult. Inwardly I rebelled at the very idea. And because of my apparent resistance, I suffered enormously. It took literally hours of the leather cane, or a leather strop speaking to my flesh before I heard my own softer voice of reason come through.

Crea whipped far harder than Elizabeth. And yet it was Elizabeth who knew my weaknesses and directed that inhuman hand so skilfully. My body during the day was sore from my punishments. My anus throbbed in pain from the hours of impalement by that enormous cock. And my balls ached as Elizabeth drained them over and over each night. It was a delicious agony that kept me sane. But the effects did not last long and by midday I was again tense and distrustful, doing or saying something that annoyed Elizabeth. This would last until we retired to the attic and that tension was thrashed from my hide.

I cannot say this was unpleasant. I did, however, feel as though I'd entered a cycle of pleasure and pain that made me nearly oblivious to all else.

Around me plans for the wedding were in full swing. I was fitted for a suit. Parties were held, gifts presented and unwrapped. Rehearsals attended. And through it all my body and soul were in turmoil. I longed for the day when our vows were taken and Elizabeth and I could be alone together so that I might do the thing that I feared had already been done—claim her maidenhead.

Of course, I questioned Elizabeth about her hymen. While she had me dangling from a type of sling strung from the attic beams, or lying across her knee, or impaled by Crea's monstrous cock, or when her mouth was full of my own cock as he emptied his love into her. When I plugged her bottom hole, or watched in despair as Crea took her rectum. When the three of us sucked and fondled and bit and fucked one another throughout the sweltering summer nights in the attic. And always she assured me that she was intact, waiting for me and me alone. Even my fingers in her cunny hole did not stay my doubts, for was I not

the master of creation? If I could create an intact hymen in Crea, could not Elizabeth have resown her own?

This dangerous line of thinking drove me nearly out of my mind, day after day, and the voices of paranoia only dimmed to a whisper when I'd been thrashed and fucked to within an inch of my life.

Finally the day arrived. The service was held outdoors, at the foot of the garden. The screens had been removed from the gazebo, and the wood and lattice freshly painted and adorned with fragrant pastel flowers.

Elizabeth and I stood in the gazebo with our clergyman between us, Crea and Henry on either side. The ceremony went smoothly. We exchanged our vows. Our kiss was longer and deeper and involved more tongue exchange than normally my mother would have permitted. Rice was thrown as three musicians played the familiar musical refrain.

A lavish reception was held that afternoon, and even before the sun set we were driving to the train station alone together for our honeymoon trip to the Alps.

Crea would be leaving in the morning, returning to Oxford and M. Krempe, who could not attend the wedding. It had been a tearful goodbye between Elizabeth and Crea, but finally I had managed to separate them. For the first time in almost a year I felt on solid ground with my beloved.

As we sat in our compartment, I stared across at my radiant bride. Her waif-like beauty overwhelmed me with desire. Tonight she would be mine, and mine alone.

"You are so lovely," I told her.

"Oh, Victor, you have made me so happy," she said.

"Not as happy as I intend to make you. Come, sit by me."

She came across the compartment and sat close.

"Tell me, darling," I said, "what is your fantasy? I want to please you and I shall endeavour to give you what you most desire."

She thought for a few moments. Suddenly her smile broadened and she kissed me on the lips. "My fantasy is to be impaled by both you and Crea at once!"

I felt my face darken as my lips turned down and the muscles in my cheeks tensed. This was not what I expected to hear. Still, I tried to be patient with her. She was a virgin in many ways. "Crea is gone. We are alone now. Is there something I alone can do for you?" I said this without

enthusiasm, though, since the joy had been taken out of the idea for me.

Elizabeth is a sensitive woman and noticed my distress immediately. "Victor, my husband, forgive me. I did not mean to supplant you at all. I thought we were speaking in general and not about this specific night."

"Well, this is our wedding night," I said rather testily. "I should expect you might have given it some thought."

"Victor, don't be cross with me." She ran her hand up the inside of my thigh. "I wish more than anything for the piercing that is my right as a woman and as your wife. Something permanent. This is what I wish from you, to feel the torment and delight of being completely possessed." All the while she spoke her hand worked magic on my cock through the fabric of my trousers, and my mood lifted. I pulled her to me and covered her lips with mine. My tongue slid into her warm mouth, tasting her in a manner that told her she belonged to me. Her body relaxed and I felt Elizabeth giving herself over. Would that I could have impaled her then and there!

We rode through the mountains at twilight. Elsewhere it was summer, but here it was always winter. All the better, for we could cosy up by the fire tonight. And I had a special surprise for my bride that no doubt would please her.

We arrived after dark in a village at the foot of Montanvent. It was a peaceful, quiet place, small, unpretentious, a population of no more than two dozen, as far as I could tell.

The villagers who were still up seemed taciturn and distrustful, as are many peoples who live so far from reasonably populated, civilized areas. The man who met us, a short, braided whip dangling from his belt, wore a fur vest and boots, and a peculiar high skin cap. He spoke French, as the Swiss do, although this man had an economy of words I admired. He showed us to our alpine hut, then departed quickly.

Now, finally, I had Elizabeth and her prized maidenhead to myself. While she waited on the sofa, I built a fire, stocking it with dry cedar logs that caught quickly and blazed high. When I had the flames high enough, I brought out a valise I had carried from home, and began unpacking the contents and lining them up along the grey stones before the hearth.

Elizabeth watched in silence. When I'd finished my task, we

uncorked a bottle of champagne and I poured some into flutes. We sipped the wine slowly as we cuddled together before the hearth. Eventually I said to her, "Undress, and lie on the rug." This she did, her face and cheeks ruddy from warmth and the excitement, her eyes brimming with love, her nipples bright red candies, inviting, her ass plump and white, for it had been spared these last weeks in anticipation of this night.

I used a fragrant oil to massage her body, beginning with the shoulders and working down her slender back in broad strokes to her tiny waist. Beyond lay those pristine globes that belonged to me alone. I used the linseed oil liberally to coat them and worked the lubricant in from the bottom of her ass cheeks up, paying special attention to her crack. This caused her to moan, and her cunny, as I lifted those cheeks, emitted the most divine perfume.

Once I'd squeezed and pinched those cheeks until they were pink and eager to please, I worked on the backs of her legs and feet. Finally I turned her over and massaged up from her toes. It was her Venus Mons that I spent the most time with, rubbing, kissing, licking, nibbling, until she writhed beneath me and a lovely pink blush had been sprinkled across her chest and tummy. I moved up to her breasts and spent another long time loving them. Her nipples and aureoles proved amazingly responsive; my mouth did not want to leave them. While my teeth bit and my lips sucked one tittie, my fingers pulled the other up high, twisting, pinching, rubbing, again making her squirm and moan uncontrollably beneath me.

My cock raged. It took much argument on my part to persuade him to wait. He wanted to break her at once, but I convinced him that Elizabeth could reach great heights yet and it was our responsibility to see that she did so on this night which would be remembered always.

I turned her again onto her belly. She moved her head so she could watch me, and her long hair cascaded around her face and down her back like spun gold.

A full-length oval mirror on a stand stood by the door. This I brought to the hearth where Elizabeth waited and set it before her, adjusting the frame that held the glass so that she had a proper view of her gorgeous naked body.

One of the items I'd brought from home had been a special gift,

made for Elizabeth, for this night. It lay on the grey stones and I picked it up. Elizabeth watched me in the mirror. I'd had the four foot white wedding whip made-to-order in England by a well-known leather-smith, employing fine imported Spanish cowhide. This, being a special-ized tool, required much practice on my part. I know my darling had not experienced a bull whip of any size before, or at least she had not told me so. This shorter-than-normal item would be a new and won-drous experience for her, an experience I intended to make perfect.

I poured a solution into a large bowl and dipped in the white whip, tail to handle, until it was properly coated. Her eyes grew large and round and yet were fully trusting as I snapped the end of the whip into the crackling fire. Flames shot along the whip shaft. I now held a whip of fire.

I looked into the mirror and saw Elizabeth watching me in the glass. Her mouth had dropped open and her eyes were very wide. I took up a position close to her and raised the whip above my head. With a loud crack, I snapped it across her waiting ass.

She gasped loudly and her hips jerked into the air. The tapered leather strand left a serious red line. Of course, she was not burnt. The fire was mere theatrics. The "oil" I'd used on her body had been dilut-ed with a fire retardant, while the tail of the whip had been coated in alcohol. The most the flame would produce was a pleasant tingling on her skin. The whiptail itself, though, was another matter.

As the alcohol dried quickly, I was forced to redip the whip shaft fre-quently and relight it.

I snapped the virgin cowhide against her ass again. She gasped loud-ly, and another red line appeared. The lines were just short of cutting the flesh. Blood welled beneath the skin's surface. I did not wish to slice her open, merely to come as close as possible. The effects would last several weeks, which I knew Elizabeth would appreciate, for I'd discovered she liked to show off her marks as if they were precious jewels.

I needed to work fast, though, as the fire along the whip was con-stantly burning itself out. And I wanted to heat her quickly and pierce her when her own fire was at its zenith.

I lay the whip on, lashing her ass raw, using just enough amount of pressure to raise the desired welts. She bucked and rode up to meet the leather, watching in the mirror. Her bottom soon became striped with

short crimson lines, so many that they melted together. I whipped carefully to make that happen, without overlapping, which would have opened the skin. Her scent rode the warm air and her cries of "Victor, whip me, mark me, fuck me!" filled my ears.

Finally I could restrain myself no longer. I dropped the whip onto the stones before the fireplace and positioned myself behind her. Automatically she raised herself to her knees, head down in a submissive posture that was like a kiss to my cock. Her red welted ass rose high in the air, trembling, offering its well-guarded treasure chest to the one who would master the lock. I moved against those steaming cheeks and my cockhead went to her opening like a magnet drawn to iron.

Her bottom quivered and she pleaded, "Victor, rend me!" I felt her pussy pulsing against my cockhead, and slick him with juices in preparation for his journey into this unknown region.

"That is exactly what I intend to do, my love," I assured her, feeling well prepared for my trip.

My cock moved inside and she moaned. I felt the hot thick pussy juices moistening my head, and those plump nether lips puckering around me. My cock soon knocked against her locked gate for admittance into this most sacred of places.

"Master! Fuck me!" Her words made him automatically rear back like a snake ready to strike.

Suddenly there was another knock, this one on the door to the chalet. It was loud and insistent and would not be ignored. And then, without warning, the door was flung open. In an instant, my cock shrank.

Chapter Thirty Two

"Oh my God, Crea!" Elizabeth screamed in delight. She jumped up and ran to her. The two embraced.

The blood that left my cock so rapidly rose to my head in fury. "Why are you not awaiting the train to England!" I demanded.

A sly smile crept across Crea's face, but she said in the most innocent voice, "Master Frankenstein, a letter arrived this morning, and in all the general excitement of the day, we did not open it until you two had left."

She reached into her purse and pulled out a tan envelope. It was addressed to her, with M. Krempe's return address in the corner. Suspiciously I opened it and perused the sheaves of paper within, Elizabeth reading over my shoulder. She read faster than me and exclaimed at one point, "Oh, Crea! This is wonderful."

The letter was a congratulations to Elizabeth and I on our marriage, to be relayed through Crea, as well as the wedding gift: Crea herself.

I sat heavily on the sofa. M. Krempe, in the goodness of his heart, had imagined this gift to be something, he said, "You both will find practical, and one which will afford many years of pleasure."

Elizabeth danced around Crea, helping her remove her wool hat and long fur-collared coat, and getting her out of her other clothing as well. Finally we three were naked, sitting by the fire, the two of them excitedly chattering away as if I didn't exist. As if this were not my wedding night.

I, in a morose state, drank right from the opened bottle of cham-

pagne and had consumed most of the bubbly contents before Elizabeth noticed.

"Victor, darling, isn't this wonderful! Now I shall have my nuptial wish."

I sighed, for I recalled instantly what she wanted. "Alright, then," I said, struggling to be congenial, "how shall we approach this."

"Well...," she began. Then, "I've got it! We shall both be pierced by Crea's magic organs, but my cunny will admit you, Victor, and you alone."

Mere crumbs, I thought, but said, "As you wish, my love," for after all, I did want to please Elizabeth.

Crea lay on the soft mattress of the four poster—the floor would be too hard for the arrangement required. We bunched pillows beneath her ass, which resulted in her erections jutting up high. I climbed onto her until I straddled her crotch. The large cock was higher still because of the pillows, and I impaled myself from a kneeling position for convenience. Normally I'd been entered by Crea while I was lying or bending forward. This was the first time that giant phallus went straight up into my ass. I felt it's girth expanding my rectum, shoving the rectal walls out of the way to make room for itself. Finally, though, that enormous instrument filled me to the point where I was quite silent.

"My turn," Elizabeth said happily. My cock was now positioned between both of Crea's. Elizabeth knelt over the two available penises. Crea positioned her foremost member, the one that was similar in size to my own, while I positioned my fellow—Crea took Elizabeth's back door, and I the front.

Elizabeth was exited, which cheered me. Her blue eyes were round with delight, and her cheeks flushed. Indeed, I wanted this to be wonderful for her. I kissed her full, wet lips soundly, and for several minutes, using my tongue in ways that let her know to whom she belonged.

Crea had brought to the bed from my bag of tricks the glove Miss Heidi had presented me with. While Elizabeth and I kissed, Crea slipped on the glove and ran its rough palm over Elizabeth's wounded ass.

My girl gasped and moaned and trembled with desire. Her nipples hardened as I pinched them. Her cunny juices flowed freely, and even from the inch I had entered into her I felt her muscles tensing and pulsing. No doubt Crea must be experiencing the same as the tip of her

penis pierced Elizabeth's hospitable anus.

We continued this way for a long time. Elizabeth's moans and cries became constant. She begged and pleaded to be entered.

I held her firmly at the waist so that she could not impale herself, which she attempted to do several times to relieve her itch. This was delicious torture to her. "I cannot stand it, Victor! I beg you, take me!" But I would not. In reply, I bit her nipple and her head fell back. Her lips released a deep moan and her cunny hole released more liquid and tightened. Her juices ran down the insides of her trembling thighs and coated my shaft and dripped into the hairs at the base of my cock.

My cock. He turned out to be a decent fellow after all. A year ago he would have given himself over to self-indulgence. But he had won a long and hard battle and finally learned restraint. Despite the monster phallus imbedded within my ass, despite the hot cunt so open and willing to be ravished, despite the writhing and moaning and pleading from my beloved to deflower her, he did not act. Restraint such as his must be rewarded eventually.

I gripped Elizabeth's waist tighter. Her head lay back, exposing her long, slim throat. Her eyes were closed. Tiny sounds of surrender issued from her 'o'-shaped mouth. "Look in my eyes!" I demanded.

She lifted her head. Her eyelids parted only a little and dreamy blue orbs gazed into mine with love. "Victor!" she whispered. "I want you so."

I slammed her down onto my shaft. Her pupils dilated and contracted. A look of complete surprise had been caught on her face.

The tearing had been quick and complete. My fellow had done a good day's work and now released all the tension he had accumulated. While he shot his hot cum into her, her moist walls squeezed him, contracting hard around him in rippling waves of pleasure.

Elizabeth screamed in ecstasy. Crea groaning. My cock throbbing out his gift. My anus contracted around that giant planted deep in me and I was astonished to realize that cock was shooting jism inside me. In that moment I knew the other was doing the same inside Elizabeth's rectum.

Afterward, we three lay in a heap on the blood-stained, sweat-soaked sheet. The air was thick with the scents of perspiration and sex. The fire crackled, but the flames were lower. Elizabeth dozed in the crook of my arm, one of her hands gripping my cock, her other buried in Crea's cunt. Her titties looked plump and ripe and well sucked, and I leaned

down to take one between my lips. Crea was awake, watching me.

"You ejaculated," I said simply, lying back. "When you have been commanded to refrain."

"Yes, Master Frankenstein," she said. There was a churlish quality to her voice that put me on guard. "We suppose we should be punished," she said. "We have brought along a tool of chastisement you may wish to use to discipline us. Consider this implement our wedding present to you and Mistress Elizabeth."

"Perhaps," I said, and closed my eyes. Punishing Crea would be enjoyable, no doubt. A long and agonizing whipping all the better. But my vengeful feelings toward her were laced with fear. If she had disobeyed the orders of her three Masters, then what did this mean? Was she now thinking for herself? Making her own decisions? Decisions which could override direct commands? And now that she, Elizabeth and myself seemed linked inextricably, what would this mean to my relationship with my wife?

These thoughts and worries tormented me the night. When I awoke it was the middle of the next afternoon and I was alone in the chalet.

Chapter Thirty Three

The door opened as I finished washing myself. Elizabeth entered first, with Crea on her heels.

"I've been shopping, darling," Elizabeth cried. Her cheeks were flushed from the cold, her eyes sparkling with life and enthusiasm. She'd bought a green cape with a rabbit-lined hood, like Crea's, that framed her pretty face.

She removed her hands from the matching fur muff that had warmed them and handed me a small, prettily-tied package.

"What? Another gift? Surely we must own everything there is to own already."

She slipped off her boots and undressed as she came to the sofa before the fireplace where I was now sitting; she wore only a new red corset, which I found fetching. "Open it, Victor." She turned and motioned for Crea to join us. Her ripe nipples spilled over the top of the corset as she twisted and I found this even more alluring.

Crea sat at Elizabeth's feet and while I examined the tiny parcel, my wife unbuttoned Crea's blouse and untied her skirt. I waited until they were through before unwrapping the gift.

Once they were both paying attention, I pulled the ribbon off the gold box and lifted the lid. Within were four gold rings, each three quarters of an inch in diameter.

"We have wedding rings," I said a bit tightly.

"Oh Victor," Elizabeth laughed, kissing my cheek. "You are such a silly. They are not for the fingers."

"What then?"

"Well, I shall show you."

From a shopping bag she carried with her, she removed a few items, some of which I recognized. When I saw the needle, her intention was clear to me: she intended to pierce someone.

"I think we should draw straws," she giggled.

"Perhaps, Mistress," Crea said, "a test of skill. The one who is superior shall be the winner."

Crea stood and picked up the wedding whip I'd used on Elizabeth's bottom last night. She plucked several sprigs of mistletoe from the vase on the table and removed the leaves, then snapped the stems so each was but a single stem with three white berries at the end.

"Oh Crea!" Elizabeth said, catching on immediately, but I was still in the dark.

"What is your plan?" I asked.

"Master Victor," Crea said deferentially, for she knew she still had a good hiding coming from me. "We propose this. We shall see who is most skilled with the whip. Whoever can snap the berries off without cutting the flesh wins. We shall be the first vase, as an example."

Still, I was confused. Crea got down on her hands and knees and offered her bottom to Elizabeth, who inserted the stem of the mistletoe into her rectum, leaving only a breath between the berries and her bottom.

"I shall go first, if you don't mind," Elizabeth said.

"Be my guest," I told her.

Elizabeth took up a position a few feet away. She raised the white whip and brought it down with a flick of the wrist. The whip cut the stem and the three berries dropped to the floor one at a time in quick succession.

"Bravo!" Crea shouted.

"Well done, my dear!" I said enthusiastically, warming to this game.

Elizabeth inserted a second stem into Crea's anus. Now it was my turn. I knew I could cut the stem easily. My long practise on Elizabeth's behind had honed my skills in whip arts. Still, this competition would prove nothing in the long run, and I longed to use the opportunity to express myself.

I took the position and raised the bullwhip. I brought it down with the full force my arm could muster. A crack cut through the room. The

sharp tip of the whip sliced deep into Crea's ass. A cry spewed from her. The thin red line across her bottom quickly opened and blood flowed.

"Victor!" Elizabeth shouted.

"Forgive me, darling," I said. "Last night was so full, and the wine as pleasing as the woman before me, well, my hand slipped."

She accepted this, and attended to Crea's wounds.

Elizabeth was next. Her bottom could not take another whipping, and I was careful, as was Crea, to keep the sharp leather tip of the wedding whip from striking her. In fact, we were both so careful, neither of us cut the berries off.

"Oh, you two!" Elizabeth cried in mock chastisement. "You shall both need to work on your technique."

I was last. I took the position and Crea jammed the flower's stem into my bottom hole a bit harshly, I thought. The thin hard stem felt foreign, and stimulating in a way that a thicker object would not. Frankly, my anal opening began to itch unbearably. I felt rather exposed and found myself thrusting out my ass in an exhibitionist manner, perhaps as an overcompensation.

Elizabeth was first up. She snapped the berries off readily enough. The whip whizzed by my behind and just brushed the skin. I felt a peculiar braised sensation.

"Oh, damn!" she said. I'd never before heard a curse on her lips. "Well, that's one mark against me. And I was in the lead! Your turn, Crea."

I braced myself, knowing that what occurred now would determine what was to come in the future between us. For if Crea cut the berries only, or missed completely, I still held the reins. But if she carved my flesh as I had sliced into hers, between us there would be war.

I waited, willing my bottom to be still. My cock, bless him, stood erect, prepared for whatever would come. Crea took her time, increasing my tension. Finally I looked over my shoulder. Apparently she had simply been waiting for just this moment. Her mis-matched eyes caught mine and that twisted smile crept over her full lips. She raised the weapon.

I heard the sound first. The air parted as the whip divided it. The second the leather made contact, my cheeks jolted. My cock shot his wad. For a blessed moment, my ass numbed. Then, suddenly, pain flared, not

simply a line of it, but pain that streaked and spread all through my bottom, setting it afire.

The agony was so intense I was not certain I could bear it. Through will alone, only one long, low sob escaped my lips, but tears blinded me, and my body quaked.

Around me I heard Elizabeth castigating Crea in the same manner she had me, then felt her pressing a cooling wet cloth to my open wound. This would scar. Forever I would bear the mark of my creation turning on her creator and mastering him.

When I recovered sufficiently to again be aware that there were others in the room, we three sat on pillows on the floor—for all three bottoms were inflamed—staring at one another, more like glaring between Crea and myself. Elizabeth's supplies between us. Slowly she explained the procedure.

"As I've won," she said gaily, "I shall go first. Victor, I choose you to pierce me."

"I would be honored," I said.

She handed over the supplies. I bathed her left, the designated nipple—"It's closest to the heart," she said—with alcohol, which acted as both an astringent and a mild disinfectant. The areola puffed around the tit like a round pink pillow, swollen from a night of being suckled. The tit itself sat red and perky, as if it had a will of its own and sought attention. I could not resist tweaking it.

I heated the large needle in the fire's flame until it was red hot, then allowed it to cool a bit by dipping it in the alcohol. The fire burnt off impurities and inhibited infection. Another swab of that saucy tit with alcohol and I was ready to go.

"Hold her," I instructed Crea, who moved behind Elizabeth.

She lifted my darling up and impaled her on both cocks, one in the anus, one in the vagina, then she secured Elizabeth's arms behind her back, and wrapped her legs around hers so that my most cherished one was nearly immobile.

I held Elizabeth's breast, pressing it back into her chest to keep it from jiggling. The nipple lay completely exposed and vulnerable. Her face filled with fearful longing. "Pierce me, Victor," she whispered. "Let me feel you claim ownership."

I wasted no more time.

I pushed the needle from left to right slowly through her tit. Her body began to tremble. She panted and her lips parted to enable her to sob. A delicious aroma filled my nostrils. As I slid the sharp metal through, tears rolled down her cheeks, but her face lit with the most beatific smile. As the tip exited on the right side of the nipple, it brought a drop of blood with it. I bent my head and licked it off with my tongue. The side of my tongue brushed the side of that trembling nipple, offering it comfort for the pain it had so willingly subjected itself to at my hands.

I bathed the nipple again with alcohol. This time, because of the open wound. The clear liquid stung. Only Crea's strength held Elizabeth to the floor. My darling sucked air in between her clenched teeth, and tears flowed freely from her eyes. But when she gazed at me, I saw only love.

My hand reached down to her soft pussy and was instantly rewarded with a wash of fluids. Because of Crea's front cock, I had no access to Elizabeth's cunt. Still, I rubbed and pinched her clitty, making her hips writhe and buckle, with the restraints of Crea's firm embrace. In seconds Elizabeth came, joyously, orgasmically.

While she floated back down to earth, her energy temporarily spent, I removed the needle by pulling it all the way through her tit. The wound bled and I applied more alcohol, causing another round of cries and jerking.

Finally I picked up one of the small gold rings and opened it. The hoop had a slender inner hoop, which I slid into the newly formed hole in Elizabeth's nipple. Once I'd secured the gold ring to itself, it hung from that bright red tit as though it wished to show itself to the world.

Elizabeth sighed and stared down at her new adornment.

"Oh, Victor," she cried. "You are so good to me."

I lifted her off Crea's cocks and plunged her onto my own, which had waited more than patiently. I took her quickly and roughly, lying her back against the floor, thrusting the full length of my shaft into her again and again until I was satisfied. She gazed up at me, her eyes dreamy. "You are so masterful," she sighed.

It was time for another piercing. I held Crea while Elizabeth repeated what I had done to her. There were differences, of course. Crea's nipple did not bleed, and, perhaps from so many needles sewing her flesh

together, she did not react to the pain as violently as Elizabeth had. I had staked her rectum with my cock, holding her from behind, although there was little need. While the metal pin rested in her left tit, opening the wound wider, Elizabeth used her mouth on those two cocks.

I could see her dilemma at once: which one to begin with, and how to appease both. She began with the one closest to Crea's stomach, figuring, no doubt, that the one in front would receive some stimulation at the same time. She used her hand on the second one as she ran her lips up and down the larger.

Crea's capacity to orgasm outlasted both Elizabeth's and mine. My poor darling sucked and licked and even nibbled for an hour before that giant cock gave up its contents. In fact, both cocks shot at once. I felt Crea's rectum spasm simultaneously and made a note: again, another area forbidden to climax had reached that state, against all orders. I wondered if her vagina had orgasmed as well, and decided to find out.

Before Elizabeth could stop me, I pushed Crea onto her hands and knees and entered her cunt from behind. It was slippery and warm, hugging me at once. I thrust into her fiercely, as I had with Elizabeth, and soon those rough folds grabbed my shaft. I stroked them hard until they gave way to my superior intent. Her contractions were strong, the orgasm powerful. I let fly into her and she kept spasming until my poor cock was deflated and shoved out of her hole.

Well, this was strange indeed. I made a mental note to write to M. Krempe that day and let him know how things had developed. Crea held no inhibitions at all now.

Elizabeth removed the pin and slid the gold hoop through Crea's tit, where it dangled in imitation of Elizabeth's.

There was one final piercing to be accomplished, and I dreaded it. My own capacity for pain was not great, at least with respect to what Elizabeth and Crea could endure.

It was Elizabeth who moved behind me. Panic welled within me. "My love, I would prefer if it was your hand that pierced me."

"But, Victor, then Crea would be left out. I shall be here," she patted my penis. "Don't worry. It will be over soon, and then you shall have a wonderful piece of jewelry all your own."

I struggled to keep my muscles from trembling, but was not very successful. Elizabeth held my arms behind me, but I knew that would do

little. "You'd best tie me up," I told her.

She used a rough hemp to bind me to a leg of one of the heavy oak posts in the room, wrapping the rope around me several times until I was quite secure.

Crea swabbed my left nipple, and the delight on her face at the prospect of inflicting more pain on me was humiliating. I felt ashamed before her, unable to keep the fear out of my eyes, and the quivering from my lips. My cock quivered as badly, the skin stretched taut, the blue veins pressing hard against the skin, the head red in fear and anticipation.

I watched Crea heat the needle to a white heat. Elizabeth, the darling, sucked my cock and fondled my balls, but I was hardly distracted.

Crea only permitted the needle to cool to a yellowish red.

Even the tip of it touching my terrified nipple sent me into spasm and I screamed uncontrollably.

I felt utterly ashamed. I did not mind Elizabeth seeing my weakness, but I loathed the fact that Crea gloated in my failings.

She slid the needle in unnecessarily slowly, it seemed to me. I could not contain myself. I screamed and cried like a baby. My muscles spasmed from the tension. My cock shot into Elizabeth mouth, and she swallowed my juices eagerly. No sooner had she licked the overflow from my member, than he was firm again.

When the needle was finally through my nipple, I lay back with my head against the post sobbing. My body was covered with sweat and shook uncontrollably. The tit itself felt swollen to five times its size. The needle burned mercilessly, and the new opening throbbed in pain. I could do nothing but suffer this, my only relief my darling's lips comforting my cock.

I felt the ropes untied and my body lifted onto that Amazon cock. It plundered my rectum, piercing it slowly and unforgivingly, as had the needle with my tit. All the while Elizabeth's remarkable mouth worked over my shaft—the fact that I had just orgasmed four times into her mouth did not impress her, it seemed.

Crea forced me forward, onto my hands and knees, into the most submissive position. She pushed my forehead to the floor, the delicious position Elizabeth had assumed before we were interrupted the night before. Elizabeth crawled under my stomach so that she could continue

sucking my cock and fondling my aching balls. And that amazing cock nearly ruptured me.

They fucked and sucked me until I forgot about the needle mutilating my tit and could only feel my ass primed and my cock pumped over and over. I lived in that area of my body, riding the surf they provided, until the sea became a tidal wave that washed over me and I sank beneath the heavy waters.

When finally I washed to the surface, I was still impaled mightily, but my mind was freer.

Finally Crea eased her cock out of me and Elizabeth's mouth released me. I lay on my back while they removed the pin and bathed my nipple with the impossibly stinging alcohol. Then Crea inserted the third gold ring. It lay cool against my breast, although the nipple was too sore to feel more than a burning heat.

"There is one ring left," I gasped in pain, one of those nonsense observations that comes at inappropriate moments when the mind is fatigued.

"Darling," Elizabeth said, "they sell them in pairs."

We three slept before the fire, the warm glow flickering off our gold ornaments, the crackle of the resin in the logs lulling.

As I drifted off to sleep, my eyes opened briefly and I saw Crea watching me. "Master Victor, you have promised us a sound thrashing. When may we expect our just desserts?"

"Your punishment has been cancelled. Your flesh is saved from my wrath. I shall punish you no more."

Chapter Thirty Four

I awoke to sobbing. Elizabeth perched on the bed alone, a frail bird. Crea was not in the chalet.

I roused myself and wrapped my arms about her from behind. "What is it, dearest?"

She lifted her tear-stained face to me. Never have I seen such a forlorn look on a human being. Her blue eyes spoke of fathomless seas, and drowning therein. "Oh, Victor!" she cried, and threw her arms around my neck. "I am wretched!"

I held her close, her body warm, in need of comfort and caresses, while she sobbed her heart out. Eventually I took hold of her shoulders and turned her a little. "What's all this, now? You behave as if your love has deserted you, and yet am I not here? What could be the source of such tragedy?"

"Love has deserted me," she cried, "or at least one of them. Here!"

She thrust a letter at me that she'd been clutching. I smoothed out the grey stationery. It was a note from Crea. The gist of her missive was that she could no longer bear my animosity. She was leaving. "Forever!" she declared. She would miss both of us. Unbearably. She expected her life would be filled with pain and loneliness but that would be her cross to bear, for she could no longer tolerate my rejection. We were not to look for her.

I admit it, I was overjoyed. At last we were rid of Crea, the inhuman monstrosity. And while it was true that Elizabeth was inconsolable at the moment, she would change her tune once she'd adapted to the situa-

tion. I knew I could more than satisfy my wife's passions without rely-ing on artificial means. In time she would get over Crea who was, after all, a created being.

But that day Elizabeth took to her bed, and refused to leave it. Whenever I approached her, she rebuffed me. I tried simple and com-forting caresses, I also offered her a paddling, which, much to my amazement, she refused. That alerted me at once to the fact that she was genuinely grieving for Crea, and the situation was serious.

Days and nights passed with no improvement. I tried to be support-ive of her, but had to admit to myself that my heart was not in my efforts. Good riddance, I thought, when thinking about Crea. If only Elizabeth would forget my creation, life would be good. We were young, and in love. Everything lay ahead of us.

We had been at the chalet one week. Crea had not returned. Elizabeth was not improving. She had roused herself on several occasion, but only to search everywhere in the village for Crea, interrogating all the locals, trying to find Crea's tracks in the snow, even. A moratorium had been placed on all our loveplay. I felt more than frustrated. And when Elizabeth garnered some enthusiasm and made her suggestion, I admit, out of sheer frustration, I reacted badly.

"Victor, I have a plan. I propose we search for Crea. The only home she knows is the one where she was born, in England, and I suspect she has returned there, to your professor's house, no doubt."

"Then let her, Elizabeth, if that is where she wishes to be."

"She does not wish to be there. She is simply hurt, prickled by your rejection."

"Oh, Elizabeth, can't you see this for what it is? Only a game. She is trying to drive a wedge between us."

"That's ridiculous. Why should she do that? No, Victor, it's far sim-pler and less conspiratorial than you make it out to be. You have treated her badly and she, as any would, has reacted by feeling wounded."

"She is incapable of true feelings."

"That's a lie!"

My frustration soared. "Elizabeth, Crea is not a human being. You seem to forget that I created her from spare parts and metal plates. I had not told you this, but those parts were from three separate bodies, all of them belonging to criminals who had committed acts that led them to

the gallows. If, indeed, she has feelings, an idea I cannot seriously entertain, they would be of an evil and manipulative nature."

"Whatever she did in her past lives does not apply to what she has been to me. She is a decent creature, loving, eager to give and receive. Eager to please."

"Nonsense! She has been programmed to function on a variety of levels. If she did not please you, I would have failed utterly. As it is, in the end she exhibited a propensity toward disobeying my orders, and where did that leave us?"

"If there is a failure, it is within you, for you have not realized what you have created, a being of intellect and passion."

"What I have created is a conniving monster."

"Victor! I cannot believe I am hearing this."

"Then I suggest you take some time to mull over my words, for these are my true feelings."

"If she is conniving, it is only because she was created in the image of her maker."

"Now you've gone too far. We can settle this argument with a paddling." I was hoping to provoke her, then cajole her out of her mood, and the mood she was pulling me towards.

"No! This is not a matter of clashing wills, but one of honor. Yours. If you have any left, you will come with me to Oxford to retrieve Crea."

"Then I have no honor left, for I shall not hunt for her, nor shall I permit you to either."

Her face became steely. She rose from the bed to which she had taken and dressed at once.

"And where do you think you're going?" I asked, seeing her putting on her boots and cape.

"As I said, I am off to bring Crea home. You may try to stop me, Victor, and you might succeed. But if you do, you shall never again feel your backside warmed by my hand, and I shall never again submit my bottom to you willingly."

This made me furious, so much so that I acted inappropriately. "Fine. Go off and search for Crea. But remember, Elizabeth: Crea is not human, despite what you wish to believe. I liken her reactions more to that of a machine which has malfunctioned."

She pulled the hood of her cape up and stuffed her tiny hands into

the fur muff. She was out the door before I realized it.

I am a stubborn man and it took me a day to come to my senses and go after my wife. The man in the village who had first greeted us informed me that she'd caught the train headed for England the day before, which meant there was a full twenty-four hours between us.

As I sat in the first class compartment, my emotions vied for attention with my intellect. Frustrated though I was, still, I admired Elizabeth's loyalty—it was one of the virtues I'd sensed in her from the start. It tempered my fury and brought me to understand that she was acting out of love and devotion, qualities directed as much toward me as toward Crea.

Chapter Thirty Five

Robert Walton had listened to Victor Frankenstein's story over the course of many days. During this time, the man he generously shared his cabin with had gained strength. He now looked normal enough. His energy had increased as well. Billie did double duty each night, which helped.

Walton had come to admire and care about this mad scientist, whose wish to please his beloved had led to such a disastrous situation.

Robert entered the cabin one morning to find his cabin 'boy' having her bottom painted by a short cat, the hand of Frankenstein guiding it. Walton envied the work. Indeed, this man was a master with a whip. Weren't these stripes evenly spaced? Not one of the nine tails overlapped another. "Quite a feat," he admitted.

Billie writhed and bucked beneath the lash, thrusting her worn rump higher while her lips uttered the words, "Another, sir, if you please."

The lashing lasted a further half hour, at which point Frankenstein mounted her from behind. Robert found himself unbuttoning his own pants and spontaneously stepping up behind the doctor, whose anus looked so welcoming. Frankenstein turned his head briefly, a look of surprise on his face, but that shifted quickly to a nod of encouragement, and Robert plugged him.

The two men moved in a rhythm, cock to ass, cock to ass, while Billie masturbated herself to the sounds of flesh slapping flesh. They came together, all three, groaning and moaning until they sounded like waves crashing against the hull.

Once they had separated and Billie pulled her drawers up over that ruby bottom and scurried above deck, Robert made his announcement. "It seems, Victor, that we have escaped the ice jam. The boat this morning is free, and we likewise are free to sail."

"And your direction?"

"Before I make that clear, I'd like to hear the rest of your tale."

Frankenstein sat nude by the pot-belly stove, the fine gold nipple ring glittering in the light from the oil lamp.

Walton was eager to hear the remaining story, of what had led the doctor so far north.

"The remainder of my saga is short. I reached Oxford quickly. M. Krempe informed me that both Crea, and then Elizabeth had been there, the first just before the second, and Elizabeth just before me. Crea, he claimed, was bitter and angry, and held thoughts of vengeance in her heart.

"'Did you tell this to Elizabeth?' I asked him.

"'Of course, although she accused me of misinterpreting. Your wife stayed the afternoon, long enough to taste the clock in the basement, and then she was off.'

"'Which direction?' I pleaded.

"'North. It seems the man and woman who were the main source for Crea's components were from the north coast of Scotland. I believe Crea is drawn there organically.'

"Of course, I left at once. I traveled by train, then by cart, following leads along the way, for a being of Crea's size could not go unnoticed for long.

"She had been spotted as she'd traveled, and as well, there were reports of Elizabeth, just ahead of me, searching for her. "Finally I reached the tip of Scotland, only to discover that they had each taken passage on separate boats headed towards the Shetland Islands. There was nothing to do but purchase passage myself. And when the seas froze and the ships refused to travel further, I was forced onto a dogsled. Two days travel, and, had I not been found by you, I should surely have perished."

Frankenstein bowed his head, and Robert felt sorry for the man. He knew it was likely the man had lost both his wife and his creature to the ice floes... It was too tragic.

Frankenstein looked up suddenly. "And again I ask you, what is your destination, captain?"

Robert had been considering this for many days, as the weather cleared and warmed, in anticipation of just such circumstances developing.

"My crew, naturally, wish me to return to the mainland. That is a sane proposal. And yet your story intrigues me. More than intrigues, for I feel compelled to see a resolution to your situation, even if nature herself has exacted the ultimate solution."

"If you are suggesting that they are both dead, this I do not believe."

"The chances of survival in this climate are slim. Still, from what you've told me, the ingenuity which both Elizabeth and Crea possess would indicate that they have a better than average chance."

Robert paused. The man before him was handsome, his muscles enticing, seeming to invite the hand of another, despite the fact that he was still recovering and obviously under stress. A handsome face such as his should not be subjected to such worries, and Robert had a desire to see that face in a more relaxed atmosphere. "You are a genius," he assured Frankenstein. "You have done what none before you have."

Victor brushed that aside. "More like a fool who has believed himself greater than he is. I see now the error of my ways on all counts. But for another chance..."

"I think I can give you that chance. At least let me try. The way north will not be easy. The ship will move at a snail's pace. And yet, if they are to be found, I am determined that we shall find them. For I am fascinated with your tale and wish to see this monster for myself."

Frankenstein jumped to his feet and embraced Robert. "You are a true friend," he said, gazing into the other's eyes. "I am grateful. Very grateful."

With this, his hands became busy fondling Robert's crotch, bringing his cock up and making sure his balls tightened with developing tension. His hands knew where to stroke, and how, a sensation new to Robert, for he had never been under the hand of another of his gender. Slowly Frankenstein eased to his knees and took that cock in his mouth.

Robert felt hard male lips ride him in a knowing way. Hands stroked beneath his balls, that strip between the anus and the sacks, and it drove him mad with lust. He grabbed Frankenstein's head, a hand on each

side, and thrust into the hungry mouth so eager to show gratitude, and felt a broad tongue licking the underside of his phallus.

While this was happening, Frankenstein had reached into his bag. Robert watched him remove the leather glove with the grommets imbedded into the palm, the glove of Miss Heidi.

Thoughts of what had been told him about that woman made his cock even harder, and his balls strain for release. He fought to control his ejaculation in order to prolong the pleasure.

The gloved hand rubbed his ass cheeks, cheeks which had never felt a strap or paddle. How much more delicious if the skin was sore. And yet the glove felt divine, and Robert tensed his bottom and released as he thrust deep.

When he came, it was slowly, the ejaculation lingering. The lips and tongue cleaned his juices while the glove still danced over his bottom.

He gazed down at Frankenstein, who, although he was on his knees, looked less like a submissive and more like a master.

"We sail for the Shetlands at once!" Robert cried.

He was pleased to see Frankenstein smile.

Chapter Thirty Six

Robert and Victor stood at the rail together in the freezing cold. Wind bit their cheeks and Robert pulled his collar up and tied the scarf tightly around his neck, covering his lower face.

They had traveled for less than forty-eight hours when the weather turned bad again. The ship was boxed in by larger floes now, much to the consternation of the crew. Just this morning Robert had had to quell another attempted mutiny. When enough backs had been heated, tempers had cooled.

Yet all was far from lost. For ahead were two ships, also stuck in the ice. Billie had spotted them and informed her captain; he had patted her bottom briefly and said, "I shall reward you properly later." At that, she grinned that toothless smile from ear to ear.

"The Manatee!" Victor shouted, pointing to the dark lettering on the side of the closest vessel. "That's the ship Elizabeth has taken, or so they told me in Lochinver. And the one further on, it must be the Anemone."

Robert held his brass spy glass to his eye. Sure enough, the furthest ship was the other one they sought. He was excited at the prospect of finding both Elizabeth and Crea. Elizabeth was a woman like none he had encountered. She knew her mind, her heart and her cunt, which impressed him. Mental images of her receptive bottom had entertained him throughout the day, at odd moments, hardening his cock at the prospect of delivering the desired attention, or to be on the receiving end of such a small but fierce hand. Crea, of course, would be a wonder to behold. Since Victor's tales, Robert had dreamt nightly of this

astonishing being whose abilities seemed endless and whose limits had not yet been found. The notion of so many useful parts filled him with a great desire and the explorer within him found new terrain which compelled him to investigate.

The ships were not far off, and not far apart, and the two men decided that slipping on snowshoes and walking over the snow-encrusted ice would be the quickest way to get there. The journey was treacherous for the cracks in the bergs, and exhausting, but eventually they reached The Manatee and boarded her. They soon discovered that the ship had been abandoned.

"This is not good news," Victor said morosely.

Robert agreed. "I wonder what this will mean regarding the sister ship, for the crew have to be somewhere and since they are not on the ice, they must have boarded her."

They rested and warmed themselves, and indulged in a bit of energizing foreplay, then started off for the Anemone, further in the distance.

The landscape was solid white, the sky nearly as colorless as the ice, and the distance they had assessed between ships proved deceptive. It took them until nearly nightfall to reach the Anemone.

Unlike the first, this ship was not abandoned, but supported the crews from both vessels. Rum from the Caribbean, and rye from Scotland flowed freely and a jolly event seemed underway on the decks.

Robert, accustomed to dealing with loutish men, made his way briskly through the merry crowd of loud, slovenly sailors littering the fore deck and moved down into the captain's quarters.

There he found the officers had taken over this room. These bearded, burly fellows were in varying states of undress and somnambulance. General rutting was taking place. Leather snapped against bottoms, penises rammed into rectums, cocks were being sucked—two and three by the same eager mouth, alternating.

The air was sharp with the scent of leather and sweat and other excretions, all woven into the undercurrent of hard liquor. Fights had broken out here and there, and there was much shouting and raucous laughter as fists blackened eyes and bashed-open lips.

Clearly, Victor had never seen the like. Robert studied him studying these men and wondered how he would feel about having his bottom whaled by a raw leather strap held by such powerful hands. But this was

not the time to indulge, even Victor knew that, as was clear from the regretful look he passed to Robert.

"Where is your captain?" Robert demanded of one tall, slim fellow, who scratched he bare, blistered ass, then pointed further back in the ship.

"The galley, sir. You'll find him dining on the most succulent birds."

Robert and Victor elbowed their way back up to and along the starboard deck to the stern of the ship, then they headed down the narrow steps to the ship's galley. By contrast, this large room lay empty but for three souls.

"Elizabeth!" Victor cried, running to the woman tied to the table. She was naked, her shapely legs bent at the knees and pulled up to her chest along her sides. This splayed her, so that her bottom cheeks plumped up. She resembled a frog. The position also exposed her, for her cunny and bottom hole were clearly visible and, from the raw, moist look of them, Robert deduced they had entertained many visitors of late.

"Darling, are you alright?" Victor said, pulling the gag from his wife's mouth.

"Of course I'm alright. Why would I not be? The captain and his crew have simply been entertaining us until the ice melts. But Victor, I am so glad you're here. These men have been too long at sea. They know nothing of how to fulfil a woman. That is the place of a husband, to be certain, which makes me glad I'm married."

Robert saw that Victor picked up on her meaning at once. He was already busy liberating his rod and climbing atop the table. Instantly he mounted her from behind, much to her delight.

While this domestic reunion had been taking place, Robert's eyes had been drawn to the corner where he heard loud grunting. The heavyset man with the red hair and beard, surely the Norwegian captain of this vessel, was busy fucking a tall woman from behind. His hands had not grabbed onto her hips, but had reached around and each grasped one of her two cocks, stroking them both in a disjointed rhythm. The lovely, radiant being having her cunt stoked was surely Crea.

Robert moved closer. Her eyes watched him, the blue so calm, the brown one inviting and eager for something new. For it seemed to Robert that this skipper was a rather coarse fellow who likely sang all songs with only one note, and that off-key.

Behind him he heard sounds: Victor groaning and Elizabeth moaning, begging him, "Victor, my love, take my heinie hole when you've finished with the other."

Ahead, the captain came in one great thrust and an ear-shattering grunt. This massive ejaculation seemed to have taken much out of him. He bent and reached for a bottle of rum on the floor, raised himself up, lost his balance, took a large swig from the bottle and staggered. His glassy eyes rolled into his head. He fell backwards and landed with a thud on his naked rump on the rough floor. Instantly he keeled sideways and was within seconds snoring loudly.

Crea's eyes never left Robert and he took advantage of the situation that made her available. "I see this fellow has left you high and dry. Are you in need of assistance?"

Crea moved forward at once. "As it pleases you, sir," she said, which is exactly what Robert wanted her to say.

"Then it pleases me to mend fences, for I can see a new dwelling being built of a more stable foundation that needs to be fenced in properly."

Crea, of course, had no idea what he meant. He did, though, have a plan, one he had been fantasizing about much of late. He led her to the table where Mrs. Frankenstein was having her bottom hole nicely skewered. Her blue eyes were filled with rapture yet she looked at Crea and Robert with longing.

"Crea, my darling," she panted, "introduce me to your friend."

"Her mouth needs filling," Robert directed, and Crea climbed the table obediently and leaned forward until she could slip her largest cock between Elizabeth's waiting lips. Robert mounted Crea from behind at once, slipping into her recently vacated cunny hole. This position put him face to face with Victor. The two men pumped away and stared at each other, grinning. It was only natural that their lips met and their tongues explored one another's mouths.

The four throbbed and fucked, taking turns coming, synchronizing their movements, shifting positions and orifices until all had an equal opportunity at giving and receiving.

As the sun finally rose and they lay in a heap, exhausted, it was Robert, though, who best understood the nature of their situation.

"If we wish to move we must do so when the ice frees up. I can feel from the slight movements of this ship that liberation is near. I suggest

we return to The Virgin at once and head south, while the opportunity presents itself."

The other three agreed to this, and they bundled up and trundled across the floes with the brilliant sun rising to their left. When they reached The Virgin, however, they discovered that the crew had vanished, leaving the ship empty, no doubt having joined the party. Robert regretted the fact that Billie must be on the festive ship, as her jig was undoubtedly now up, although that likely would open up opportunities for her.

"They shall find their own way home," Robert announced, "and so shall we. What has been lacking here with your situation is obvious, and of course that lack has bred unnecessary conflict and jealousy. You've needed another set of genitals to break the deadlock."

Crea and Elizabeth stared at one another, then each looked at Victor, who looked to Robert. Enlightenment flashed through their faces one at a time like shooting stars descending from the sky to alight in their eyes.

"Of course!" Elizabeth exclaimed. "Can you not see the truth to this, Victor?"

"Indeed," he said. He turned to Crea. "I understand now what was lacking. The captain is correct. Our balance has been off all along. Conflict was inevitable. It kept me from seeing you in a more human light. As I have thought on it, when there were four at Oxford, these jealousies did not arise."

"Master Frankenstein," Crea said, "We believe you are correct. We are prepared to rectify the matter..." She left it open.

"As am I. At once!" Victor said, turning to Robert. "What say you?"

"My ship is at your command, as am I," Robert said. "To travel the seas with those who fulfil me, I can wish nothing more for myself. I would be a happy man, although in many ways I admit to being yet a virgin."

"That can be a delightful state," Elizabeth said, reaching for her purse. Crea opened the stove's gate and began making a fire. Victor removed the leather razor strop from the wall. He folded the wide strip of hide and snapped it. The sound reverberated in Robert's ears, filling him with fear and anticipation. Already his cock was firming and his ass muscles twitching in terror and excitement.

And when Victor commanded, "Bare your bottom," a delicious

tremor passed through Robert's body. He knew he was about to explore that new terrain which he found so enticing.

When the fire blazed, and Robert lay prone across the short bench, his hard cock beneath him, Elizabeth sat on the floor near his face. She bared her breasts and his fingers went to the one with the gold ring automatically, tugging at the precious metal, pulling the tittie out so far he wondered if it was painful.

Elizabeth, though, only smiled at him. She held something in her closed palm. "Victor, apply the strop," she said. "He needs priming."

The leather landed hard, shocking him. Pain he had never felt, but which he had inflicted so often, ran through him, a direct connection from ass to balls to cock. He could only gasp at the onslaught. Victor walloped his ass until it blazed and Robert gasped for air. "How can pain be so pleasurable!" he cried. Victor strapped him harder. The leather seemed to find new spots, awakening agony so sweet it lifted his spirit.

"Crea!" Elizabeth called. "Bring it here."

Crea, her cocks unfurled, knelt beside the bench and handed Elizabeth something. Automatically Robert's free hand reached out to hold that enormous cock for comfort and reassurance, as his other hand still toyed with Elizabeth's nipple ring. His eyes were so blurred by tears he could barely see what Crea had brought. His brain was able to make out that it was a small pot, with a small fire burning from it.

Crea lay the pot on the floor beside Elizabeth, then slipped her hand under his hips and stroked his swollen member. He gasped, torn between the soft caresses and the hard leather smacking him.

Suddenly Elizabeth opened her hands. What lay in her palm was the large needle, and a gold ring matching the ones the three wore.

He watched her heat the needle to red-hot, the color he felt his ass to be. Crea swabbed his left nipple with alcohol.

The strop halted in mid-air, and the hand beneath him stilled.

"Will you submit to each of us and all of us as we see fit, Robert?" Elizabeth asked.

"Oh yes, Mistress Elizabeth!" he cried.

"And will you dominate as we each and all require?"

"Indeed, I shall!"

"Good. Then we three will do the honors."

The hand began to stroke him, the strop whip him and the needle

pierce him. Through it all he felt the ship rock from side to side as it began to move out once more into open waters and the new, uncharted lands ahead of them.

About the Author

Amarantha Knight is the steamy pseudonym of Canadian horror writer Nancy Kilpatrick. Under both names she has published fourteen novels, including *The Darker Passions* series (the next two books in the series will be out from Circlet Press in 2004); *The Power of the Blood* series (being reprinted beginning with *Child of the Night*); *As One Dead; Dracul: An Eternal Love Story*; and her most recent novel *Eternal City*. She has written for VampErotica comics, and is currently editing her eighth anthology, for Roc/NAL. *The goth Bible*, her non-fiction book on the gothic culture worldwide, will be released by St. Martin's Press in 2004. The several awards under her black leather belt include the prestigious *Arthur Ellis Award* for best mystery story. Nancy/Amarantha and her black cat Bella make their home in Montreal. Visit her website for the latest news: http://www.nancykilpatrick.com